MW01504924

Performance
Anxiety Strategies

Performance Anxiety Strategies

A Musician's Guide to Managing Stage Fright

Casey McGrath
Karin S. Hendricks
Tawnya D. Smith

ROWMAN & LITTLEFIELD
Lanham • Boulder • New York • London

Published by Rowman & Littlefield
A wholly owned subsidary of The Rowman & Littlefield Publishing Group, Inc.
4501 Forbes Boulevard, Suite 200, Lanham, Maryland 20706
www.rowman.com

Unit A, Whitacre Mews, 26-34 Stannary Street, London SE11 4AB

Copyright © 2017 by Rowman & Littlefield

All rights reserved. No part of this book may be reproduced in any form or by any electronic or mechanical means, including information storage and retrieval systems, without written permission from the publisher, except by a reviewer who may quote passages in a review.

British Library Cataloguing in Publication Information Available

Library of Congress Cataloging-in-Publication Data
Names: McGrath, Casey, 1983– | Hendricks, Karin S., 1971– | Smith, Tawnya D., 1970–
Title: Performance anxiety strategies : a musician's guide to managing stage fright / Casey McGrath, Karin S. Hendricks, Tawnya D. Smith.
Description: Lanham : Rowman & Littlefield, [2017] | Includes bibliographical references and index.
Identifiers: LCCN 2016026587 (print) | LCCN 2016026888 (ebook) | ISBN 9781442271517 (cloth : alk. paper) | ISBN 9781442271524 (pbk. : alk. paper) | ISBN 9781442271531 (electronic)
Subjects: LCSH: Music—Performance—Psychological aspects. | Performance anxiety.
Classification: LCC ML3830 .M36 2017 (print) | LCC ML3830 (ebook) | DDC 781.4/3111—dc23
LC record available at https://lccn.loc.gov/2016026587

♾️™ The paper used in this publication meets the minimum requirements of American National Standard for Information Sciences—Permanence of Paper for Printed Library Materials, ANSI/NISO Z39.48-1992.

Printed in the United States of America

Contents

Preface

As a student skydiver on my fourth solo jump, I remember experiencing what the author of my skydiving manual calls the "First Breath Dive": a jump in which the student diver finally gives herself up to the freefall, no tension or fears attached. It's a freeing sensation, a moment of complete submission to the elements—a place where the tension dissolves and your body finds peace with what you're doing.

In performance, we often call this *flow*. Top-tier musicians describe it as a state where concern for consequence and others' opinions are upstaged by an overwhelming sense of fascination and enjoyment. We play better because we feel better—our focus is on what is important to us and not what we think is important to others. Fear hasn't poisoned the moment because we haven't let it—we're too busy creating, enjoying, and sharing to be bothered with hypothetical disaster.

So what's the formula? How do we tempt the spirit of optimal performance to possess our fingertips? Surely that's why you picked up this book to begin with and why many of us beeline to self-help sections in bookstores: It's because you care enough about what you do to try whatever it takes to do it well, even if it challenges your comfort zone in the process. And really, that feeling of discomfort is usually testament to the effectiveness of the approach. If you exercise but don't break a sweat, then you're probably not challenging yourself enough. Similarly, we're often advised as musicians to not practice the things we're already good at. The practice room and the private lesson are seen as safe spaces in which to fail; failure is better labeled as *learning* in these environments, and we accept it as part of the process. Our standards shoot through the ceiling in actual performance situations, though, which is likely one of the reasons we may walk away disappointed: We accept ourselves as evolving entities anywhere but the stage. Audition panels are ruthless, but it's almost understandable: When six hundred people show up for one job, even one misplaced pitch can be justification for the obligatory "thank you" from behind a screen.

But as I once heard it said that stage fright is "being held to the same unrealistic standards to which you hold others," we are probably all guilty of cringing at one sour note in an otherwise great performance or criticizing a recording for some interpretive quality we feel was overlooked. But as we can always push ourselves to achieve higher levels, part of what makes performing such a satisfying pursuit is its insatiable capacity to surprise and challenge us. We can prove ourselves capable of more than we ever imagined just by employing a strategic mind, a peaceful heart, and an eagerness and willingness to learn. The quest to finding a balance between all of those components is—if we let it—as rewarding as finally getting there.

This book is about that same journey I took with myself. It is about the mission I assumed when I knew I was meant to be a violinist and the devastating weight of disappointment I felt from being unable to express myself as an artist onstage. It's kind of an unofficial response to the advice I was once given to eat a banana before a performance and the realization I had upon doing so: A fruit will not fix this, but it might help. Doing a few yoga postures will not cure your troubled mind, but it might calm it. Performing often may never rid you of the concern you have for others' opinions, but it may diminish it. Just as courage is not the absence of fear but the step forward despite it, fearless performance is not about being perfect; it's about being at peace.

In considering the research presented in this book, I hope you will feel compelled to do the same. Music performance anxiety is an epidemic. It is not about survival of the fittest; it does not mark a weaker artist; it does not mean we are doomed to never enjoy what we love. We need to get the conversation started, if nothing else than for the sake of better appreciating the music we work so tirelessly to create. After all, we spend hours in a practice room for mere minutes onstage; isn't it about time we start making those moments some of the best of our lives?

Casey McGrath

AN INVITATION TO ALL MUSICIANS

While music performance anxiety may well be a serious threat to the mental and physical health of professional and aspiring professional musicians, it is also a concern for many other musicians. Although this book focuses primarily on performing musicians, we aim for it to be applicable and meaningful for music teachers, student musicians, and amateur musicians who wish to learn how to better manage their anxiety. We hope that learning how to cope and manage performance stress might open a way for more musicians to engage in music making with greater joy and fulfillment, or even help someone who has been too fearful to feel empowered to begin.

Acknowledgments

We extend our deepest appreciation to the following artists, athletes, and experts for their contributions to this project: Cynthia Lawrence, Rook Nelson, Angella Ahn, Jesus Florido, Stefan Milenkovich, Brian Germain, Jeremy Moeller, Dan Kirschenbaum, Jill Burlingame, Frank Diaz, Meagan Johnson, Stephen Paparo, Steve Duke, Robert Bartiz, Lisa Landley, Henrik Csuri, and Alain Milotti. We are also grateful to the editing team at Rowman and Littlefield for their support and enthusiasm in making this book a reality.

Casey thanks her collaborators, Tawnya and Karin, for their energy, passion, and devotion to this project. She also acknowledges with gratitude the many people who have encouraged her pursuit of confidence, both onstage and in the sky: Dr. Mark Ponzo, Larry Shapiro and the music faculty at Butler University, her colleagues in the music department at Joliet Junior College, the musicians of the Fox Valley Orchestra, her students, and everyone at Skydive Chicago. She also thanks her family and friends for their love and encouragement, especially her dad, Kevin; sisters, Erin and Kelsey; and husband, Thomas J. A particularly special note of thanks to her teacher and mentor, Drew Lecher, for his unwavering enthusiasm and relentless support of her musical aspirations and whose patient and personable guidance continues to inspire her artistic progress, every day.

Karin acknowledges her "collaborating heroes," Casey and Tawnya, for their brilliance, humor, and friendship over the past decade and especially throughout the writing of this book. She offers a special thanks to her research assistant, Chad Putka, for his enthusiasm and willingness to transcribe several interviews with just a few hours' notice. She acknowledges Jon Skidmore, psychologist and performance coach, who was a catalyst in her own journey toward expressive musicianship, and Ted Ashton, a teacher, "musical father," and nurturer of musical community who has modeled life-giving musical priorities to her and countless others. She thanks

her research mentors Gary McPherson and Louis Bergonzi, who cultivated many of the ideas she presents in this book. Finally, she thanks her family, beloved former students, and current students and colleagues at Boston University for their inspiration and support.

Tawnya thanks Casey and Karin for the opportunity to collaborate with two such intelligent and caring women on a project that was fired from the heart. She thanks Liora Bresler, who nurtured her writing and research; her instructors at Lesley University, who shared their passion for the expressive arts; as well as her instructors at the University of Illinois, who guided her growth in educational research. She thanks the many music students she has learned from over the years. It is because of them that she cares deeply to work for an educational environment that nurtures the musical potential of everyone. She also thanks her family for their love and support. And finally, special thanks to Karin, for not everyone has the patience and wisdom to be able to write a book with their spouse. Tawnya and Karin would like to thank Aunt Hannah for her moral support, wisdom, and companionship.

Disclaimer

This book is meant to inform the reader about available therapies and to provide activities that may increase personal awareness, but it is not a substitute for therapy with a qualified professional. While some individuals with mild levels of performance anxiety may find that they can use this as a self-help book, others may find that the descriptions of various therapies lead them to an appropriate therapy or that the activities serve as a useful complement to therapy. In any case, we hope that this book helps you to find the resources you need to effectively manage music performance anxiety (MPA).

The statements made in this book have not been evaluated by the FDA, the APA, or any other professional association involved in regulating physical or mental health care; therefore, they are not intended to diagnose, treat, cure, or prevent any disease or mental health condition. This book is meant to provide educational resources and basic information to introduce well-established treatments for MPA and to inform the reader of the research that has been conducted on the efficacy of these treatments. While it was the intention of the authors to conduct an exhaustive review of the published research, it is possible that important insights regarding these treatments have been overlooked.

1

Introduction

What some naïvely dismiss as butterflies is, to many with music performance anxiety (MPA), more comparable to barracudas: The physical and psychological symptoms of anxiety experienced by performing musicians can disrupt, damage, or even lead to the premature end of otherwise promising careers. But while anxiety consistently poses the cruel possibility of performance-compromising side effects, the strategic use of the right interventions can help transform even the most terrifying of moments into empowered opportunities for success.

WHAT IS MUSIC PERFORMANCE ANXIETY?

It's important to understand what music performance anxiety is—and isn't. MPA has been defined as the "experience of persisting, distressful apprehension about and/ or actual impairment of, performance skills in a public context, to a degree unwarranted given the individual's aptitude, training, and level of preparation."[1] Research suggests that approximately 15 to 25 percent of musicians experience MPA[2]—but suffering from this skill-compromising affliction has traditionally been regarded as a reflection of personal weakness or just an unavoidable part of performing, so treatments often go unexplored and symptoms go unaddressed.

Stage fright refers to the basic state of nervousness prior to or during performance in front of an audience and affects people in numerous disciplines, from seasoned athletes to first-time public speakers. Generally, a little apprehension or a healthy surge of energy in these situations is perfectly normal. It's when the symptoms escalate to such a degree that performance quality suffers and mental, emotional, or physical health are threatened that nicknames like *jitters* or *butterflies* become less and less appropriate and music performance anxiety becomes a more fitting label.[3]

Perhaps one of the most frustrating things about MPA is that we often experience it even when we've adequately prepared.[4] Rare is the musician who can't relate to the exasperation of having invested countless hours of diligent practice, only to walk off stage disappointed. But while our immediate response is to fine-tune our practice-room strategies, research suggests that the degree to which people suffer from MPA is less related to preparation and more to their ability to manage heightened emotional states. Nervousness serves a necessary biological function to *increase* our chance of survival by adjusting our bodies to life-threatening or challenging situations.[5] But the heightened arousal necessary for escaping a house fire is rarely appropriate for the sensitive execution of fine motor skills, so when our brains process a performance in the same manner in which they process physical danger, the resulting corporeal responses can be extremely frustrating.

In better understanding coping strategies for performance anxiety, considering the tactics of athletes dealing with similar pressures is valuable because, while the playing field differs, the inner game is comparable. Joseph B. Oxendine studied the relationship between emotional arousal and its effects on athletic performance, offering three generalizations that can easily apply to the performing musician:

1. A high level of arousal is essential for optimal performance in gross motor activities involving strength, endurance, and speed.
2. A high level of arousal interferes with performances involving complex skills, fine muscle movement, coordination, steadiness, and general concentration.
3. A slightly above-average level of arousal is preferable to a normal or sub-normal arousal state for all motor tasks.[6]

Several researchers have found that these inappropriately high arousal states resulted in physiological, psychological, cognitive, or behavioral changes, occurring either by themselves or in conjunction with one another:

1. Physiological changes that take place within the body, including increased heart rate, sweating, shortness of breath, muscle tension, shaking, numb fingers, clammy hands, dry mouth, upset stomach, headache, dizziness, nausea, and diarrhea.
2. Psychological/emotional conditions, such as intensified apprehension, fear of failure, irritability, and panic.
3. Cognitive problems, such as loss of confidence, lack of concentration because of interfering thoughts or concerns about the performing situation, memory lapses, and interferences in the creative process.
4. Behavioral changes, such as shoulder lifting, pacing around the room, or backing out of performance commitments.[7]

Conditions of anxiety are frequently accompanied by physical symptoms. As you anticipate technical failure or a subpar performance, your body may react as if it had

actually happened. Additionally, because musicians dedicate hours to automating physical skills in the mastering of repertoire, they may experience what is referred to as blocking and depersonalization.[8] *Blocking* refers to the fear of losing technical control over diligently rehearsed motor functions. *Depersonalization* is the sensation of observing the mechanics of one's functioning self in a sort of out-of-body way, as if viewing one's self from the audience's perspective.[9]

Experiencing either of these phenomena as they are occurring only perpetuates the symptoms, and like noticing sweaty palms or a shaking bow arm, paying attention to them poses even a greater risk of further distraction.[10] Dale Fogel refers to this as "defensive playing" versus "creative playing." He explains:

> Performance anxiety thus tends to de-automatize performance, as the player reverts to a more self-conscious, laborious style of playing. . . . If the performer attributes some performance detriment to his/her nervousness or stage fright, this insight will not necessarily be of much help. Deliberate (and anxious) efforts to reduce tension before, much less during a concert often fail, and they further deflect the victim's effort and attention from any larger musical values.[11]

Performance anxiety isn't limited to occasions in which an audience is present. Though many performers can attest to an increased sense of anxiety in the case of public performances, it may just as easily show up in lessons, rehearsals, and individual practice.[12] Any situation in which a performer is being assessed or judged can serve as a potential trigger.[13]

WHY WE NEED OPEN DISCUSSIONS ABOUT MPA

There has been a long-standing myth that depression, substance abuse, and general emotional suffering somehow produce the most artistically effective individuals.[14] This tradition, coupled with the common discomfort and misconceptions associated with the treatment of mental health in today's society, may all work to discourage musicians from seeking help. Additionally, many musicians are so focused on technical improvement that the assumed sacrifice of practice hours for the sake of treatment is rarely seen as justifiable.[15]

But the truth remains that, if left untreated, MPA could not only make the stage a constant place of uncertainty and distress, but it could also lead to the development of various medical and psychological symptoms. Consequentially, some turn to maladaptive coping behaviors, such as abuse of beta-blockers,[16] alcohol, and illegal substances.[17] In one study, psychologist Jung-Eun Park found that, of his sample of 230 young adult classical musicians who had studied music at an intensive professional institution, the students with high levels of MPA commonly reported substance abuse as a coping strategy in comparison to those with only occasional on-stage discomfort. The danger, Park warns, is that other students who have assumed a maladaptive behavior may influence others to resort to the same self-treatment, and

outside of a physician's supervision, this could be unnecessary and—in some cases—quite dangerous. To prevent this, Park stresses the importance of music schools establishing an open dialogue between teachers, administration, and the student body about stage fright and its treatment.[18]

SOME GENERAL THOUGHTS

It is unfortunately all too common for a performer to feel like the "only one" who suffers from performance anxiety. In truth, most of us experience some sort of aroused or changed state (physically, psychologically, emotionally, or behaviorally) when we perform. As described in this chapter, up to one-fourth of musicians suffer from music performance anxiety. However, because many people perceive MPA as a personal shortcoming rather than something that can be dealt with, these symptoms are often left untreated. Similarly, sometimes those of us who feel the anxiety deeply or intensely are unwilling to talk about it with others—for fear of judgment or even fearing fear itself—so we allow the thoughts, emotions, and negative self-talk to further fester and spiral inside of us.

As you read this book, we hope you will recognize that you are not alone! In fact, you are in the company of some of the world's greatest musical performers, including Arthur Rubinstein, Pablo Casals, Luciano Pavarotti, and Barbra Streisand, among many others.[19] Throughout this book we share vignettes of our own journeys with MPA and offer similar stories and advice from performance experts. We also provide an overview of the immense amount of research that has been conducted regarding this issue. This wealth of information demonstrates that MPA is indeed a common experience. There are scholars who have devoted their entire lives to this issue to help others transform anxiousness into expressive freedom. With this book, we invite you to join a community of performers, teachers, and scholars who love music and performing enough to find a way.

Learning performance skills, including how to manage anxiety, can be as important to a performance as preparing the repertoire. With this in mind, we recommend that performers and teachers devote more time to the practice of performing in addition to practicing technique and repertoire. These are distinct skills that may need to be practiced separately. Because the practicing of technique and repertoire might necessarily involve a perfectionistic ear, we recommend declaring a "performance practice" time each day in which you shift gears and practice the art of graciously playing through a portion of previously prepared music—mistakes and all. This can be accomplished either in front of others or completely alone with an imaginary audience. In any case, it may allow you to focus your attention on developing different yet crucial skills, such as body awareness, breathing, relaxing, and performing expressively.

Later chapters address specific ways in which you can manage anxiety, but for now we invite you to simply add a daily "performance" to your practice routine. Just as

your musical technique has developed over time, your management of anxiety and successful performance practice can grow over time as well. At this beginning stage, simply allow yourself time each day to perform. As you do, take note of those times in which your anxiety symptoms increase.

Anxiety, like performance, is a very individual experience: Not everyone will experience it to the same degree or in the same way in any given context. At the simplest level, we may simply experience butterflies or excited anticipation. In these situations, when nerves are really "no big deal," a simple reminder to think positively and breathe deeply may be all we need. In other areas of performance and in life, anxiety may reach the next level of severity—a level we might call discomfort—where more intensive interventions might be needed to turn a potentially self-defeating situation into an empowering one. Finally, at the utmost level of severity are performance contexts and other areas of your life in which what you experience is comparable to standing in front of a firing squad—or catching on fire, whichever is worse.

Depending on your mental and physical health at any point in your life, you will likely experience each of these levels of anxiety in some context or another. This book addresses each of these varying levels of discomfort as they relate to music performing so that, depending on the performance context and level of severity, you will be able to find something that is appropriate for your present needs. If something in this book doesn't resonate with you now, feel free to skip it; it will be waiting here for you should a different context or situation bring you back. For now, as you take steps forward to help yourself, we invite you to do so without judgment or comparison with others but rather with an understanding that you—like everyone else—are on your own unique journey.

INTRODUCTION TO ACTIVITIES

In each chapter, we include activities to help you to apply new ideas to personal practice. Many of these activities begin with a "reflection for awareness" designed to deepen or heighten your awareness of specific aspects of music performance anxiety. Following each of these reflections is an "application and integration to practice" activity designed to help you work with new insights to transform your performance practice. The first activity is the longest and is designed to help you better understand yourself. Setting aside time to do this activity before you read on will help you get more out of the book, as you will be better able to understand which of the therapies might be best for you.

It is important to keep in mind that most of us have spent years of practice thinking negative thoughts and engaging in habits that reinforce our music performance anxiety. Instead of thinking that these exercises are one more thing to add to your practice repertoire, we suggest you consider that you are actually working to identify and eventually replace thought patterns and habits that are not working for you now. When you release the old and embrace the new, you will likely have more energy and ability to

focus on the important work of improving your technique and learning new repertoire. Making beneficial changes to your practice routine works by reinforcing your new understandings. Regular repetition also works to counter the voice inside that might lure you back into the negative patterns that no longer serve your development.

ACTIVITY A: HEALING YOUR MEMORIES

Reflection for Awareness: Recalling Your History

The following questions will bring aspects of yourself to your conscious awareness so that you have a clearer understanding of why and how you express music performance anxiety. This is an important first step; taking an honest look at these issues will allow you to identify actions you can take and the therapies that might be of most use to you. Ultimately, it will allow you to transform your current practices to ones that reinforce positive coping strategies.

1. Find a place where you feel safe and will be undisturbed. Take a few moments to relax, breathe deeply, and become centered in the present moment.
2. Recall the time when you experienced your most extreme performance anxiety. How old were you? Where were you performing? Was this place familiar? What music were you playing? Did you feel adequately prepared to perform the repertoire? Did you feel pressured to perform by a parent, teacher, or one of your peers? Did you choose to perform at a time when you felt ready to do so, or did a teacher or organization schedule this event in advance?
3. Recall how you felt in your body before, during, and immediately after the performance. Scan your body from head to toe and note any of the sensations you experienced at each of these stages (increased heart rate, sweating, shortness of breath, shaking, numb fingers, clammy hands, dry mouth, upset stomach, headache, dizziness, nausea, diarrhea, etc.).
4. Recall what emotions you were feeling before, during, and immediately following the performance (intensified apprehension, fear of failure, irritability, panic, etc.).
5. Recall what you were thinking before, during, and immediately following the performance (loss of confidence, lack of concentration because of interfering thoughts or concerns about the performing situation, memory lapses, interferences in the creative process, etc.). What were you saying to yourself?
6. Recall any behavioral symptoms you noticed before, during, and immediately following the performance. Have you ever avoided performing in certain situations or certain types of music because of music performance anxiety? Have you consciously or unconsciously become ill or become more aware of a physical problem as a way to prevent the performance? Do you ever make facial expressions or nonverbal gestures to acknowledge when you have made

an error during performance? Do you mention your errors to others following a performance in such a way as to control the feedback you might receive from others?

7. Take a few minutes to rest, breathe deeply, and center in the present moment.

Application and Integration to Practice:
Healing Painful Memories through Re-Storying

Now that you have collected many details about your performance anxiety experience, it is important to look at these experiences from a fresh perspective. While it is important to fully acknowledge how you were feeling before, during, and after the event, it is also equally important to be able to recall this experience in a way that is empowering and supports your continued development. This activity will transform the stories that still have the power to hurt you into ones that encourage you and make you feel strong.

1. Find a place where you feel safe and will be undisturbed. Take a few moments to relax, breathe deeply, and become centered in the present moment.
2. Select one event or issue that carries with it an emotional charge. (While it is important to work with only one story at a time, we recommend repeating the following activity with each of the stories that brings up bad feelings when you think about it.)
3. Think about what else you can remember about the event or situation (both positive and negative). Notice if you resist recalling positive aspects of the situation. If you do, be aware that there is a part of you that is afraid of letting go of the pain in this situation. Be gentle with yourself, but proceed through this fear if you feel ready. If you don't, perhaps there is another story that is less emotionally charged that you could work with instead. Trust yourself to know which story to transform.
4. Rewrite the story from a position of power and strength. Include positive aspects of the story, write from your perspective today, and include details that make you feel good about yourself. See the following example story and re-story:

Example Story: In sixth grade, I performed a solo for my studio teacher's recital. I was proud of my performance because I knew that it was the best that I had ever played the piece. Following the recital my mother said, "It is too bad you missed those notes in the middle section," and "You really need to work on your intonation!" without mentioning anything that I did well. I felt angry and as if someone had punched me in the stomach. All of the good feelings I had were now replaced by the feeling that I had not performed well at all.

Example Re-Story: In the sixth grade, I performed a solo for my studio teacher's recital. I was proud of my performance because I knew that it was the best that I

had ever played the piece. Although my mother thought she was helping me to improve by pointing out the minor flaws in my performance, my teacher noticed that I played the piece with a greater sense of confidence and was more expressive than in rehearsals. Several of the students in the studio came up to me and complimented aspects of my performance. While my mother didn't choose the best way to encourage me, I do recognize that she was trying to help me improve my intonation. I also know that I did my very best performance that day. I know that I created the best music I could and that the recital was evidence that I was improving and accomplishing my goals. As I look back at this recital, I am proud of my sixth-grade self!

In the first story, the angry and painful feelings are related to the disapproving words spoken by the mother. When a story brings up painful emotions, it is likely that the emotions felt in that moment were not allowed to be fully expressed. In this case, it probably would not have been polite or even safe for a sixth-grader to stand up to her mother, cry, or express herself in the lobby of the recital hall. To heal this story, it may be necessary to do something to express the anger and feelings of disappointment. If feelings are held inside, then over time they may contribute to a negative inner dialogue that emerges in similar situations. For example, after a performance you enjoyed, you might say to yourself "I missed too many notes" or "My intonation was awful" much the same way the mother did in this story.

5. Select your most comfortable mode of expression other than your primary instrument (e.g., dancing, drawing, journaling, dramatic role-play, or a physical activity where you can fully exert yourself). This activity should be one you can do alone (if it is safe to do so) or in the company of a person in whom you have complete trust (if safety is a concern). In any case, you should be in a situation where you feel free to yell, cry, or express yourself fully in a way that will not hurt yourself or others.

6. After your feelings have been expressed, it may then be helpful to journal about what you notice about your feelings as they are expressed. Was there something deeper underneath those feelings you are now aware of? Did another memory surface? What seems different now?

7. In some cases, it is important to extend compassion and forgiveness (to yourself and others) to fully release the energy of the memory and transform it into wisdom. In this case the performer may need to forgive her mother for not being able to provide balanced feedback and needed encouragement. It may also be important for her to forgive herself for internalizing her mother's statements and being equally harsh on herself.

8. Take a few minutes to rest, breathe deeply, and center in the present moment.

Once a new story is written and the emotional energy is transformed, it is important to practice the new story. As you do, notice if and when the old story tries to reestablish itself in the mind. If a story comes back or you catch yourself replaying or restating the old version of the story, then there may be more work to do with the

story. In other words, you may discover that the story is a complex of multiple and similar events and that you need to rewrite several versions of the story so that emotions can be released. This is why it is important to re-story the other memories that you listed in the first part of the exercise and any stories that you recall as a result of the process. These stories work together to inform your inner thoughts and reactions. The more emotional energy you release, the less power your emotions will have to influence your present performance practice.

JOURNEYS: PLAYING WITH FIRE

By Tawnya

We all need the fire of motivation to encourage our work. The question is: In what part of our body do we light this fire? Do we work from the warm flame of passion in our hearts, or do we work from the acidy, spiky burn in the pit of our stomachs? While it is likely that we tend both of these fires in different situations, if we rely on the immediate agitation of fear more than the steady but gentle nurturance of passion, then we may be setting ourselves up for some negative side effects.

In my dissertation study, I discovered that some of the participants believed that being hard on themselves was useful and that pessimism helped them to work harder and improve more quickly.[20] Others described how they compared themselves with others who were more accomplished as a way to motivate themselves to work harder. Tragically, some even presumed that, if they stopped working from fear, then they would not achieve their goals at all.

I label this type of thinking *internalized fear-based motivation*. Fear is a quick and easy way to persuade someone. Fear-based motivation has been practiced by parents, teachers, and coaches and is common in the workplace. The strategy involves motivating people by making them afraid of a negative result or by issuing a threat. Often there is no harm in this approach, and it has a clear advantage: It works quickly. By lighting the fire of fear in someone, it is possible to increase their stress levels or even trigger the fight-or-flight response and send adrenaline coursing through their veins. However, motivating someone in this way can be oppressive and even abusive if done without concern for the overall well-being of the person in mind.

Internalized fear-based motivation, then, is fear-based motivation that is learned through experience and then directed toward the self. People who use internalized fear-based motivation have learned to drive themselves by making themselves afraid of failure or some other negative result. Again, it is likely that all of us use this type of motivation from time to time to get things done, and this is appropriate if there is a real consequence we are trying to avoid. For example, if we don't prepare our music before rehearsal, then we and others are negatively impacted by our lack of consideration and preparation. If we eat foods that are not healthy for our bodies, then in time we will become diseased. Fear-based motivation might occasionally be

useful or even necessary. However, choosing to use it as one's primary form of self-motivation or taking it to excess can be damaging and debilitating.

I mentioned earlier that fear-based motivation could be oppressive or abusive if the person using it is not concerned with the well-being of the individual(s) he or she is trying to motivate. This also applies to internalized fear-based motivation. For example, if you learned fear-based motivation from a loving and respectful caregiver, then it is more likely that you will use it in a healthy way. However, if it was learned by someone who was oppressive or abusive, then internalized fear-based motivation may result in a form of self-abuse. For those who have developed in emotionally or physically abusive situations, bad things *did* happen when threats were made. For those recovering from trauma and abuse, internalized fear-base motivation can result in excessive self-induced stress or trigger extreme fear or panic similar to what was experienced in those hurtful situations.

Even for those of us who have not experienced trauma or abuse, relying on internalized fear-based motivation to provide a quick and easy stimulus may be problematic in the long term. Just like taking ever-larger doses of caffeine doesn't make up for lost sleep, motivating ourselves out of fear does not make up for a lack of motivation through passion. When we intentionally choose to focus our thoughts on fear, we are simultaneously choosing not to focus on our passion and love for making music. What we focus on we create. If our goal is to play with flow and ease of expression, we need to focus on and visualize that instead of fearing the opposite. In this case, tending the fire of passion is more likely to yield our intended results.

Like the benefits of long night of deep and restful sleep, the flame of passion provides a steady, balanced, gentle, and enduring type of feeling that is less demanding and more nurturing. For those of us who have relied on the expediency of fear, it may feel at first as if we are being too easy on ourselves when we stop driving ourselves and let ourselves work from a different place within. However, if our goal is to devote ourselves to a lifetime of musical service, then we need to consider sustainable and healthy ways to perform at our best. We always have a choice: Do we fire up the fear, or do we trust the flame in our hearts and the anticipation of joy-filled flow experiences to inspire us to work well?

ACTIVITY B: PREPARING FOR SUCCESS

Reflection for Awareness: How Do You Prepare?

In this chapter we note that MPA often occurs even when one is adequately prepared. However, in "Journeys: Playing with Fire" above, Tawnya described how some musicians use internalized fear-based motivation to get themselves into the practice room and that excessive use of this strategy might increase MPA in musicians practicing with the fear of failure in mind. This reflection is designed to make you aware of how much you motivate yourself using fear. If anxiety comes from an honest assessment of your level of performance as compared to the time you have to prepare, then

the fear is naturally occurring and appropriate. However, if you create an irrational fear that is not based on your level of preparation or if you procrastinate to create fear as a way to drive your practice, then you may be unintentionally reinforcing or practicing the very fear you would like to eliminate.

The following questions will help you understand your history with performance preparation. Once you identify any unhelpful patterns, you can make new choices to better support your preparation.

- What is your very first memory associated with music performance anxiety? How old were you? What and where did you perform? Were you adequately prepared for the performance? If not, why? Were you pressured to perform before you felt ready by your parents, peers, or teacher?
- How often do you recall past situations where you were ill-prepared in order to motivate your practice?
- Recall a recent performance. Did you feel adequately prepared for the performance? If not, why? What could you have done differently, if anything?
- Recall a performance when you felt that you were not adequately prepared. Were you overcommitted? Were you ill or physically not at your best? Were there circumstances beyond your control? Is there something could you do to prevent a similar situation? Are you prepared and willing to find a substitute performer to take your place if you are not adequately prepared or are physically unable to perform at your best? Are you willing to reschedule or postpone a performance if needed? Do you procrastinate or become ill in order to avoid performances?
- What do you need to feel totally prepared for a performance (musically, physically, emotionally)?
- How often do you practice because you love making music? Do you have a consistent practice routine each week, or do you wait and practice more as you approach a major performance? How often do you procrastinate in order to use fear to drive your practice?

Application and Integration to Practice: Cultivating Healthier Habits

Now that you better understand your patterns and motivations for practicing, you may have identified things you could change to prepare in a healthier way. The following are a few ideas that may be helpful to consider:

- Establish a regular practice routine, and keep it whether you have an upcoming performance (excluding holidays and needed vacations) or not. Practice at a time of day that you enjoy working, and make it a special time where you *get* to do what you love. Make certain that you practice at a time when you are well rested and have had enough healthy food and plenty of water. Notice if you prioritize other things over the conditions listed here. Notice if you have occasional

reasons to deviate from your routine or if you are consistently depriving yourself of a healthy practice regimen. If so, why?

- When you deviate from your practice routine, notice the reason. While there may be many good reasons to change your routine, notice if the reason was procrastination. Don't judge yourself; just notice. Notice how often you do this. If you do this occasionally, then it is probably not problematic. If it is a regular occurrence, however, then you may be generating fear for motivation, or it could be that you are not genuinely motivated to practice for some reason.

FROM THE STAGE: CYNTHIA LAWRENCE

Lyric Soprano, Metropolitan Opera, and
Professor and Endowed Chair, Voice and Opera,
University of Kentucky, School of Music

I grew up showing horses. At times it was a very stressful, competitive business. From the age of eight, I was riding live animals, and I learned very early on that if I was nervous, they got nervous. So I learned how to concentrate on the task at hand, and ultimately that translated to my performing.

What is the task at hand? The task at hand is not standing in front of hundreds of people and looking for their approval. The task at hand is, Have I done my work? Do I understand the music? The task at hand is, What am I accomplishing here? And for me, the bottom line is that I'm telling the story as I understand it with my best technique or vocal ability at any given time. Am I a finished product? No. Is that OK? Yes.

Figure 1.1. Cynthia Lawrence, Lyric Soprano. *Photo courtesy of Ken Howard*

I try very hard to not put huge expectations on myself that are absolutely impossible to achieve. If you put your expectations up in some sort of unachievable place, like "It has to be perfect" or "I have to get the job" or "I have to sing better than so-and-so," then it's just not going to happen because there is no perfect performance. There's only the best creative artistic expression of you and your colleagues, however many colleagues that happens to be.

If [in an audition] you think, "I have to get that job," then you're generally going to fail. I prefer to think of it as, "Did I do my best job?" and if I feed into their need, then great. But if I don't, then it wasn't meant to be. It's always a question of fit.

Very, very early on when I started singing, I thought, "I'm competing against everybody." Well, that's not true. I'm competing against the sopranos who sing my repertoire. I'm not competing against tenors, basses, mezzo-sopranos, or even violinists, for Pete's sake. I'm not because that's a different animal. Apples and oranges. A particular soprano who sings this particular repertoire? OK. Maybe there are two or three of them at general auditions.

I'm really competing against myself. Did I do better than the last time? Did I learn something? Am I crafting my art better? Am I able to understand it better? It comes down to the bottom line of, Did I do my prep? If you didn't do your prep, you don't understand your music, you don't know how to translate everything word for word, you haven't practiced your steps on stage, you're not memorized, and you haven't understood the nuance that people crave, then yeah, get nervous. Because you're probably not going to do what you should do. So that's how I approach learning and performing. But in order to put my brain at ease and my body and my ability, I do yoga before performances and before rehearsals.

I have had times when something has mattered too much to me. There was one time when I was getting frustrated with myself, and I was just repeating the same mistakes. I was practicing and repeating the same mistakes again and again and again. What is the thing that they say? "Repeating the same thing and expecting a different outcome is the definition of insanity." That's what I was doing, and finally my husband came over to me and said, "Stop! Stop, do something different." And I thought, "OK, but I don't have time." He said, "You have time because you're not getting anywhere doing this." So, I took time, and I did something completely different, and I thought about it, and I thought about it, and I came back more relaxed and I was able to fix it. So, stress and nerves are not helpful. Just not helpful.

Stop the pattern. Sometimes I tell the students, I say, "Why are you starting at the beginning all the time?" I like to start at the end when I'm practicing. "What are you setting out to learn and perform? Let's start at the end. Let's find the outcome and then backtrack. Oh, that's how we get there." The students who make conscious decisions about what they will accomplish when practicing are amazed by this process. This approach is not new. But it's new to them.

One story that comes to mind as far as nerves: I was doing a concert with Luciano [Pavarotti]. We were in Alba, Italy, and it was winter. We were in this lovely little theater, doing the concert that we'd done a hundred times. We did a little run-through

Figure 1.2. Cynthia Lawrence in the role of Lady Macbeth, Verdi, Metropolitan Opera. *Photo courtesy of Ken Howard*

of pieces before the concert, and I saw him getting very nervous. He was worried and doing vocal things that were just not really helpful. I was in a good place, and I thought, "What's going on here?" After the rehearsal, I walked by his dressing room, and the door was open. I saw him sitting in the chair slumped over, kind of looking like he was afraid and about to cry.

I asked him, "Luciano, what's up?" He said, "Oh, I am so nervous, I can't figure out what to do." He was nervous. He was afraid of disappointing his public. I thought to myself, "Oh my gosh, what a terrible burden!" The weight of expectations. This is what I'm talking about—putting your expectations too high. If you're worried about something that has nothing to do with your ability to please other people, then you're going to fail. So, here he was worrying about disappointing them, and he wasn't focusing. This is what I helped him to do. I said, "One: Luciano, we've done this. We know this. You've got this. Two: They love you. The people are here to be with you. They just want to see you, OK?"

He started relaxing. I said, "The other thing you have to understand is that I'm going to be there. We're all going to be there. It's the music, Luciano, it's not perfec-

tion." He said, "Yeah, you're right, baby." I saw him relax bit by bit, and then he took a big breath, smiled, and all the time I knew he was thinking, "I've done this. I can do this. I'm a singer. I know how to do this." And I said, "You do! I mean, you've taught me so much." He just looked at me and said, "Thank you." I was stunned and humbled.

We all have to find in our heads the thing that's terrifying us. I find that more often than not the thing that terrifies us is the fear of failure. Failure is the opportunity to fix something, isn't it? If you think you're perfect, well, you're never going to fix it. So if you're open to the aspects of learning something new, well, sort of by definition, that's failure. Isn't that weird? I mean, if you think you're perfect and you don't need to learn anything new, well you're going to be a boring performer. The person who crafts, thinks, allows the unexpected, and looks for the unexpected is the artist I'd like to hear and see.

I've seen a thousand different performances of X, but the one who captivates me is the one who's new. The one who's different. And the only way that it's different is because it comes from the individual performer, if it's different and surprises me. I remember that performer far longer than the one who's just like everything else.

I think what's happening is people are thinking there's some sort of perfect ideal that we should be. It's unattainable. The grassroots of the human element—human existence—your peace within yourself is where you need to find it. If you live your life on "shoulda, woulda, coulda"—wow. It's just too hard. I think that's where the stress comes from. It's all the expectations we put on ourselves and we think other people are putting on us, too. You can't get there and perform your best if you're incapacitated. The end product of the calm, secure, making-their-own-choices performer is very, very key. You see that. You see and hear that in the result. It is hard work; nothing worthwhile is easy, but taking care of our reasons, health, and mental peace is what will keep us performing and teaching for a very long time.

NOTES

1. Paul Salmon, "A Psychological Perspective on Musical Performance Anxiety: A Review of the Literature," *Medical Problems of Performing Artists* 5 (1990): 3.

2. Anne McGinnis and Leonard S. Milling, "Psychological Treatment of Musical Performance Anxiety: Current Status and Future Directions," *Psychotherapy: Theory, Research, Practice, Training* 42, no. 3 (2005): 358.

3. Adriana Ortiz Brugués, "Music Performance Anxiety: A Review of the Literature" (PhD diss., University of Freiburg, 2009).

4. Glen O. Gabbard, "Stage Fright," *International Journal of Psychoanalysis* 60 (1979): 383–92; Salmon, "Psychological Perspective."

5. See Joseph B. Oxendine, "Emotional Arousal and Motor Performance," *Quest* 13, no. 1 (1970): 23–32, for an intriguing essay on various levels of arousal and their relative effectiveness at helping us accomplish certain tasks, such as high arousal for life-saving rescues (in contrast to performances requiring fine motor skills).

6. Ibid., 25.

7. Melissa Brotons, "Effects of Performing Conditions on Music Performance Anxiety and Performance Quality," *Journal of Music Therapy* 31, no. 1 (1994): 63–81; Mark C. Ely, "Stop Performance Anxiety!" *Music Educators Journal* 78, no. 2 (1991): 35–39; Virginia Dee Hingley, "Performance Anxiety in Music: A Review of the Literature" (DMA diss., University of Washington, 1985); Salmon, "Psychological Perspective."

8. Donald M. Kaplan, "On Stage Fright," *Drama Review* 14, no. 1 (1969): 65.

9. Thomas M. Plott, "An Investigation of the Hypnotic Treatment of Music Performance Anxiety" (PhD diss., University of Tennessee, 1986).

10. Ibid., 6.

11. Dale O. Fogle, "Toward Effective Treatment for Music Performance Anxiety," *Psychotherapy: Theory, Research and Practice* 19, no. 3 (1982): 369.

12. Ibid.

13. William C. Sanderson, Peter A. DiNardo, Ronald M. Rapee, and David H. Barlow, "Syndrome Comorbidity in Patients Diagnosed with a DSM-III—R Anxiety Disorder," *Journal of Abnormal Psychology* 99, no. 3 (1990): 308–12.

14. Mogens Schou, "Artistic Productivity and Lithium Prophylaxis in Manic-Depressive Illness," *British Journal of Psychiatry* 135, no. 2 (1979): 97–103.

15. Alice G. Brandfonbrener, "History of Playing-Related Pain in 330 University Freshman Music Students," *Medical Problems of Performing Artists* 24, no. 1 (2009): 30–36.

16. David Alan Harris, "Using [Beta]-Blockers to Control Stage Fright: A Dancer's Dilemma," *Medical Problems of Performing Artists* 16, no. 2 (2001): 72–77; Andrew Steptoe, "Stress, Coping and Stage Fright in Professional Musicians," *Psychology of Music* 17, no. 1 (1989): 3–11; Robert B. Wesner, Russell Noyes, and Thomas L. Davis, "The Occurrence of Performance Anxiety among Musicians," *Journal of Affective Disorders* 18, no. 3 (1990): 177–85.

17. Susan D. Raeburn, John Hipple, William Delaney, and Kris Chesky, "Surveying Popular Musicians' Health Status Using Convenience Samples," *Medical Problems of Performing Artists* 18, no. 3 (2003): 113–19.

18. Jung-Eun Park, "The Relationship between Musical Performance Anxiety, Healthy Lifestyle Factors, and Substance Use among Young Adult Classical Musicians: Implications for Training and Education," (EdD diss., Teachers College, Columbia University, 2010).

19. See, for example, Salmon, "Psychological Perspective," 2; Anne Edwards, *Streisand: A Biography* (New York: Little, Brown, 1997); and the interview with soprano Cynthia Lawrence at the end of this chapter.

20. Tawnya D. Smith, "Using the Expressive Arts to Facilitate Group Music Improvisation and Individual Reflection: Expanding Consciousness in Music Learning for Self-Development" (PhD diss., University of Illinois at Urbana–Champaign, 2014).

2

Why Do We Experience MPA?

Violinist and pedagogue Kato Havas explores the onset of music performance anxiety in her 1973 publication *Stage Fright: Its Causes and Cures with Special Reference to Violin Playing*. Using violin pedagogy as an example, Havas cites the damaging repercussions of teachers prioritizing flawless technique and audience approval in young musicians because in doing so, she suggests, students might miss out on some of the greater benefits of music study. She writes,

> With the accumulation of technical difficulties, examinations, international competitions, the positive side of music making, the overriding desire to communicate soon gives way to anxieties and fears. "Will I succeed at the audition?" "Will the great man teach me?" "Will I win the first prize and thus become known overnight?" It is almost inevitable that by the time a student reaches maturity, the importance and constant evaluation of his own self becomes the dominant factor in his career—and stops him from fulfilling his potential of the "right divine."[1]

While performance preparation, venue, and audience characteristics may have an impact on a performer's level of anxiety, numerous studies have found that disposition, family dynamics, and mental health have a much greater influence.[2] Besides demanding expectations from studio teachers, school directors, or other music mentors, unhealthy home experiences in early childhood have also shown to be significant predictors of music performance anxiety later on.[3] According to Alfred Adler's theories of inferiority, our self-perception is profoundly influenced by whether we receive the family support we need in adolescence to develop a positive self-image and sense of confidence as an adult.[4] Without positive reinforcement at home, then, it's just more likely that a child will grow to habitually doubt his or her abilities in a number of areas. In music performance, this can prove especially unfortunate, as

both gainful employment and artistic freedom depend on a strong sense of self-assurance regardless of technical mastery.

For the emotionally healthy, being a little nervous before going onstage is better described as being excited, and an optimistic boost to your blood flow can aid in delivering an engaging, energetic performance. But for those struggling with self-confidence or regularly fighting an insufferable inner critic, the stage becomes about as appealing as a shark tank. Furthermore, allowing yourself to be bullied by a defeatist mindset only perpetuates the problem: As it distracts from the technical task at hand, it can lead to an endless cycle of error and judgment that makes it an increasingly more difficult force to dispute.[5]

There are likely many factors that contribute to the onset of MPA, but our personal histories may hold important clues in guiding long-term healing and the management of symptoms. For some, MPA may be linked to previous physical or mental trauma: In a study of composers and musicians, Inette Swart suggested that unresolved trauma may lead to acute stress disorder and post-traumatic stress disorder (PTSD). In these cases, trauma is encoded in the brain and nervous system, causing an interference in healthy functioning and stress response that detracts from the quality and level of music performance.[6]

For others, trauma may not be the cause of MPA but rather unhealthy behaviors and thought patterns that were learned and reinforced during early development and then internalized into habits. Cognitive-behavioral psychologists theorize that the sources of music performance anxiety are largely connected to a person's recurring thought patterns and the general attitudes they assume. When we regularly rehearse a pessimistic outlook and discouraging self-statements like "If I botch the opening of *Don Juan*, I'm a sorry excuse for a violinist" or "Everyone else at this audition sounds so much better than me—I could never win this position!" we can potentially compromise assertiveness and focus, rendering months of careful preparation useless. On the other hand, if more positive mental affirmations become our default, then the outcome could be exponentially more empowering. (For more on mental rehearsal, see chapter 4.)

How we feel about ourselves and our abilities to handle the tasks set before us play a large role in how successful we are in executing them.[7] Not surprisingly, the opposite is also true in that our beliefs about ourselves—both as performers and as people in general—are also affected by our performances. For example, researchers have found that music students who believed the outcome of a performance jury examination would influence their self-perception reported more anxiety as the dates of their juries approached than students who were able to better separate their sense of self from their performances.[8] In another study, 80 percent of student musicians surveyed reported that their self-esteem was significantly affected by how well they performed.[9] Simply said: When we succeed, we can feel like rockstars, and when we struggle, we can feel like failures. As Dr. Mark Ponzo, professor of trumpet at Northern Illinois University and a regular solo recitalist, so candidly puts it, "When I play like crap, I feel like crap."

The character sketch of the classic stage-frightened musician is comparable to both Adler's description of the inferior individual and the American Psychological Association's diagnostic criteria for social anxiety.[10] Both experience marked fear of social or performance situations in which they might be embarrassed or humiliated, and the subsequent anxiety is inevitably produced by the anticipated or actual performance. For any performer, the stage offers the possibility of embarrassment as readily as it does the possibility of artistic triumph. For those who regularly rehearse a defeating inner dialogue, however, the most rewarding moments can be easily overshadowed by the tendency to find flaws in even the most well-deserved of successes.

It's a common thing for the more confident performers to point out all the reasons the stage is not something to be feared, which doesn't necessarily help those who are the least confident among us. Well-meaning teachers may list the ways in which progress has been made or reference past successes to overshadow moments of panic or defeat. But even accepting that the fearfulness is in excess doesn't suddenly infuse those suffering from MPA with the courage they need. More commonly, despite the encouragement of colleagues and mentors, technical progress, or more favorable circumstances, people with extreme levels of anxiety tend to abstain from performing altogether. Or, when the performance can be avoided no longer (such as in the case of end-of-semester juries, lessons, and auditions), they endure it with debilitating emotional and physical distress.[11]

There is hope, however, when considering performance contexts: For some musicians, their anxiety can be potentially curbed with less individual exposure, or the "safety in numbers" so frequently enjoyed in ensembles. In comparing nearly eight hundred adolescent boys' anxiety levels while taking tests, playing sports, and performing music, researchers found the greatest levels of stress in boys performing solo on an instrument as opposed to in a group.[12] The same is true for professional musicians: In a study of seventy elite professional orchestral musicians, results indicated significantly higher levels of MPA among musicians who performed frequent solo passages versus those who played mostly as a section.[13] What this validates is the hunch that section string playing isn't as stressful as sitting principal horn—at least as far as exposure is concerned. String players know that a missed note can easily be disguised by the twenty other people surrounding them, but if the principal trombone chips an entrance in *Bolero*, we immediately assume the whole orchestra knows it, as does the music critic in the audience. Regardless of where we are most comfortable, the right tools and strategies can help hone our mental performances, whether we're called to blend and balance with our colleagues or to stand in front of them as soloists.

AUDIENCE AND VENUE

When discussing the triggers of stage nerves, researchers often mention audience size, personalities, and performance environment, as well as the performance's perceived

importance. Anxiety worsens when failure could potentially render undesirable ramifications, such as being placed last chair or missing out on a spot in a top-level ensemble.[14] Crowd size also factors into the equation: While most afflicted by performance anxiety prefer smaller audiences, some prefer the anonymity of fuller halls. Moreover, performances set in more intimate spaces versus larger, more elaborate venues have shown to be less anxiety-provoking: Most people prefer performing in a more relaxed atmosphere—such as a lesson, studio class, or family party—over the stiffness of an evening recital. Mistakes are bound to be made in either case, but while the errors never lose their ability to inspire frustration, they feel more acceptable in lessons and mostly go unnoticed in postcasserole concerts.

In recitals or comparable engagements, however, the efforts to justify months of preparation by one isolated performance can lead to an increased heart rate, as Charlene Ryan found when she tested a group of young pianists in both a recital and a private lesson. Heart rates were way up in the recital setting in comparison with the private lesson, especially in the moments directly before walking onstage and actually performing. The greatest cause for most of their apprehension, participants confessed, was the fear of making a mistake.[15]

So, conclusively, performance anxiety is tied to the fear of judgment and consequence: The more weight we place on audience opinion and the more potentially miserable the aftermath, the more intense the sense of dread. Auditions, perhaps the most famously formal and consequential of all performance situations, have been deemed the least likely setting for favorable results,[16] as the ability to present one's self as virtually flawless—to play with the technique of a superhuman but the sincerity of an artist—often inspires either a sense of hopelessness or an unhealthy idealistic resolve to meet these impossible standards.

PERFECTIONISM

The habitual rehearsal of self-defeating mantras and negative evaluation not only makes people anxious, but it also may reinforce perfectionist tendencies. Psychologists Dr. Paul Hewitt, professor at the University of British Columbia, and Dr. Gordon Flett, professor of psychology at the University of Toronto, have been researching perfectionism for decades. In 1990, they devised a means of assessing the severity of a person's perfectionistic drive by how much they agreed with certain statements and designated three classifications of perfectionism based on the responses: socially prescribed, self-oriented, and other-oriented.[17]

Socially prescribed perfectionism involves people feeling particularly pressured by excessively high standards set for them by significant others and an incessant fear of negative evaluation.[18] Having a high socially prescribed perfectionism can lead to anxiety, depression, and suicide risk if a failure to uphold flawless standards is observed—and critiqued—by others. The failed competition; the memory slip in recital; the bombed audition; and the subsequent letdown of mentors, friends, and

family led socially prescribed perfectionists who filled out Hewitt and Flett's "Multidimensional Perfectionism Scale" to strongly agree with such statements as "The better I do, the better I am expected to do" and "Anything I do that is less than excellent will be seen as poor work by those around me."[19]

When not answering to others, musicians spend hours in practice rooms answering to themselves. Those with a *self-oriented perfectionism* tend to agree with generalizations like "It makes me uneasy to see an error in my work" and "I must work to my full potential at all times" in an effort to avoid failure and humiliation.[20] While it is often associated with greater productivity and career success, self-oriented perfectionism has also been evidenced to influence depression,[21] anxiety,[22] eating disorders,[23] and maladaptive cognitions, which basically means that a person is incapable of compromising standards, even when there is a legitimate reason for underperformance.[24] This is particularly detrimental for those with *other-oriented perfectionism*, as the unrealistic standard is projected onto others. Like many crafts that require the cultivation of technical skill, successful music making is contingent on the understanding that mastery is a process; ruthless idealism may lead to conflict and discord between members of a string quartet, being labeled as the "hard judge" at the middle school solo contest, or explaining away the senior high band director's tyrannical pedagogical practices as simply "tough love."

Some researchers have argued that, as it pertains to developing a high level of skill in some area, perfectionistic strivings in small doses can be a healthy pursuit for self-improvement.[25] In a 2007 study by Stoeber and Eismann of almost 150 young high school musicians, perfectionism was tied to intrinsic motivation, higher effort, and higher achievement—but the opposite was also true: Critical response to errors brought on more distress and intensified the motivation to strive for technical perfection to please others.[26]

People with perfectionism often struggle to separate their self-worth from their performance record. In a 2003 American Psychological Association article, staff journalist Etienne Benson sat down with Hewitt and Flett to get their perspectives on whether perfectionism can be synonymous with having a high standard. Hewitt asserted that to do so would be to overlook the stark difference—and lurking dangers—between the basic ambition to excel and the relentless longing for flawlessness.[27] To illustrate this point, Hewitt recounted a story in which one of his patients, a university student suffering from depression, was convinced that he needed to ace a particular class. After successfully earning an A+ in the course, however, Hewitt found that the student's self-imposed concept of being a failure worsened. From the student's perspective, his success in the course was simply another "demonstration of how much a failure he was" because, if he were perfect, Hewitt explained, such an effort wouldn't have been necessary.

Unfortunately, this student's logic is not that uncommon: The actualization of a lofty goal often inspires the genesis of new standards with an even greater implausibility than before, putting the perfectionist at even greater risk for perpetuating

damaging habits. Take this experiment from 2004 by Besser, Flett, and Hewitt, for example: Two hundred students with varied severities of perfectionism performed a laboratory task of differing levels of motor difficulty, for which they were given either negative or positive performance feedback, regardless of how well they performed the task. Results showed that participants with high self-oriented perfectionism experienced an increase in negative thoughts upon receiving unfavorable feedback on their performances and were especially prone to discouragement.[28] Similarly, Conroy, Kaye, and Fifer investigated the links between fear of failure, perfectionism, and negative self-beliefs of nearly four hundred college students and found that socially prescribed perfectionism was found to be strongly associated with beliefs that failure would lead to personally catastrophic consequences, especially as it pertained to upsetting "important others."[29] Consequently, people with a history of demanding authority figures, even if they're not related to music study, often apply similarly unreasonable expectations to their musical performances.[30]

Perfectionism occupies a unique niche in the classical music world, as both job competition and recording technology have dually contributed to the fantastical illusion that even the slightest error indicates technical incompetence. The relentlessness of self-directed perfectionistic standards invariably fosters a tendency toward catastrophizing (assuming something is far worse than it is), the use of extreme language (e.g., *should, have to, must*), and other similarly defeating thoughts.[31] No surprise there, really, as we've all heard horror stories of people preparing months for an audition only to be dismissed after the first two notes of their concerto or to have made finals only to lose to another candidate over missing a shift in Brahms 2.

However unfair, unrealistic, and outright ridiculous it may be, the increasing level of technical prowess among aspiring musicians continues to foster and support the expectation of flawlessness. And while competitions are being won, contracts signed, soloists debuted, and recitals passed, the partnering emotional distress as evidenced by these studies suggest a much greater, more extortionate price tag than is readily visible to an audience. The good news is that, according to the many experts cited in future chapters, we're more in control of those toxic thought patterns than our emotional agony might lead us to believe.

The tremendous effort required to play completely free of inaccuracies, some researchers theorize, may actually trigger music performance anxiety in some musicians.[32] On the other hand, some musicians who have achieved a high caliber of performance may be so overwhelmed by the need to maintain that success that they avoid performing altogether. In these cases, their anxiety becomes a defense mechanism to sabotage the development of their careers.[33] Additionally, excess physical effort leads to tension and coordination issues, which can compromise the dependability of a musician's performance in a stressful situation. Perfectionists may also develop the habit of catastrophizing, a behavior closely related to error count, in which they anticipate anything possible that might go wrong and mentally conjure up disastrous consequences should a certain standard not be upheld.[34]

KEEPING SCORE

Classical musicians are continually in competition or evaluation. When we practice, we compete with the version of ourselves we left with our concerto the day before or battle it out with the technical skill necessary to achieve mastery over a particular passage. Lessons and master classes, though intended to be inspiring environments for personal growth and musical development, also serve as magnifying glasses through which others can assess even the most inconspicuous of flaws. An extreme emphasis on competitive comparison comes at an expense: One study revealed that high school students at a competitive all-state orchestra seating audition associated their performance capabilities more with their ability to impress others than with their ability to perform expressively.[35] Working in such a pervasively competitive classical performance environment, it is no wonder that large percentages of professional classical musicians have reported performance anxiety severe enough to interfere with both their careers and personal lives,[36] and some have sadly even turned to alcohol or drug abuse in attempt to cope with the symptoms.[37]

Interestingly, however, even the most apprehensive among us tend to avoid coping strategies that may help alleviate anxiety.[38] Considering the shame that our society often imposes on a person with any kind of mental or emotional disturbance, many of us may resist seeking the help we need to avoid the discomfort we would face by divulging such issues. As previously mentioned, some musicians view performance anxiety as an indication of personal weakness or, as Jung-Eun Park found in a survey of performers, a qualifier of "bad musicianship."[39]

Although stage nerves seem to be a natural occurrence in many performers, the stigma of music performance anxiety persists. One of Park's survey participants commented, "I don't think MPA is formally addressed in the curriculum within a conservatory environment. It is as if there is a certain stigma about suggesting that there is some weakness in a person as a performer or musician if they feel affected by it. So much of the pre-performance aspect is left in the hands of the individual."[40] Another survey respondent attributed the persistence of MPA to a lack of teacher and mentor intervention, concluding that the issue of performance anxiety was simply not something administrators wanted to bother themselves with or acknowledge it as being an issue worthy of their attention.[41] Given the competitive nature of the field, some music teachers and professors might simply consider MPA a necessary component of "survival of the fittest," by which those who are most capable of success will naturally adjust their mentalities to the pressure and demands of the profession. Other music faculty may have been exposed to high-pressure performance situations so often and at such an early age that the idea of inferiority-based anxiety has become somewhat foreign to them, as research tells us that musicians with more extensive performance history tend to report less anxiety than those with less experience onstage.[42]

In any case, anxiety management should be more highly emphasized in music education settings because equipping music majors with performance skills is an

educational mission on which conservatories are founded. As another participant in Park's study suggested, including specialized performance anxiety counselors on the staff of music learning institutions would be a valuable means of ensuring that each student's potential is rightfully realized.[43] To be able to mentally manage the challenges posed by a variety of performance variables would better equip any musician with an empowered, versatile confidence.

SUMMARY AND CONCLUDING THOUGHTS

This chapter outlines many of the issues in our environment and within ourselves that influence or predict higher levels of performance anxiety. We address potential dangers of prioritizing perfectionism and ruthless competition in music performance instead of focusing on music as a means of artistic expression. We also consider social and environmental influences (including personal disposition and family traits) that have been shown to powerfully influence performance anxiety. Low self-image can start from childhood as influenced by family dynamics and can develop over time into issues of anxiety. Especially in severe cases, this may mean that performers need to address other non-music-related issues in their lives before tackling music performance anxiety; otherwise, the root of the symptoms may remain. Severe cases might require the help of a therapist or counselor. Other issues, such as level of exposure (e.g., solo vs. section playing, featured playing); audience size; performance environment (e.g., recital, audition, lesson); and perceived importance of the performance, play a role in the amount of anxiety that you may experience.

With this in mind, we recommend practicing performing in situations that gradually increase the risk involved. In other words, start small (perhaps a mini-performance for your unconditionally loving pet). Then, with every performance, add some element of risk so that each performance can build on the successes of the prior performance. Mistakes and problems will happen, of course, and you may find that you need to go back a step or two every once in a while. But experience and research have shown that gradually increasing risks while practicing more productive thought patterns can lead to much freer performances.

In her power-promoting book *Feel the Fear and Do It Anyway*, Susan Jeffers encourages the process of gradual risk taking by offering five "truths" about fear.[44] These "truths," found in the box below, remind us that fear will not go away on its own, and it is something that we need to face and work through in order to grow and thrive. We encourage you to read these "truths" and ask yourself if any of them trigger a particularly strong response in you. If so, that "truth" is quite possibly the place for you to most deeply meet your fears head-on.

Cognitive-behavioral psychology suggests that habits of thought can influence anxiety levels as well. Just as a musician might spend hours mastering a piece, so do we also "rehearse" patterns of thought that can either strengthen or weaken our abilities to perform. Although we recognize the influence of early-life experiences on

Five Truths about Fear

1. The fear will never go away as long as I continue to grow.
2. The only way to get rid of the fear of doing something is to go out . . . and do it.
3. The only way to feel better about myself is to go out . . . and do it.
4. Not only am I going to experience fear whenever I'm on unfamiliar territory, but so is everyone else.
5. Pushing through fear is less frightening than living with the underlying fear that comes from a feeling of helplessness.

Source: Susan Jeffers, "Five Truths about Fear," in *Feel the Fear and Do It Anyway* (New York: Ballantine, 1987), 30.

later habits of thought, we also call upon recent research to suggest that thoughts and thought patterns *can* be self-regulated and changed.[45]

We recognize the potential impact of teachers and performers to break cycles of negative thinking. It is never too late to change the way you think; however, the earlier you start the process, the easier it may be. Simply noticing thoughts in a nonjudgmental way can do much to bring awareness of "habits of mind" that can then be rehearsed in a more positive and productive way. Performers and teachers can practice recognizing negative thought patterns and gradually create more productive ways of thinking. We discuss these ideas further in chapter 3.

ACTIVITY: WHAT *ARE* YOUR INNER THOUGHTS?

Reflection for Awareness: Identifying Your Current Thought Patterns

The following questions will help you identify the thought patterns you currently have. It is important to increase awareness of your inner dialogue, look at it in a neutral way, and decide if it needs to be replaced with more honest, supportive, and effective thoughts. Many people with music performance anxiety have abusive and self-debasing thoughts and are shocked when they take an honest look at their own inner dialogues. Some realize that they would never say out loud to another person the thoughts that they say to themselves over and over every day!

Thought Journal Exercise

Write down the thoughts that you are thinking before, during (as best you can remember), and after practice sessions, rehearsals, lessons, and performances. Do this for at least a full week at a time when you have a scheduled performance. Be honest and write down everything you think, both negative and positive.

Are the thoughts you are thinking about yourself harsh or unkind? More negative than positive? Do the statements that you made toward yourself sound like those made by a parent, teacher, or authority figure from your childhood? If so, note who is making the statement and his or her tone of voice or gestures.

Do you compare yourself to others rather than to your own levels of progress? Do you constantly worry about what others are thinking about your performance abilities?

Reflection Questions

1. What situations trigger MPA symptoms? Rate your level of MPA in each of the following situations (0 = no anxiety, 10 = extreme anxiety).

 Solo Performance
 Chamber Music Performance
 Large Ensemble Performance
 Auditions or Juried Performances
 Large Audiences
 Small Audiences of Your Peers or Colleagues

2. Was/is anxiety management included in your studio training, group, or individualized instruction?
3. Do you feel that talking openly about MPA will cause you to experience disadvantages in your education/career?
4. Do you consider yourself a perfectionist? Do you feel you have to be a perfectionist to be a good performer in your chosen musical field? If so, do you equate musical errors with personal inadequacies, or do you differentiate the two?

Application and Integration to Practice: Flash Scans

After you have finished the week-long "Thought Journal Exercise" and have determined your own patterns of inner dialogue, it is important to do quick check-ins during practice, rehearsal, and even performance situations. This is important so that you develop the ability to be aware of thinking that is abusive or unhelpful to your progress. Just noticing negative thoughts gives you the power to choose differently. The following flash scans will help you to quickly identify your thoughts, emotions, and physical sensations. Integrating these into your routine are as important as other checks you might do with posture, muscle tension, or other technical habits. Remember: You are already practicing patterns of inner dialogue and emotional states. The idea here is to improve your ability to notice them.

1. Stop what you are doing and sum up what you are thinking about yourself using just one word. This should only take a few seconds to do but can give

you powerful information about what you are thinking. Your word might be *terrible* or *awesome*, but knowing this word gives you instant feedback about what is going on in your mind. Honor what you are thinking.

2. If your word is negative rather than neutral or positive, it is likely that you are thinking hurtful thoughts or you may have been emotionally triggered and are reliving a negative (and possibly unexpressed) memory that is somehow similar to your current situation. Honor what you are feeling.

3. Scan the physical sensations you are experiencing from head to toe. Pay particular attention to any discomfort, stress, pain, or agitation you are feeling in your body. Honor these sensations.

Caution: Noticing without Judgment

It is possible that doing these activities will activate your "inner judge." This inner voice might say things like (with a scolding tone) "There you go again! You are thinking negative thoughts!" If this happens, just notice it, take a deep breath, and remind yourself that *you* are not your thoughts and that you *have* accomplished what you set out to do, which is to increase the awareness of your thoughts. If you have difficulty redirecting the inner judge, then it may be time to take a short walk or break. If this happens often, you may find it helpful to work with a therapist or counselor to help you strengthen your ability to witness your experience from multiple perspectives (such as from your encouraging, wise, supportive, and nonjudgmental selves). Having an inner judge is not necessarily a bad thing, but if it is the only inner voice we listen to or our judge is also abusive, then we might be stuck in a distorted view of our abilities.

JOURNEYS: COLLABORATING WITH HEROES, COOPERATING WITH OURSELVES

By Karin

The people with whom we choose to associate, both in music and in life, can have a deep impact on how we feel about ourselves and how we perform. For instance, members of professional string quartets often say that being in a quartet is like a four-way marriage: After spending countless hours together, year after year, in very intense situations, who knows you and your idiosyncrasies better than your musical companions? Who knows better when and how to pick up the pieces for you if things fall apart? Yet, at the same time, who knows better which buttons to push in times of stress? Because it requires a high level of intimacy and trust to perform collaboratively with others, it is crucial to surround ourselves with people who not only inspire us but also support us, both musically and emotionally.

Accompanists play a significant role in performance success. They are coaches as much as they are tiny orchestras, cooperating colleagues, or even a lifeline when performers lose their confidence or their place. Unfortunately, however, accompanists who are unprepared or otherwise unsupportive can provoke anxiety in performers who might otherwise feel prepared and self-assured.

While serving as an adjudicator of student competitions, I have witnessed accompanists with a diverse range of musical, technical, and collaborative skills. In cases where an underprepared accompanist has struggled to keep up technically with a student soloist, I have ached to jump out of my seat and help, recognizing that a student's sense of self-efficacy was at stake. In these cases, I have often wondered if the soloist ended up in this predicament due to a lack of finances or even from sheer naïveté, perhaps simply opting for the nearest and most convenient pianist—be it a parent, sibling, neighbor, or even well-meaning teacher—who played just well enough to get by.

On the other end of the spectrum are accompanists who are so well prepared that their sheer ease and finesse inspires a magical musical experience for the soloist as well as the audience. I will never forget one such pianist who, in moments of student memory loss, would unfailingly turn on a dime to add embellishments in the left hand while outlining the performer's temporarily missing melody in the right hand, thereby spinning the error into an aesthetic flourish that left many wondering if the whole thing was on purpose.

It is tricky enough as an adjudicator or audience to separate out a performer from the musical backdrop and provide a fair assessment of a soloist's skills independently from the accompanist's influence. However, the audience's perception is likely nothing in comparison with what a performer experiences. When at odds with other performers onstage, it can feel like the waves are working against you and pulling you underwater. Yet, when collaborating with those you trust both musically and emotionally, it can feel like a life preserver is there to help you keep your wits about you in a simple moment of humanness, granting you space and fortitude to move forward with grace.

I see two primary lessons here. The first is obvious: We need to do whatever it takes to choose accompanists and other performance partners who will support us both musically and psychologically. A friend of mine once collaborated with an outstanding pianist who took it upon himself to be a dictator of perfection, regularly berating her and even reminding her of various mistakes she had made in rehearsal mere seconds before they walked onstage to perform. Fortunately, my friend had the sense to recognize this abusive behavior and eventually contracted a different, more emotionally supportive accompanist. This simple act of self-respect not only afforded her the opportunity to secure a better performance partner but also provided her with the confidence and assurance she needed to thrive in the future.

The second lesson is a bit more subtle but perhaps even more life giving: It involves sustaining ourselves so that we have the resilience to handle anything that

comes our way and even turn it into fuel for fabulousness. With so many perfectly spliced recordings out there, some might assume that virtuosi are also perfect. In fact, they are not—instead, in live performances, these masters combine technique with such expressive artistry that it distracts the audience from any minor flaws. This is a secret of successful performers: They still make mistakes, but they recover quickly and go on with the show, often even making the performance more exciting as a result.

Here's one example: My world was rocked more than twenty years ago when I first attended a performance of the Dvorak Cello Concerto with a major symphony orchestra. Joseph Silverstein conducted the orchestra as they accompanied a renowned cello soloist. With only a minute or so left in the piece, the cellist skipped two lines of music. My throat went into my stomach out of empathy, fearing this was the fated end of the cellist's career! Much to my surprise, he carried on with nothing more than a vigorous shake of the head, continuing to play his part with even more intensity.

Meanwhile, thanks to a few strategic hand signals from Silverstein, the entire orchestra jumped ahead in the music and caught up with the soloist—all within a phrase or two. Cellist and orchestra ended together, with a most triumphant postperformance celebration that included the cellist raising Silverstein's hand like a winning prizefighter while accepting a standing ovation. Did the audience know? Perhaps some did—but those who recognized the mistake also realized that they had witnessed something much more impressive than refined octaves and dazzling bariolage. A perfect performance would have been remarkable, but this leap of artistry was historic.

When we share the stage with others, it is comforting and inspiring to have someone we trust beside us. We can be collaborative heroes for one another when things go rough and celebrate together when things go well. Ideally, we perform with others through a dynamic interplay of mutual support. Yet, no matter how generous others are to us—and even when they are not—we need to play a supporting role for others as well as for ourselves. In music performance, mentally beating ourselves up only leads to physical and emotional tension and distracts us from the task at hand. Furthermore, in any area of our lives, the efforts of others to help us can only go so far if our own self-defeating behaviors minimize their effect.

Two centuries ago, William Ellery Channing penned these words: "No power in society, no hardship in your condition can depress you, keep you down, in knowledge, power, virtue, influence, but by your own consent."[46] We can choose to filter the feedback we let in from others, and we can choose to associate with people who make our performances—and our lives—more uplifting. Yet as important as it is to choose accompanists, collaborators, and even people in our personal and social circles who support us, it is even more crucial for us to first support ourselves. Then, no matter what circumstances arise, we will be personally empowered and, much like Silverstein and his orchestra, be ready to take whatever happens and make it momentous.

Figure 2.1.　Casey under a canopy over Ottawa, IL. *Photo courtesy of Henrik Csüri*

JOURNEYS: AN ORDINARY BATTLE

By Casey

Be kind, the saying advises. *Everyone is fighting a battle you know nothing about.*

Whenever I stumble across this piece of advice, I first give it an inner nod of affirmation and then reflectively scold myself for not being more compassionate. I should exert more understanding, more empathy; I should strive to be more encouraging to my peers and exercise more grace with my own shortcomings. I should recognize that, when my heart is a stormy tangle of distress over the unpredictable road to success, others know the same turmoil—even those whose lives appear, from my view, perfectly full of promise.

This is the inner battle that people don't talk about: the part of the obligatory reassurance to the well-meaning inquirer that everything is—on some level—good. It is the inflection of polite dishonesty, the surge of melancholy as you recite the same platitudinal pleasantry, the systematic recycling of exaggerated wholesomeness in words like *great, wonderful,* and *fine.* This is the armor we assume to protect ourselves from the judgment that inevitably comes with being honest, the risk we avoid when we force hope into our voices in spite of the discouragement in our hearts.

As I was leaving a student's home the other day, I was struck by how blue the sky was. It had just rained a half-hour before, and as I craned my neck to look, the student's mother explained that it was the lightning—the storm itself—responsible for purifying the air.

What a relevant metaphor: The storm cleanses the air. The battle revives the warrior. The struggle leads to clearer, more distinctly brilliant aftermaths. There wasn't a conflict in my history that hadn't led to less-obstructed views in its passing: My whole musical life is one epic standoff after another, with both failure and victory equally reenergizing to my efforts. One of the most enlightening conclusions I came to recently was the realization that I am not, in fact, unique. I am not special in that the inner turmoil to which I refer is something other people "know nothing about"—the angst of second-guessing our progress, abilities, purposes, and career directions is so commonplace that it's ordinary, so normal that it's refreshing.

So, when your buddy emerges from the next audition and laments how his bow bounced uncontrollably, when a fellow conservatory student looks absolutely dejected from not making the top-level orchestra, or when your perfectionistic drive is making it hard to even brush your teeth without some form of constructive criticism, give yourself—and others—room to vocalize that, yes, in fact, the struggle is real. To approach any endeavor with this degree of obsessive detail would be taxing in any discipline, but to pursue it without the collective encouragement of colleagues and teachers with war stories of their own poses a completely unnecessary burden. If we're priming ourselves to be expressively transparent artists, shouldn't we start by first exercising the same level of transparency with each other?

Too many musicians are crippled against the wall of their practice rooms, weary from the repeated blows of perfectionism, self-doubt, and the fight for self-preservation. We dress it up in tuxes and recital gowns, we flash confident smiles to audiences and audition panels, we compose ourselves before a student walks in so we can do our job. But this isn't about survival of the fittest; it's the endurance of the bravest. And courage, like camaraderie, is a terrible thing to be without.

FROM THE STAGE: STEFAN MILENKOVICH

Violin Soloist and Professor of Violin,
University of Illinois at Urbana–Champaign

Figure 2.2. Stefan Milenkovich, violinist. *Photo courtesy of Stefan Milenkovich*

Not feeling fear is, above all, unnatural. It's there to protect us and prepare us for perceived situations of emergency. Knowing that, I believe, is the first step in conquering fear, although I don't think there is such thing as "conquering" fear as much as doing something *in spite* of feeling fear. This is what ultimately makes a difference when we're facing scary situations.

Personally, I think it's very important to know yourself and to learn what happens to you when you get nervous. Knowing this is very important. After that, awareness and control of body through breath is essential in calming the mind as well. Of course, it also works vice versa: A calm mind quiets the body. Breathing exercises, as well as some mediation techniques, help me a lot to minimize nervousness. I also think that big part of fear reduction is the correct preparation of the performance. The more I'm ready, the less I'm nervous. But not only that: I can assume that, for an important performance, I will be nervous and perhaps lose 20 percent of my preparation. Therefore, I try to overprepare and be at 120 percent so that, if I fall back, my mind and body are trained enough to help me if needed.

In the end, I quote a friend of mine, a skydiving instructor with thousands of jumps, when I asked him if he was still nervous before exiting the plane: "I still feel butterflies in my stomach before each jump. The only difference is that now they fly in formation."

Everyone's journey to reduce fear in life is a personal one, but I think one thing is quite universal: What you resist persists. So facing your fears and dealing with them in any way you might find helpful is necessary to move toward a happier life.

NOTES

1. Kato Havas, *Stage Fright: Its Causes and Cures with Special Reference to Violin Playing* (London: Bosworth, 1973), 9.

2. Melissa Brotons, "Effects of Performing Conditions on Music Performance Anxiety and Performance Quality," *Journal of Music Therapy* 31, no. 1 (1994): 63–81; Wendy J. Cox and Justin Kenardy, "Performance Anxiety, Social Phobia, and Setting Effects in Instrumental Music Students," *Journal of Anxiety Disorders* 7, no. 1 (1993): 49–60; I. Eckhardt and L. Lüdemann, "Kennen Sie Lampenfieber," *Das Orchester* 1 (1974): 10–15; Martin Fishbein, Susan E. Middlestadt, Victor Ottati, Susan Straus, and Alan Ellis, "Medical Problems among ICSOM Musicians: Overview of a National Survey," *Medical Problems of Performing Artists* 3, no. 1 (1988): 1–8; Andrew Steptoe, "Performance Anxiety: Recent Developments in Its Analysis and Management," *Musical Times* 123, no. 1674 (1982): 537–41; Johannes F. L. M. van Kemenade, Maarten J. M. van Son, and Nicolette C. A. van Heesch, "Performance Anxiety among Professional Musicians in Symphonic Orchestras: A Self-Report Study," *Psychological Reports* 77, no. 2 (1995): 555–62.

3. Julie J. Nagel, "Performance Anxiety and the Performing Musician: A Fear of Failure or a Fear of Success?" *Medical Problems of Performing Artists* 5, no. 1 (1990): 37–40; Julie J. Nagel, David P. Himle, and James D. Papsdorf, "Cognitive-Behavioural Treatment of Musical Performance Anxiety," *Psychology of Music* 17, no. 1 (April 1989): 12–21.

4. Heinz L. Ansbacher and Rowena R. Ansbacher, eds., *The Individual Psychology of Alfred Adler* (New York: Basic Books, 1956).

5. Glen O. Gabbard, "Stage Fright," *International Journal of Psychoanalysis* 60 (1979): 383–92.

6. Inette Swart, "Overcoming Adversity: Trauma in the Lives of Music Performers and Composers," *Psychology of Music* 42, no. 3 (2014): 386–402.

7. Albert Bandura, *Self-Efficacy: The Exercise of Control* (New York: W. H. Freeman, 1997); Carol S. Dweck, *Mindset: The New Psychology of Success* (New York: Random House, 2006); Karin S. Hendricks, "Relationships between the Sources of Self-Efficacy and Changes in Competence Perceptions of Music Students during an All-State Orchestra Event" (PhD diss., University of Illinois at Urbana–Champaign, 2009); Karin S. Hendricks, "The Sources of Self-Efficacy: Educational Research and Implications for Music," *Update: Applications of Research in Music Education* (2016): 32–38.

8. Jerome J. Tobacyk and Alan Downs, "Personal Construct Threat and Irrational Beliefs as Cognitive Predictors of Increases in Musical Performance Anxiety," *Journal of Personality and Social Psychology* 51, no. 4 (1986): 779.

9. C. L. Barney Dews and Martha S. Williams, "Student Musicians' Personality Styles, Stresses, and Coping Patterns," *Psychology of Music* 17, no. 1 (1989): 37–47.

10. American Psychiatric Association, *Diagnostic and Statistical Manual of Mental Disorders DSM-5*, 5th ed. (Arlington, VA: American Psychiatric Publishing, 2013).

11. See Adriana Ortiz Brugués, "Music Performance Anxiety: A Review of the Literature" (PhD diss., University of Freiburg, 2009).

12. Julie Ann Simon and Rainer Martens, "Children's Anxiety in Sport and Nonsport Evaluative Activities," (PhD diss., University of Illinois at Urbana–Champaign, 1977).

13. Nora A. Rife, Leah Blumberg Lapidus, and Zachary M. Shnek, "Musical Performance Anxiety, Cognitive Flexibility, and Field Independence in Professional Musicians," *Medical Problems of Performing Artists* 15, no. 4 (2000): 161–67.

14. Albert LeBlanc, Young Chang Jin, Mary Obert, and Carolyn Siivola, "Effect of Audience on Music Performance Anxiety," *Journal of Research in Music Education* 45, no. 3 (1997): 480–96.

15. Charlene Ryan, "Exploring Musical Performance Anxiety in Children," *Medical Problems of Performing Artists* 13 (1998): 83–88.

16. Steptoe, "Performance Anxiety."

17. Gordon L. Flett, Paul L. Hewitt, Kirk Blankstein, and Sean O'Brien, "Perfectionism and Learned Resourcefulness in Depression and Self-Esteem," *Personality and Individual Differences* 12, no. 1 (1991): 61–68.

18. Ibid.

19. Paul L. Hewitt and Gordon L. Flett, "Perfectionism in the Self and Social Contexts: Conceptualization, Assessment, and Association with Psychopathology," *Journal of Personality and Social Psychology* 60, no. 3 (1991): 456–70.

20. Kristie L. Speirs Neumeister, "Understanding the Relationship between Perfectionism and Achievement Motivation in Gifted College Students," *Gifted Child Quarterly* 48, no. 3 (2004): 219–31.

21. Paul L. Hewitt and Gordon L. Flett, "Dimensions of Perfectionism, Daily Stress, and Depression: A Test of the Specific Vulnerability Hypothesis," *Journal of Abnormal Psychology* 102, no. 1 (1993): 58–65; Hewitt and Flett, "Perfectionism in the Self."

22. Martin M. Antony, Christine L. Purdon, Veronika Huta, and Richard P. Swinson, "Dimensions of Perfectionism across the Anxiety Disorders," *Behaviour Research and Therapy* 36, no. 12 (1998): 1143–54.

23. Paul L. Hewitt, Gordon L. Flett, and Evelyn Ediger, "Perfectionism Traits and Perfectionistic Self-Presentation in Eating Disorder Attitudes, Characteristics, and Symptoms," *International Journal of Eating Disorders* 18, no. 4 (1995): 317–26.

24. Hewitt and Flett, "Perfectionism in the Self."

25. Osamu Kobori and Yoshihiko Tanno, "Self-Oriented Perfectionism and Its Relationship to Positive and Negative Affect: The Mediation of Positive and Negative Perfectionism Cognitions," *Cognitive Therapy and Research* 29, no. 5 (2005): 555–67.

26. Joachim Stoeber and Ulrike Eismann, "Perfectionism in Young Musicians: Relations with Motivation, Effort, Achievement, and Distress," *Personality and Individual Differences* 43, no. 8 (2007): 2182–92.

27. Etienne Benson, "The Many Faces of Perfectionism," *Monitor on Psychology* 34, no. 10 (2003): 18, accessed April 30, 2016, http://www.apa.org/monitor/nov03/manyfaces.aspx.

28. Avi Besser, Gordon L. Flett, and Paul L. Hewitt, "Perfectionism, Cognition, and Affect in Response to Performance Failure vs. Success," *Journal of Rational-Emotive and Cognitive-Behavior Therapy* 22, no. 4 (2004): 297–324.

29. David E. Conroy, Miranda P. Kaye, and Angela M. Fifer, "Cognitive Links between Fear of Failure and Perfectionism," *Journal of Rational-Emotive and Cognitive-Behavior Therapy* 25, no. 4 (2007): 237.

30. Eric A. Plaut, "Psychotherapy of Performance Anxiety," *Medical Problems of Performing Artists* 3, no. 3 (1988): 113–18.

31. Russell C. Curtis, Amy Kimball, and Erin L. Stroup, "Understanding and Treating Social Phobia," *Journal of Counseling and Development* 82, no. 1 (2004): 3–9; Dews and Williams, "Student Musicians' Personality Styles"; Shulamit Mor, Hy I. Day, Gordon L. Flett, and Paul L. Hewitt, "Perfectionism, Control, and Components of Performance Anxiety in Professional Artists," *Cognitive Therapy and Research* 19, no. 2 (1995): 207–25.

32. Andrew Steptoe and Helen Fidler, "Stage Fright in Orchestral Musicians: A Study of Cognitive and Behavioural Strategies in Performance Anxiety," *British Journal of Psychology* 78, no. 2 (1987): 241–49.

33. Nagel, "Performance Anxiety."

34. Havas, *Stage Fright*, 1988; Nagel, "Performance Anxiety."

35. Hendricks, "Relationships between the Sources."

36. van Kemenade, van Son, and van Heesch, "Performance Anxiety."

37. Brugués, "Music Performance Anxiety."

38. Paul M. Lehrer, Nina S. Goldman, and Erik F. Strommen, "A Principal Components Assessment of Performance Anxiety among Musicians," *Medical Problems of Performing Artists* 5, no. 1 (1990): 12–18.

39. Jung-Eun Park, "The Relationship between Musical Performance Anxiety, Healthy Lifestyle Factors, and Substance Use among Young Adult Classical Musicians: Implications for Training and Education" (EdD diss., Teachers College, Columbia University, 2010), 87.

40. Ibid.

41. Ibid.

42. Steptoe and Fidler, "Stage Fright"; Mary L. Wolfe, "Correlates of Adaptive and Maladaptive Musical Performance Anxiety," *Medical Problems of Performing Artists* 4, no. 1 (1989): 49–56.

43. Park, "Musical Performance Anxiety," 87.

44. Susan Jeffers, *Feel the Fear and Do It Anyway* (New York: Ballantine, 1987), 30.

45. Bandura, *Self-Efficacy*; Dweck, *Mindset*; Hendricks, "Relationships between the Sources"; Hendricks, "Sources of Self-Efficacy"; Barry J. Zimmerman, "A Social Cognitive View of Self-Regulated Academic Learning," *Journal of Educational Psychology* 81, no. 3 (1989): 329–39.

46. William Ellery Channing, *The Complete Works of William Ellery Channing* (London: George Routledge and Sons, 1870), 30.

3

Cognitive-Behavioral Therapies

The goal of cognitive-behavioral therapy (CBT) is to address dysfunctional emotions, behaviors, and thought processes through a goal-oriented, directional approach very much grounded in science. It follows the traditional psychotherapeutic style of "talk therapy" in that the counselor and advisee engage in an active, intimate, fully disclosing discussion, yet hundreds of studies collectively show that CBT helps people make constructive changes far better than conversation accomplishes alone.

CBT addresses and troubleshoots the patterns of behavior and problematic thoughts that often fuel mood, anxiety, personality, eating, substance abuse, and other psychological disorders. CBT emphasizes changes in preperformance behavioral routines, as well as self-instruction and attention-focusing techniques, in an effort to eradicate negative emotional responses that can compromise our concentration in pressured situations. As performers, some success in doing so may not only render more rewarding experiences onstage but may also potentially inspire a sense of optimism and control and increase the chances that we're at our best when it matters most.

Cognitive-behavioral therapy is used in individual as well as group settings, with specific therapies that are either more thought based (e.g., rational emotive behavioral therapy), more behaviorally based (e.g., exposure therapy), or a combination of the two. In the case of music performance anxiety, individuals may become preoccupied with irrelevant thoughts that both distract and worsen conditions onstage, such as the fear of memory lapses, the fear of being compared to others, and the fear of negative criticism.[1]

Some of us may feel particularly susceptible to these destructive thought patterns because of how our bodies react when in performance situations; sudden muscle tension or hand trembling may be a common annoyance among many musicians, but when experienced persistently, it can pose an overwhelming interference to the

advancement of our careers. Behavioral-based therapies center more on addressing these and other observational characteristics to equip the performer with skills to counteract the physical manifestations of anxiety should they occur.

CONVERSATION VERSUS COGNITION

So that we're clear on the difference, traditional psychotherapy (or talk therapy, as we'll refer to it from here on) uses patient-therapist dialogue to explore the ostensibly subconscious factors behind behaviors or emotional conditions. By contrast, cognitive-behavioral therapy uses both therapist-guided analysis and strategy to counteract unhelpful thinking and problematic behaviors. Talk therapy relies more on the expertise of the therapist to diagnose, label, and assign a treatment plan, while CBT involves the patient jointly in the recovery process. Dr. Dan Kirschenbaum, clinical psychologist, describes CBT as a partnership: The therapist may be the expert on psychological change, but the client, he claims, is always the expert on him- or herself.[2]

When considering treatment for music performance anxiety, researchers have evaluated the effectiveness of empowering patients with tools to help redirect their thoughts into more productive, confidence-inspiring habits. An investigation particularly focused on musicians documented noteworthy benefits when taking this approach[3]: In a study of fifty-three pianists, participants were divided between a behavior-rehearsal group, a cognitive-therapy group, and a no-treatment control group. Aside from the narrative self-reflection in which all subjects participated, those in the cognitive-therapy group also reviewed footage of their own performances in small groups and discussed the often-defeating inner monologues occurring as they played.

Instead of simply dismissing the thoughts as irrational, participants were encouraged to challenge and redirect the negative self-talk with positive self-statements that ranged from task oriented ("I can pull back the tempo so I can play this passage more musically and relaxed!"), comforting ("You can do this!"), technique focused ("Relaxed breath is the best support for full, rich tone."), and self-rewarding ("Every time I perform, I gain more confidence."). At the conclusion of each session, the participants were then asked to rehearse this positive redirection in both mental rehearsal and while performing for a live audience to further reinforce their new ways of thinking.

Meanwhile, the behavior-rehearsal group simply practiced performing. They followed a similar therapy schedule as the cognitive-based group, but the procedure was more demonstration based: The therapist leading the sessions stressed the importance of regularly performing for an audience but didn't mention redirecting any cognitive thought pattern that may have disturbed the performers onstage. Consequently, although both the cognitive and behavioral groups showed progress in comparison to the wait-listed control, the cognitive-therapy group's integration

of addressing defeatist thought patterns was more successful in reducing visual signs of anxiety and in rebuilding participants' self-confidence. The findings of earlier studies by Meichenbaum[4] agree, further impressing the idea that directly addressing our own behavior by intervening when self-defeating mantras compromise our concentration may be the most effective means of preserving our practice room preparation onstage.

RATIONAL EMOTIVE THERAPY (RET)

While due credence can be given to addressing detrimental thought patterns, behavior rehearsal is just as crucial to solidifying new habits. If a diagnosis is made but no action is taken, then the problem persists; supportive self-talk must be applied and routinely practiced to effectively manage anxiety. According to psychologist Frederick H. Kanfer, the success of this intervention-based approach is only fully supported when reinforced by the enthusiasm of participants in exercising their newly acquired skills. Rational emotive behavior therapy (also called simply rational emotive therapy) is a means by which to do that.[5]

Rational emotive therapy is firmly grounded in the belief that negative thought patterns are rarely isolated to just one type of situation. If we feel inadequate in the spotlight, then we have likely felt inferior in other aspects of our lives. If we scold ourselves for missing a shift, we've probably berated ourselves for losing our car keys, too. Learning to identify and redirect our personal "demons of degradation," whether performing a sonata or trying a new casserole recipe, is precisely what RET aims to accomplish.

Rational emotive therapy was first developed by renowned psychologist Albert Ellis in the mid-1950s and soon thereafter in a parallel fashion by psychiatrist Aaron Beck. It is a therapy based on self-intervention, as it provides us with the tools to challenge, dispute, and rationalize groundless beliefs and negative self-talk as it happens.[6] Ellis explains how a person is more emotionally affected by internal thought processes and attitudes than anything external—so, for a musician, it's not so much the stage but the thoughts we have about and during performing. Ellis claims (and many studies support this) that people's moods are influenced by what they believe or tell themselves, so if they adopt hopeful, cheerful, optimistic mindsets, then their moods improve, and if they believe in the pessimistic, cynical, or hopeless predictions of certain doom, then the opposite effect ensues.

How RET works, according to Ellis's model, is that anxiety-inducing thoughts or negative cognitions are interrupted the moment they occur. When a defeating thought enters our minds, we are then to challenge its reasoning, rationalize its validity, and subscribe a more constructive and positive perspective. Compelling ourselves to choose courage over catastrophizing, then, is to simply practice this ritual of confrontation and rationalization—both on and off the stage. Acknowledging the issue is not enough; the effectiveness of rational emotive behavioral therapy depends on

the patients' efforts to assume a more positive, rational perspective in their entire life experience. Ellis writes:

> There is usually no way to get better and stay better but by continual work and practice in looking for, and finding, one's core irrational beliefs; actively, energetically, and scientifically disputing them; replacing one's unhealthy feelings to healthy, self-helping emotions; and firmly acting against one's dysfunctional fears and compulsions. Only by a combined cognitive, emotive, and behavioral [approach], as well as a quite persistent and forceful attack on one's serious emotional problems, is one likely to significantly ameliorate or remove them—and keep them removed.[7]

In addition to his own experimental research supporting this fundamental theory, Ellis cites what he refers to as the "pioneering study"—an experiment that spearheaded the scientific acceptance of and interest in RET by Emmett Velten in 1968. In this study, sixty college students practiced focusing on either positive or negative self-statements, and with postactivity assessments, Velten confirmed that encouraging self-statements inspired a sense of elation and that defeatist self-statements made people feel depressed and discouraged.[8] From there, other similarly modeled studies were conducted[9]—all of which unanimously supported Velten's conclusions that our attitudes heavily influence our realities.

Freeze Frame

Freeze Frame, a research-based technique offered by the Heart Math Institute, is an approach similar to rational emotive behavior therapy and suggests that negative emotions can be "frozen" in the moment they are experienced and changed through self-intervention. The five steps of the Freeze Frame technique are:

1. Recognize the stressful feeling and freeze-frame it! Take a timeout.
2. Make a sincere effort to shift your focus away from the racing mind or disturbed emotions to the area around your heart. Pretend you're breathing through your heart to help focus your energy in this area. Keep your focus there for ten seconds or more.
3. Recall a positive, fun feeling or time you've had and try to reexperience it.
4. Now, using your intuition, common sense, and sincerity, ask your heart, "What would be a more efficient response to the situation, one that would minimize future stress?"
5. Listen to what your heart says in answer to your question.[a]

The book *The HeartMath Solution* expands each step with further guidelines and examples. In addition to the Freeze Frame technique, the Heart Math Institute utilizes the latest scientific research to provide a wealth of resources and strategies for achieving peak emotional performance. Additional resources and products can be found at www. heartmath.org.

a. "Freeze Frame" in Doc Childre and Howard Martin, *The HeartMath Solution* (New York: HarperCollins, 1999), 67.

SCHEMA THERAPY

Emotional disturbance is often fueled by the mental distortions we make when we handle life experiences through negative interpretations and predictions. While Albert Ellis asserts that psychological troubles are only partially related to the outside events that caused them to surface, the true core may be also attributed to a set of internalized irrational beliefs, or what is referred to as an individual's "schema."[10] Schema therapy, designed by Dr. Jeffrey Young and Dr. David Bricker of the Schema Therapy Institute, is a psychotherapy that expands on the theories and techniques of other therapies (especially cognitive-behavioral therapy) but draws more on the practice of revisiting earlier life experiences. According to these authors, schemas are "self-defeating life patterns of perception, emotion, and physical sensation."[11] These are extremely enduring patterns that develop during childhood and manifest themselves as emotional deprivation, abandonment, social isolation, mistrust, defectiveness, failure, incompetence, self-sacrifice, and unrelenting standards, among others.[12]

Schemas influence human behavior through different approaches: schema surrender, schema avoidance, and schema overcompensation.[13] In *schema surrender*, people passively confirm the schema by acting in a manner that validates it. For instance, a musician with a failure schema might purposely underprepare for performances and then react in an exaggerated, excessively negative way to reinforce the belief that he is incapable of performing as well as his peers.

A musician with *schema avoidance* will either emotionally diminish or mentally block the memory of upsetting events. If she identifies with the defectiveness/shame schema, for example—the belief that divulging personal flaws risks abandonment by others—she might avoid performing altogether so that her deficiencies are never revealed.

Finally, a musician making a practice of *schema overcompensation* tends to behave in a manner contradictory to the schema in order to avoid setting it off. For example, a musician dealing with the hypercriticism/unrelenting standards schema may act encouragingly and supportive of others despite their performance flaws or technical deficiencies but then regard himself as being unworthy of the same compassion.

Schemas seem to work as if they are always on the lookout for affirmation (also referred to as "schema maintenance"). A musician with the defectiveness/shame schema might approach the concert stage thinking, "No one will enjoy my performance" or "No one really wants to hear me play," thereby supporting the belief that rejection is inevitable. Similarly, musicians with the unrelenting standards/hypercriticism schema might excel onstage due in part to the excessive expectations they put on themselves in practice. Usually people who have this schema had parents whose love or approval was contingent upon achievement during much of their childhood.[14]

A person's schema operates in either healing or perpetuation, Bricker and Young explain, as all of our behaviors either support the set of beliefs that initially inspired its existence or help us to move beyond it. While the initial stages of therapy involve much exploration of personal history, once a core schema is identified, therapists can then assess and identify a proper course of action to weaken it.

At a schema's center is what the *Wiley-Blackwell Handbook of Schema Therapy* refers to as a "frustrated core emotional need."[15] While the core beliefs we have about

ourselves are an integral focus of schema therapy, its dual interest in identifying necessities to our emotional wellness and offering a proactive, goal-oriented therapeutic approach has been proven effective not only for anxiety, but for a variety of other mental health disorders as well.

While not all musicians suffering from music performance anxiety are necessarily afflicted with more severe psychological disturbances, schema therapy is worth considering when attempting to pinpoint the possible underlying sources of resistance to change that some performers experience. Dr. Kirschenbaum cautions, though, that this "tough step" should only be taken when CBT therapy with a highly skilled therapist has still left some issues unresolved.[16] For a full reference of schemas and their trait breakdowns, see Bricker and Young's *A Client's Guide to Schema Therapy.*[17]

HYPNOTHERAPY

Hypnosis was championed for its therapeutic potential by Scottish surgeon James Braid back in the 1840s. Hypnosis, whose root comes from the Greek word *hupnos*, meaning "to sleep," is induced by a series of preparatory instructions and suggestions that lead people to an altered state of consciousness and increase their receptiveness to therapeutic targeting. During hypnosis, people are said to lose the power of voluntary action and are highly responsive to suggestion, making them more responsive to the redirection of problematic behaviors.[18]

Hypnotherapists use two styles of suggestions to modify behavior while patients are in a state of trance: *direct suggestion*, which employs explicit instruction in an authoritarian tone ("Stop eating excessive amounts of bananas now!"), or *indirect suggestion*, which allows the patient's unconscious mind to participate more actively in deciding the best application and timetable for change ("I wonder when you will balance out your banana eating and start enjoying the nutritional possibility of other fruit").[19]

Hypnotherapy has been part of the treatment of test anxiety, and as taking an exam is comparable to playing an audition, we offer a couple of case studies. In the first, the treatment subject was a college student needing to earn a high grade on his Spanish final in order to pass the class. He often got nervous when taking exams and expressed that it was an ongoing challenge for him to concentrate and to feel amply prepared for assessments. Researchers began hypnotherapy sessions a week before the exam, and through the therapist's direct suggestions to assume more empowered behavior (such as improved ability to concentrate and increased self-confidence) and the complete dismissal of apprehension, the student was able to better both his ability to study and his confidence while test taking and went on to score the highest grade he had earned to date.[20]

In the second case, an engineering student with an admirable IQ (138 on the Wechsler Adult Intelligence Scale) believed that panic contributed to his test scores being poor reflections of his potential. The student received hypnotherapy in several sessions before important tests, and due to direct suggestions designed to boost his confidence, the student was successful in raising his grade.[21]

Inspiring as they are, these isolated success stories can't really vouch for the general population. Thankfully, there is some research that might give the students' testimonies further credence.

In an experiment to evaluate hypnotherapy as a treatment for test anxiety, the treatment group received four weekly hypnotherapy sessions in preparation for a final exam. As in the first examples of test-anxious students, therapists used suggestions designed to foster positive self-esteem and increased confidence in preparation. Meanwhile, in the no-treatment control group, participants were simply asked to monitor daily study habits over the same four-week period. The students receiving hypnotherapy significantly decreased their test anxiety over the no-treatment control group.[22]

It would be a safe assumption, given the similar nature of situational pressure, that the favorable results of hypnotherapy as a treatment of test anxiety would readily apply to performing musicians. Dr. Harry E. Stanton, a fellow of the Australian Society of Hypnosis and the American Society of Clinical Hypnosis, evaluated hypnotherapy in treating the music performance anxiety of forty conservatory students. In Stanton's study, participants were divided between an experimental group that underwent two fifty-minute hypnotherapy sessions and a no-treatment control group, whose subjects participated in group talk therapy. The hypnotherapy sessions were similarly modeled to the test anxiety cases and included suggestions for increased relaxation, competency-based imagery, and improved confidence. Only the students receiving hypnosis treatment reported a decrease in their anxiety, and at a follow-up assessment six months later, positive results were still evident.[23]

Dr. Thomas Plott, hypnotherapist, also tested the effects of hypnotherapy on music performance anxiety in an experimental model similar to Stanton's. Although the treatment group was significantly smaller (there were only seven subjects), the means of assessment included three performances in addition to personal testimony: two performances prior to treatment and one at its conclusion. Decreases in anxiety levels were not only noticed at the final performance but also reported midtreatment.[24]

Brian Sanders, board-certified hypnotherapist and director of the Sanders Hypnosis Center, suggests that hypnosis is an effective treatment because of its ability to reframe the initial sensitizing event (ISE) that originally caused the performance anxiety. The source of stage fright, he claims, is usually unresolved childhood conflict or a negative experience that occurs before the age of eight when the mind has not fully matured. The hypnotherapist could, then, potentially reshape the experience into one with more optimism or positivity and subsequently walk the adult patient through more recent experiences attached to some negativity, allowing the patient to handle them in a similar fashion. This is also referred to as regression hypnosis, and according to Sanders, his work with hundreds of musicians suffering from music performance anxiety has demonstrated that this approach is successful. He writes:

In one case, regression hypnosis for a graduate violin student yielded a childhood incident where she played poorly in a recital and had greatly disappointed her overbearing parents. In another case, a Russian piano player witnessed his private teacher get scolded

and fired for working him too hard; the student felt responsible for the teacher losing his job and going hungry. . . . Certainly, from an adult perspective, this issue may seem relatively minor. However, to a child they can be extremely traumatic. The effectiveness of this approach is extremely favorable; 100% of my stage fright clients have reported the complete elimination of their problem.[25]

Interestingly, there is also a more private means of experiencing hypnotherapy for those who may be a little unsure—albeit curious—about the process. While a graduate music student at the University of Southern California, Jayson Joe Helgeson conducted a study in which music majors listened to prerecorded hypnotherapy treatments over the span of three weeks before going to sleep. Performances to assess progress were held before and after treatment, approximately one month apart, and even in spite of the absence of a licensed hypnotherapist, significant decreases in music performance anxiety were evidenced.[26]

In spite of the overwhelmingly favorable feedback mentioned here, more scientifically modeled experiments would be worthy endeavors in further determining hypnosis's efficacy in treating MPA. Not only could it conceivably reinforce positive testimonies with concrete data, but more exposure may also help to dispel any misconceptions of hypnosis being regarded as a novelty instead of a potentially powerful means to reconcile the subversive effects of past experiences.

EYE MOVEMENT DESENSITIZATION AND REPROCESSING (EMDR)

EMDR is a fairly new psychotherapeutic intervention strategy, originally developed by psychologist Francine Shapiro in the late 1980s when she realized that moving her eyes from side to side helped reduce the recurrence of her own upsetting memories.[27] EMDR aids in the reprocessing of memories that cause present disturbances so that they may be more appropriately stored in the brain as useful learning experiences instead of sources of emotional anguish. The therapy targets symptoms and distress caused by traumatic life experiences by empowering the mind to heal much like the body recovers from physical injury. The EMDR Institute explains:

> When you cut your hand, your body works to close the wound. If a foreign object or repeated injury irritates the wound, it festers and causes pain. Once the block is removed, healing resumes. EMDR therapy demonstrates that a similar sequence of events occurs with mental processes. The brain's information processing system naturally moves toward mental health. If the system is blocked or imbalanced by the impact of a disturbing event, the emotional wound festers and can cause intense suffering. Once the block is removed, healing resumes.[28]

Dr. Shapiro theorized that trauma causes negative emotions to be stored in the same place in the brain as a troubling event and that the eye movements in EMDR

can help reorganize the memories in a way that lessens their emotional influence. In a televised interview, Dr. Shapiro describes how our minds react to emotional distress: "When a trauma occurs, that processing mechanism gets disrupted—it doesn't work. The brain goes into shock and the mind just repeats the information over and over again. When we deal with the eye movement in the office, we seem to be able to open up that blocked processing and accelerate it."[29]

One of the advantages of EMDR is that it works much faster than more traditional forms of therapy. The EMDR Institute cites more than thirty studies, some of which indicate 84 to 90 percent of single-trauma victims no longer have post-traumatic stress disorder after only three ninety-minute sessions.[30] And while a weighty word like *trauma* seems a more appropriate label for victims of violent crimes or combat veterans, if painful childhood memories or even failed performances are proving themselves impairing, then EMDR therapy might offer a powerful, refreshing perspective on the healing process.

Dr. Charles Plummer led one of the first inquiries into how EMDR might benefit musicians. As a doctoral student at the Cincinnati Conservatory, Plummer consulted Dr. Gilbert Braun, an educator and clinical counselor, to better understand how EMDR can be applied to those suffering from music performance anxiety. Dr. Braun explained, "Each has some experience and associated beliefs/thoughts which interfere or block the musician's true ability from being utilized in a performance. . . . Bad performances, harsh, demeaning criticisms of teachers, family, and friends can become a block to interfere with optimal performance."[31]

Dr. Braun went on to relate the story of a pianist who was seemingly unable to perform to her ability:

> The background was that she had studied at a prestigious eastern school of music.
> . . . Shortly before she left, her piano teacher started getting her to change a lot of her technique. . . . She flew back home, where her parents were extremely proud of her. . . .
> [W]anting to show off their wonderful, highly trained and talented musical daughter, they organized a large concert. She went to that large concert apprehensive because her technique had not been solidified. . . . During the concert, she made at least one fairly major mistake and then fell apart. The performance was horrible. Her memory failed her. She was completely embarrassed. Her parents were horribly embarrassed. After the performance at some point, they said to her, "This is what we spent forty thousand dollars sending you east to do?" . . . Anytime that she was going to perform again, this whole experience came flooding back to her.[32]

After facilitating EMDR for this particular pianist, Dr. Braun described being in the attendance at her first recital posttreatment. While she suffered a minor memory slip, she was able to recover with ease, taking the repeat and playing the same passage a second time "perfectly and without mistake."[33]

Plummer shared several case studies in which doctoral students and professors at the University of Cincinnati College-Conservatory of Music have found EMDR

to be beneficial in neutralizing the pressures of a competitive environment. One individual expressed:

> At the start of my DMA program in trombone I was having trouble with performance anxiety. I would get up in front of studio class and completely panic and react emotionally in a very negative way to the physical side effects of being nervous. I would shake uncontrollably, get dry mouth, and have shallow breaths. . . . I had a recital planned in the spring of my first year in the program and I was concerned about getting through it. Two months before my recital I started working with Dr. Braun and EMDR. The training allowed me to focus on the right "stuff" while playing. Use of the headphones in therapy helped me to get past some emotional baggage that was getting in the way, not only as a musician, but as a person as well.[34]

For more information on the breakdown of an actual EMDR therapy session, Dr. Shapiro's book *Getting Past Your Past: Take Control of Your Life with Self-Help Techniques from EMDR Therapy*[35] is a good place to start.

PROGRESSIVE MUSCULAR RELAXATION (PMR) AND ELECTROMYOGRAPHIC (EMG) BIOFEEDBACK

PMR is a technique developed by American physician Edmund Jacobson that involves the intentional tensing and relaxation of individual muscles.[36] Defining *tension* as the "effort that is manifested in the shortening of muscle fibers,"[37] Jacobson encourages a regimen of relaxation therapy that progressively eases the tightness from each muscle group in the hopes that eventually the person will maintain only the minimum tension necessary for each task. This theory is also referred to as "differential relaxation."[38]

In considering PMR's potential benefit to music students, Charlotte Whitaker designed a relaxation-based therapy experiment to observe the elimination of stress responses in pianists. Participants used three relaxation audiotapes daily consisting of a combination of both PMR and autogenic training (another form of suggestion-based therapy with a similar goal of self-regulated relaxation). Results from the study suggest that performers participating in both muscle relaxation and cognitive-behavioral therapy had a notable decrease in psychological and physical anxiety.[39] Several other studies (though not specifically focused on musicians) have similar results in PMR's effectiveness in lessening anxiety and physical tension.[40]

According to Dr. Diana Deen, "Awareness is a prerequisite to making any physical changes in the body, particularly when the desired action is creating a new habit."[41] In electromyographic biofeedback, the principles demonstrated in progressive muscular relaxation are visually communicated to further recognize unnecessary tension in the body. Electromyographic (EMG) biofeedback measures a person's quantifiable bodily functions, such as blood pressure, heart rate, skin temperature, sweat gland activity, and muscle tension, through strategically placed sensors. If we commonly

hold tension in our muscles, for instance, we may misread the muscles as being relaxed because we've grown accustomed to the sensation. However, biofeedback immediately makes us aware of such issues, allowing for the prompt release of tension and the initiation of new, more relaxed habits.

In James Kjelland's doctoral dissertation at the University of Texas at Austin, tone quality was analyzed in performing cellists before and after sessions of biofeedback instruction on the upper-right and -left trapezius (the pair of large triangular muscles extending over the back of the neck and shoulders, whose job it is to move the shoulder blade and extend the head at the neck). Research questions were designed to assess the subjects' abilities to reduce and maintain electromyographic levels in these muscles while at peak performance quality and relationships between electromyographic readings and self-reported tension, among other variables. Tension reduction was evidenced in all experimental subjects, and improved tone quality was notable in a few. Meanwhile, for the control group who received no treatment, subjects demonstrated increased tension levels and reported "slightly worse" post-training quality ratings.[42]

A sister therapy to EMG, electroencephalograph (EEG) biofeedback has also been evaluated for its application to tension in music performance under stressful conditions. Where EMG biofeedback involves placing sensors directly on offending muscle groups, EEG biofeedback sensors are placed along the scalp and follow brain activity and impulses over muscular response. In one study, experts documented improved musical performances in a student group that had received training on attention and relaxation related to electroencephalograph feedback, and results showed the improvements were largely influenced by the participants' training in learning to progressively relax tight muscles.[43] A later study from 2006 by researcher Myron Ross Thurber also revealed significant decreases in mental, emotional, and physiological symptoms of music performance anxiety in university students as a result of EEG.[44]

CONCLUDING THOUGHTS

Regardless of how they are paired, supplemented, or independently administered, cognitive-behavioral therapies offer pertinent treatment options for the psychological elements of music performance anxiety. The success of cognitive-behavioral therapies in addressing the underlying emotional and mental causes of MPA is astounding, and because treatment methods contain many complementary aspects, they can be selected and grouped together according to the needs of each individual.

Many of the therapies described in this chapter require the help of a trained therapist or coach, while some approaches we have discussed may also be accomplished to some extent on your own. There are, however, distinct advantages to working in partnership with a trusted person to whom you can remain accountable and who can offer an external, unbiased perspective.

ACTIVITY: AFFIRMATIONS

Reflection for Awareness: Creating New Thoughts

In the chapter 2 activity, you wrote down your thoughts in a journal. In this activity, you learn how to replace those thoughts with ones that are more honest, encouraging, and helpful to your development. It is possible that you found that some of your thoughts were very hurtful, and it may be easier now to understand how your inner dialogue may contribute to MPA. This activity helps you to replace those hurtful thoughts with affirmations that better reflect your positive goals and intentions. While this may not be easy to do at first, replacing hurtful thoughts with empowering ones can gradually change your inner dialogue to one that is more likely to yield positive results.

1. Take each one of the negative thoughts you wrote down in your journal and write a new empowering thought in its place.

 Examples:

 I always miss that high note.
 I love playing this phrase.
 I play this section with ease.
 I am relaxed.

 I am not good enough to win the audition.
 I am prepared.
 I will handle whatever happens.
 I will get a job where my skills and ideas fit best.

 I know that (name of person) thinks I am not good enough to be a performer.
 I love performing and feel called to express myself musically.
 I am open to receiving all feedback, and I determine for myself what is honest and accurate.
 I love to learn and improve my skills.

 This part always sucks.
 My shoulders and arms are relaxed.
 This upcoming crescendo is thrilling.
 I am expressive.

 Everyone will see that I am shaking.
 I breathe deeply and allow myself to be vulnerable.
 I am giving a gift of myself to the audience.
 My love for this piece comes through in my playing.

 I don't deserve to be in this ensemble.
 I admire and respect the performers in this ensemble.

I perform at my best when I am myself.

Playing with amazing performers encourages me to play at my best.

2. Now that you get the idea, you may want to take the time to dream a little. When you are feeling good, take a moment to write down affirmations related to your life and career aspirations. This is a moment to *think big* and consider what it is that you really want more than anything. Write a list of your affirmations.

Examples:

I create a safe space within my mind to thrive and grow.

I love being a musician.

I love performing with other amazing musicians.

I surround myself with people who want me to succeed.

I lovingly care for myself so that I feel and play at my best.

I enjoy my work and those I work with.

I see every situation as an opportunity.

I am capable, confident, and courageous.

I support others, and others support me.

I am a channel for musical expression.

I listen to my body and nourish each of its needs.

I speak gently to myself and trust myself more each day.

As I release criticism, judgmental people leave my life.

I trust my inner wisdom in all situations.

I am worthy.

I am safe, and all is well.

I approve of myself and love who I am.

I am a solid musician who can express myself fluently.

Application and Integration to Practice: Replacing Your Thoughts

Now that you have created affirmations that counter your negative thoughts and affirmations that state what you want to create, you are now ready to convert your inner dialogue by replacing negative thoughts with positive ones. But remember that the first important step is to just notice when you are thinking negative or hurtful thoughts. When you do, it is essential to exercise self-compassion. If you have been harsh with yourself in the past, the last thing you need is more harshness. Some of us have been practicing negative thoughts for a long time, and they are deep patterns that may continue to surface for the rest of our lives. The idea here is to become more aware, not to keep score.

1. When you notice negative thoughts, emotions, or sensations, take a deep breath and see if you can return to a centered and nonjudgmental state of

mind. When you can, introduce an affirmation, and use your imagination to embody the feelings and emotions that accompany the affirmation. For example, you could say, "I am safe and calm" and then recall the emotions and sensations you felt in the past when you have been safe and calm. If you think about it, it is the same imaginative process you have used with negative thoughts to create anxiety and debilitating symptoms! The difference is that you are not creating negative thoughts by default but are consciously choosing what you create in your mind and body.

2. Over time you will become more aware of your inner dialogue and have an increased ability to redirect it toward the thoughts you consciously choose to think. When you can, replace old thoughts with new ones. This may not feel authentic at first, or you may not believe the new thoughts. Do it anyway, and trust that the statements will resonate more deeply over time.

3. It is important to mention here that this is not a quick fix. Just as the deep patterns of negative thinking were not created in a week, month, or year, it is not realistic to expect an immediate shift to only positive thoughts. That is why it is important to regularly practice being mindful of your thoughts just as you practice your instrument or voice. The good news is that, as a musician, you likely already know how to implement a daily practice routine in order to accomplish a long-term goal. This gives you an advantage, as you understand that lasting changes and improvements do occur with regular and consistent effort. If this seems difficult at first, then remember an aspect of your technique that you have mastered that was also hard at first. Remind yourself that you achieved this mastery through practice.

JOURNEYS: A PERFECTLY GOOD PLANE

By Casey

Years ago, one of my biggest fears was heights—particularly flying. I avoided roller coasters, dreaded plane travel, and never had a desire to visit the top floors of famous skyscrapers. I attributed my fear of "death by plunge" to the fact that you'd have a good thirty seconds to come to terms with your imminent doom before smashing into the earth. The thought alone of being afforded those final, reflective moments was terrifying.

As luck would have it, my studio teacher during my doctoral study was Stefan Milenkovich, who was not only an established violin soloist but also a licensed skydiver. He knew I had come to the University of Illinois with a handful of solo appearances but also a crippling underdog mentality, and after struggling through a simple passage in his studio one afternoon, we put down our instruments to discuss not only the fears I had in the lesson space but also the other things that made me apprehensive.

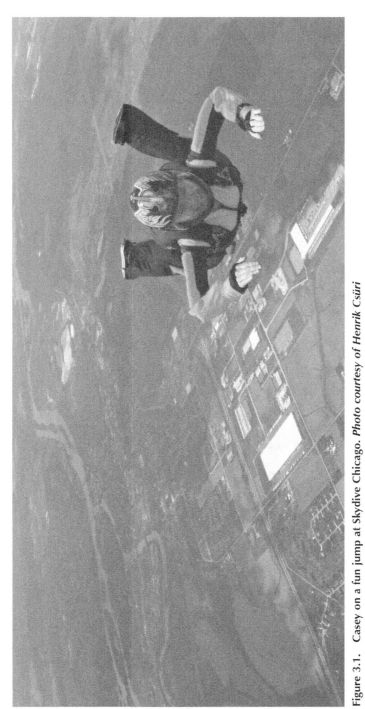

Figure 3.1. Casey on a fun jump at Skydive Chicago. *Photo courtesy of Henrik Csűri*

"You know what?" he asked me, his face suddenly serious.

I didn't, but I braced myself. Whenever Stefan got a distant look in his eyes and his index finger started wagging, you were wise to anticipate both insightful realization and a potentially humorous proposition.

"Skydiving," he said, his voice short and certain. "You should go."

I laughed—I remember that distinctly. And then, somehow, not nine months later, I found myself in a turbo prop with a few good friends, readying myself for my first tandem jump.

In tandem skydives, you are attached to a professional skydiver. Although you could opt to simply go along for the ride, they still empower you to remember to do a short list of tasks in freefall, including pulling the parachute at an altitude of 5,500 feet. When you're descending toward the earth at 120 miles per hour, trying to remember to do anything is a daunting expectation. Still, as my altimeter's number climbed during our plane's ascent, I couldn't help but make a parallel to a preperformance experience: The tiny plane cabin was like being backstage, with everyone going over last-minute instructions for what to do once they were in the air. Freefall was a foreign, predictably intimidating situation in which was I had to focus well enough to save my own life—much like playing an audition, extraneous variables (or disruptive, panic-induced thoughts) are always potential distractions. Pulling a cord is not hard. Playing an excerpt may not be that challenging after solid practice. So why is it that, in some situations, we're rendered unable to execute what we've trained ourselves so thoroughly to do?

Figure 3.2. Casey's first tandem jump at Skydive Chicago with Mickey Nut-tall. *Photo courtesy of Skydive Chicago*

For the record, the parachute opened and, thanks to my tandem instructor Mickey, we both landed safely—as did everyone else on my plane, who congratulated each other on their successful return to earth with the kind of enthusiasm only people who have just laughed in the face of danger can know. They shout and cheer with their whole bodies; they jump up and down and offer high fives that leave your hand stinging. For a moment, we are all warriors. We are invincible. Not just because we jumped out of a "perfectly good airplane" but also because we faced something terrifying—and triumphed.

We all have "perfectly good airplanes." For some, it's the idea that you will never play your oboe in front of an audience of more than ten or that you won't audition for a professional orchestra because you can't fathom surviving the process. We bench our insecurities on comfortable write-offs because it's easier to rationalize that we're simply being honest with our limitations. But supposing that those self-inflicted labels were slapped onto your heart because of a handful of failures, sour moments onstage, or botched auditions, it could just as readily be lifted by a resilient effort in the opposite direction. Although it's true that risks should always be carefully assessed to maximize the potential for personal growth, pushing ourselves back onstage—or out of perfectly good plane doors—is the only way to ensure our personal truths stay in constant cultivation.

Figure 3.3. Casey's first solo jump as part of the Advanced Freefall Program at Skydive Chicago. *Photo credit: Sarah Beckers*

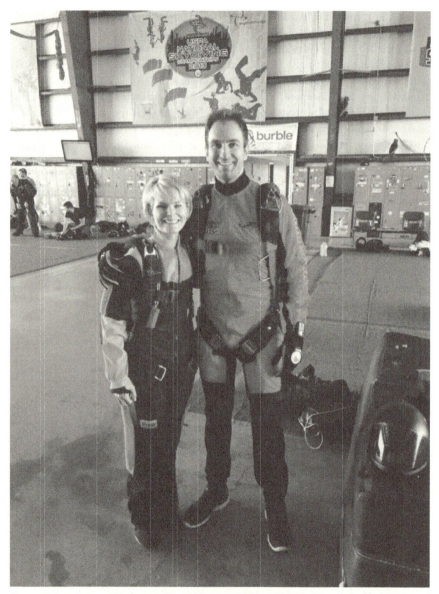

Figure 3.4. Casey with her violin professor, Stefan Milenkovich of the University of Illinois at Urbana-Champaign. *Photo courtesy of Tom Bahar*

And this is how, five years after my first tandem jump, I found myself crouched on the floor of a twin otter, harnessed to my own rig. Until then, I'd resolved to only enjoy the sky from the safety of professional assistance. The stress of saving my own life and navigating my own canopy was unfathomable, I'd decided, so I opted instead to leave that to people better suited for such responsibility. Securely attached to my

tandem instructor for the eighth time, I watched again with awed fascination at the solo jumpers disappearing into the clouds, silently marveling at their steely self-assurance and the sheer tenacity it must require to handle such a pressured moment with such obvious grace. Surely, I reasoned, I was not one of those people.

But, as my heart has been known to do when witnessing some act of monumental courage or artistic mastery of which I immediately dismiss myself as incapable, it responds to even the most convinced *cannot* with an increasingly enthusiastic *why not?* Three weeks after my last tandem, I enrolled in the Advanced Freefall Program at Skydive Chicago. Two days after the transition class, I made my first solo skydive. By September, I had qualified for my first parachuting license.

Getting through that first solo jump was just the beginning: Skydiving, like many things, is much more challenging than it looks. You have to maintain mental focus, but you've also got to be physically relaxed; the determination to balance your efforts can easily translate to tension, which then impairs your ability to fly well. There's also the added complication of parachute malfunctions and the dangers of collisions, but to fly your canopy with fearful caution—like playing your clarinet without artistic conviction—rarely results in masterful and moving performances. And while it kind of goes without saying that you'll regularly run into situations that compromise or outright pulverize your sense of purpose, the great thing is that there are just as many positively affirming moments to be had in the process. How else do we gain the intrinsic power of resilience, if not carved from the denial of our own terror?

Figure 3.5. Casey practicing for her first Rookiefest tournament with Sarah Beckers and Adam Boggio, Skydive Chicago. *Photo courtesy of Skydive Chicago*

So come cannons, battle axes, subpar auditions, or skydives that end with a face plant in manure—advance your troops. Play for people who intimidate you. Get a coaching on your excerpts with the conductor of an orchestra you aspire to join. Ask to solo with a youth symphony or community orchestra. Enter a competition. Take lessons again. Jump into the shark tank that is the audition greenroom. While nothing guarantees you'll win your dream job, fortitude and strategy ensure you a better chance. And the satisfaction that comes with knowing you never made backing down a practice is more confidence inspiring than even the greatest of technical achievements.

While at one point in my history, the stage—like the open plane door—used to be a trigger for desperation and discouragement, it is now one of my favorite places to explore. The pause before a downbeat, the breath before the dive—the thrill of being on the cusp of something so potentially momentous is an exhilarating place to give pause. And while I may always find my heart beating faster when the personnel manager announces my number to the audition panel, or my breath quicken the second before plunging into the Big Blue Room, I no longer fear the voice that challenges the limitations I place on myself. Instead, I listen for it, excited by what it may decide is the next version of myself from which to leap.

FROM THE STAGE: BRIAN GERMAIN

World Champion Skydiver,
Test Pilot, Psychologist, and Life Coach

I am just a simple skydiver who has spent thirty years of throwing myself at the planet, thousands of times, and missing. I do not know as much about life in the grownup world, but I do know this: My best ideas come when I am feeling just a touch of excitement due to a risk worth taking, but when that excitement turns to fear, I am less of myself—I am smaller. It is when I live out a memorable experience in the sky or other scary experience I deem worthwhile that I call these ideas worth sharing "adventure wisdom."

Some of the lessons I have learned in such emotional moments of experiential learning are physical, and some are psychological in nature. I find these profundities in the most unlikely of places: Sometimes I am in extreme danger and yet in relative safety, gliding through risk with skill and knowledge. Other times I find wisdom through failure to find the best way to perform a task and thus learn how to do it as a result of my failure. We smash through the boundaries out of control, realizing how not to do something through direct experience. Wisdom comes in many ways, and when we listen to these lessons, our way is cleared and softened and filled with the profundity that makes our lives better. This is adventure wisdom.

One of the most important nuggets of wisdom that I have realized again and again is the impact of mood on skill and safety. The emotional tone that I carry with me out

Figure 3.6. Brian Germain in flight. *Photo courtesy of Brian Germain*

of the door of the airplane seems to continue and usually magnify in its effects. If I am in good headspace, my world glides, but the opposite is also true. My fear brings both incompetence and danger. When I feel good and therefore skilled and safe, it is due to deliberately nurtured, positive memories of my past experiences repeated in my mental movie show. I can brainwash myself into the best-case scenario because if I get out of my own way by casting doubt aside, then my most brilliant light shines through. My skill comes out and I am my best, and when I am doing something I am highly experienced in, I am a force of safety and abundance and happiness, as is everyone whom I have met. When your skill flows, you are beautiful. That skill, when gushing out of you, can then bring on an internal friction called "questioning one's worthiness." This is where thankfulness releases the full force of sustainable magnificence in both action and thought, and the world becomes a better place for having you in it.

When we look deliberately in the direction of the best-case scenario, we begin to expand those possibilities that represent the smoothest and safest way forward

Figure 3.7. *Photo courtesy of Brian Germain*

through any situation. Knowing how do something skillfully is one aspect of wisdom, but there is another. When we use our judgment to decide whether to do something, this, too, is adventure wisdom. When a "go or no-go" choice must be made, the ego and the emotions must not be allowed to make the decision alone. A cooler, more transpersonal mindset from a physically calmer body will almost always result in a more logical decision and ultimately better outcome. When the heated desire to move forward softens, there is a loosening of the grip of the ego's need to feed itself with recent confirmation of one's adequacy and self-worth. This is wisdom beyond self, the place where compassion matures into its kinetic form of compassionate heroism.

Bravery is not only for glory; it is for virtue. It is for ideals that feel right when viewed from any angle. Purposeful action devoted to the highest good is a provocation source like none other because love is at the core of virtue: love for humanity and love for the world, above and below. When we fear the loss of that which we love most, we fear the most of all. This is why adventure and its by-product, wisdom, can bring humanity back to the values and the harmony that will maintain the mutual cooperation and admiration of all who walk the earth and fly above it.

NOTES

1. Dianna T. Kenny and Margaret S. Osborne, "Music Performance Anxiety: New Insights from Young Musicians," *Advances in Cognitive Psychology* 2, nos. 2–3 (2006): 103–12; George Mandler and Seymour B. Sarason, "A Study of Anxiety and Learning," *Journal of Abnormal and Social Psychology* 47, no. 2 (1952): 166–73; Nancy J. Marlett and David Watson, "Test Anxiety and Immediate or Delayed Feedback in a Test-Like Avoidance Task," *Journal of Personality and Social Psychology* 8 (1968): 200; Donald Meichenbaum, *Cognitive Behavior Modification: An Integrative Approach* (New York: Plenum Press, 1977).

2. Personal communication, April 15, 2016.

3. Margaret J. Kendrick, Kenneth D. Craig, David M. Lawson, and Park O. Davidson, "Cognitive and Behavioral Therapy for Musical-Performance Anxiety," *Journal of Consulting and Clinical Psychology* 50, no. 3 (1982): 353–62.

4. Meichenbaum, *Cognitive Behavior Modification.*

5. Frederick H. Kanfer, "Self-Management: Strategies and Tactics," in *Maximizing Treatment Gains: Transfer Enhancement in Psychotherapy,* ed. Arnold P. Goldstein and Frederick H. Kanfer (New York: Academic Press, 1979), 185–224.

6. Albert Ellis, "Extending the Goals of Behavior Therapy and of Cognitive Behavior Therapy," *Behavior Therapy* 28, no. 3 (1997): 333–39.

7. Ellis, "Extending the Goals," 4.

8. Ibid.

9. David Aderman, "Elation, Depression, and Helping Behavior," *Journal of Personality and Social Psychology* 24, no. 1 (1972): 91–101; W. Daniel Hale and Bonnie R. Strickland, "Induction of Mood States and Their Effect on Cognitive and Social Behaviors," *Journal of Consulting and Clinical Psychology* 44, no. 1 (1976): 155.

10. Ellis, "Extending the Goals."

11. David C. Bricker and Jeffrey E. Young, *A Client's Guide to Schema Therapy* (New York: Schema Therapy Institute, 2010), 11.

12. Bricker and Young, *Client's Guide to Schema Therapy.*

13. Ibid.

14. Ibid.

15. Michiel Van Vreeswijk, Jenny Broersen, and Marjon Nadort, *The Wiley-Blackwell Handbook of Schema Therapy: Theory, Research and Practice* (Malden, MA: John Wiley and Sons, 2015).

16. Personal communication, April 15, 2016.

17. Ibid., 41.

18. Alex Lyda, "Hypnosis Gaining Ground in Medicine," *Columbia (Columbia University) News,* July 1, 2005.

19. "What Is Hypnotherapy?" *Institute of Clinical Hypnosis and Related Sciences,* accessed April 30, 2016, http://www.instituteofclinicalhypnosis.com/hypnotherapy.

20. James H. Stewart, "Hypnosis in Contemporary Medicine," *Mayo Clinic Proceedings* 80, no. 4 (2005): 511–24.

21. Ibid.

22. Ira A. Greenberg, ed., *Group Hypnotherapy and Hypnodrama* (Chicago: Burnham, 1977).

23. Harry E. Stanton, "Using Hypnotherapy to Overcome Examination Anxiety," *American Journal of Clinical Hypnosis* 35, no. 3 (1993): 198–204.

24. Thomas M. Plott, "An Investigation of the Hypnotic Treatment of Music Performance Anxiety" (PhD diss., University of Tennessee, 1986).

25. Brian Sanders, "Hypnosis as an Alternative to Beta Blockers for Stage Fright," *Sanders Hypnosis Official Blog,* accessed April 30, 2016, http://sandershypnosis.blogspot.com.

26. Jayson Joe Helgeson, "The Effects of Hypnotherapy on Musical Performance Anxiety" (master's thesis, University of Southern California, 1999).

27. "What Is EMDR?" *Eye Movement Desensitization and Reprocessing Institute, Inc.,* last modified 2016, accessed March 15, 2016, http://www.emdr.com/what-is-emdr.

28. Ibid., para. 2.

29. Quote transcribed by author from Francine Shapiro, "Getting Past Your Past," RodaleBooks video, December 2011; accessed April 25, 2016, https://www.youtube.com/watch?v=nylajeG6uFY. For more information, see also Francine Shapiro, *Getting Past Your Past: Take Control of Your Life with Self-Help Techniques from EMDR Therapy* (New York: Rodale, 2012).

30. "What Is EMDR?" para. 3.

31. Charles D. Plummer, "Performance Enhancement for Brass Musicians Using Eye Movement Desensitization and Reprocessing" (PhD diss., University of Cincinnati, 2007), 58.

32. Ibid., 58.

33. Ibid., 63.

34. Ibid., 62.

35. Shapiro, *Getting Past Your Past*.

36. Edmund Jacobson, *Progressive Relaxation* (Chicago: University of Chicago Press, 1938).

37. Ibid.

38. Charlotte Sibley Whitaker, "The Modification of Psychophysiological Responses to Stress in Piano Performance" (Ph.D. diss., Texas Tech University, 1984).

39. Edmund Jacobson, *You Must Relax* (New York: Whittlesey House, 1934), 6.

40. Paul M. Lehrer, "A Review of the Approaches to the Management of Tension and Stage Fright in Music Performance," *Journal of Research in Music Education* 35, no. 3 (1987): 143–53.

41. Diana Rhea Deen, "Awareness and Breathing: Keys to the Moderation of Musical Performance Anxiety" (PhD diss., University of Kentucky, 2000), 22.

42. James Martin Kjelland, "The Effects of Electromyographic Biofeedback Training on Violoncello Performance: Tone Quality and Muscle Tension" (PhD diss., University of Texas at Austin, 1985).

43. Tobias Egner, Emilie Strawson, and John H. Gruzelier, "EEG Signature and Phenomenology of Alpha/Theta Neurofeedback Training versus Mock Feedback," *Applied Psychophysiology and Biofeedback* 27, no. 4 (2002): 261–70.

44. Myron Ross Thurber, "Effects of Heart-Rate Variability Biofeedback Training and Emotional Regulation on Music Performance Anxiety in University Students" (PhD diss., University of North Texas, 2006).

4

Exposure Therapy

A popularly theorized antidote for music performance anxiety has been to simply perform—and perform often. Regularly exposing yourself to a live audience is a good way to find out what in your preparation can withstand the pressure of performance—even if, at the moment, your audience is limited to your grandma, the kid next door, or your family's cat. Subjecting ourselves to the evaluation of others not only empowers us to assess our progress and refine our strategies but also affords us the satisfaction of knowing that, if we were brave enough to take the stage once, then we most certainly can find the will and courage to go out there again.

Exposure therapy is roughly based on the same principles: The exposure therapist determines the thoughts, emotions, and physiological responses that accompany a fear-provoking trigger and then, to break the pattern of undesirable response, systematically exposes the person to progressively stronger stimuli until the fear is neutralized.[1] In simpler terms, take Freaked Out Fred, the bass player: If audience size is the fear-inducing stimulus, then he may start by performing something familiar and comfortable for a group of friends, eventually working his way up to a more technically demanding piece for a larger crowd.[2] With repetitive exposure to this once-uncomfortable situation, Fred may find that his body—and his emotions—learn to adapt.

A researcher tested this theory out in 1976 by using exposure therapy to treat graduate piano students who claimed to have suffered from stage fright in solo performances. Each participant was randomly assigned to one of three treatment conditions: exposure therapy, musical analysis training, and a no-treatment control group. The exposure-based therapy group engaged in frequent public performances and received progressive muscle relaxation coaching, while the musical analysis treatment group based their therapeutic approach on the intellectual exploration of the work to

be performed in terms of theory, formal structure, and style. Results indicated that, while both treatment groups reduced recital errors in comparison to the control, the exposure therapy participants reported significantly less anxiety.[3]

Since then, many studies have come to similar conclusions[4]: Regularly confronting fearsome situations seems to be one of the most powerful methods of treatment available, and many musicians regard it as such by taking auditions "for the experience," performing works in progress for more forgiving audiences, and even pushing our own students to do the same. But much like a skydiver who flies a faster parachute before being properly trained and skilled to do so, the resulting experiences could also make matters much worse. As Dr. Dianna Kenny stresses, without the proper development of musical technique and performance preparation, success is an unlikely occurrence; therefore, repeated subjection to performance situations where the person is likely to have a negative experience will reinforce, rather than remedy, music performance anxiety.[5]

So, theoretically, the technical demand of repertoire intended for performance should be well within the ability and interpretive capacity of the musician and the material so familiar that it borders automaticity.[6] The findings of a study conducted by researchers Heinrich and Spielberger substantiate this belief, as they discovered the performance quality of extremely anxious people in stressful situations improved only if they were well prepared to handle the task before them.[7]

Furthermore, it's also recommended that the sources of anxiety and their potential causes be carefully evaluated before launching into an exposure-based therapy treatment plan.[8] Should performance impairment be attributed to anxiety and not simply poor preparation, then repeated exposure to performance opportunities could turn out to be pretty helpful. It's important that the performances are scheduled close together, says psychologist Paul Lehrer, as significant time lapses pose the risk of rendering the opposite result.[9]

On the other hand, Lehrer also cautions that the approximate successions of exposure treatment must be contoured to the stage-frightened person, as the prospect of participating in some performance experiences too soon might end up being more discouraging than helpful. For some musicians, performing for large crowds multiple times per week might be beneficial; for others, the prospect might be too overwhelming and smaller, more intimate settings would serve as a better introductory step. In either case, the person must be well equipped with the skills necessary for a successful and positive experience and the incremental factors of each situation be well suited for his or her emotional comfort: enough to push toward healing but not so much as to discourage into regression.

VISUALIZING GREATNESS:
MENTAL REHEARSAL AND IMAGERY

Mental rehearsal is defined as the "cognitive rehearsal of a task in the absence of overt physical movement." Also synonymously referred to as *mental practice*, several studies

suggest that visualizing an action in the absence of actual physical execution may be just as effective as really doing it. Mental practice is based on the *psychoneuromuscular theory*, which hypothesizes that imagining an action inspires the same physical responses in the body as the actual movement.[10] Lanny Bassham, 1976 Olympic gold medalist in international rifle shooting, calls it the "most versatile" of mental tools, explaining, "When you vividly rehearse an action, neural pathways in the brain are created. These pathways are similar to small tracks engraved in the brain cells that can ultimately enable an athlete to perform the actual task. Therefore, one of the benefits of rehearsal is that it actually paves the roadways that we must travel to perform a desired task."[11]

Bassham mentions a study run at the Olympic Training Center by a team of sports psychologists in which imagery was used to influence the basic motor skill of putting a golf ball. Thirty college students were grouped into either a positive imagery treatment group, a negative imagery treatment group, and a no treatment control. In the positive imagery group, the students were instructed to visualize successfully putting the golf ball into the cup, and in the negative imagery group, the students were told to imagine a narrow miss. Notably, results indicated that the positive visualization group improved their performance, the control group maintained their current levels, and the negative visualization group's performance completely deteriorated.[12]

Bassham established his "Mental Management" coaching system after receiving a silver medal in the 1972 Olympics, which inspired him to better understand how the mind works under pressure. He stresses the use of positive mental rehearsal in his book *With Winning in Mind*, saying, "Not only does positive imagery increase performance but when we think about creating error we improve the chance of error occurring as well. When we worry that bad things might happen to us, we are actually rehearsing them. We building new neural pathways toward failure."[13]

Bassham attributes much of his success not only to mental rehearsal but also to systematically convincing his self-image that it was "like him" or typical to perform at a very high level. He describes an instance in which he wanted to set the new world record for shooting in the kneeling position: "I wanted to set the record at 400, a perfect score. But I had never actually fired a 400, even in training. Nonetheless, I vividly rehearsed shooting the first 100, then another and another. . . . I rehearsed hearing a voice say, 'That's OK, I do this all the time,' [I imagined] saying to myself, 'Another 400, that's like me!'"[14]

It's recommended that athletes (read: musicians) approach the imagery process by envisioning a specific upcoming performance where they hope to operate at optimum level and then imagine themselves producing the most desirable outcome. Researchers Esplen and Hodnett found this to be a powerful technique in soothing the stage frightened: When imagining themselves performing with confidence and control for a friendly, supportive audience, music students who were assessed as suffering from music performance anxiety reported a significant decrease in their symptoms.[15]

Research has shown that positive mental practice was an effective learning procedure that rendered improvement, while negative mental practice led to increased levels of performance anxiety and decline in performance quality.[16] This isn't entirely a

cutting-edge perspective: Early-twentieth-century pianist Luigi Bonpensiere claimed that, because it's free from the distraction of actual physical activity, mental practice is even more effective than practicing with an actual instrument. Bonpensiere further theorized that pianists can overcome fear and tension by mentally singing when they play to prevent the intrusion of irrelevant thoughts.[17] Eloise Ristad advocates the use of guided imagery rehearsal in her book *A Soprano on Her Head* to lessen the power of "inner judges" that may compromise the quality of performance.[18] Recent scholars have further found that musicians who repeated cue statements or "trigger words," such as *bold*, *confident*, and *free*, before performance played more expressively.[19] As with any aspect of music learning, however, these researchers suggest that repetition and review of cue statements may be necessary to establish long-term effects.[20]

Dr. Malva Susanne Freymuth, violinist and author of *Mental Practice and Imagery for Musicians*, recommends alternating between mental and physical practice in daily sessions.[21] Violinist Kato Havas concurs, also suggesting the alternation of thinking about movement or patterns with actually executing them. She explains, "No physical action can take place without an order from the mind. . . . [I]f the mind is disciplined to give orders only to those basic points which are the key positions of the fundamental balances, these fundamental balances in turn will have the power to motivate a chain of other actions as well."[22]

Even some of the world's most elite brass players attest to the effectiveness of mental rehearsal, as a research project led by William Trusheim in 1987 confirms. Twenty-six musicians from the brass sections of the Baltimore Symphony, the Boston Symphony, the Chicago Symphony, the New York Philharmonic, and the Philadelphia Orchestra were interviewed to discuss the potential benefits of mental imagery and how it supports solid performance.[23] Many described how hearing your ideal tone and sound in your head was the first step in actualizing it. One player commented, "I like to use the slogan, 'The music plays me.' The music that I have inside my head is what plays the horn and that's what guides the product that comes out."[24] Another spoke of the power of mental rehearsal as conditioning for the stage, stressing its particular importance for students:

> Some students have a tendency to get used to playing for the four walls of their practice studio and that's one of the hardest things for them to overcome—to suddenly realize that they're no longer playing for those four walls, they're playing for an audience. Your thinking process has to be practiced the same as your music has to be practiced. If you think you're playing in the practice room, you're going to sound like it. If you think you're playing for a performance, you will.[25]

In short, training our minds is just as important as training our fingers. Researchers Paul Severson and Mark McDunn suggest that a musician preparing for a performance should "prepicture" a successful performance in all its details, including the accolades of a positive audience reception.[26]

But as much as positive imagery is supported in both evidence and theory, imagining yourself making three-point shots on the basketball court won't necessarily make

you next season's top draft pick for the NBA—but it may improve your chances. Bassham explains that, while imagery can't improve your knowledge or skill level, it will boost your confidence, refine your preparation, and increase the likelihood of being able to demonstrate your ability under pressure.[27]

Imagery isn't for everyone, though. Many sports psychologists find that people who struggle with imagining the clarity and detail of a scenario, as well as the extent to which they feel in control of its manipulation, may find mental rehearsal a challenging tool to utilize.[28] Without the distraction of our instruments, however, those who are able to open their imaginations can make relaxed muscles, positive attitudes, and high-level musical performances a perceptive norm for our imagined self, making it more "like us" that our imagined successes will eventually transpire in real time.

SUMMARY AND CONCLUDING THOUGHTS

Exposure therapy, or progressive exposure to anxiety-producing situations, has been found to alleviate performance anxiety and may even reduce technical errors associated with music performance. Past research suggests that facing our fears may be the most powerful method of treatment for anxiety. However, recent scholars remind us that nothing can replace proper preparation and development of skills; naturally, repeated exposure to ill-prepared performances may further reinforce performance anxiety. It is important for the performer to participate *regularly* in ability-appropriate activities where skills and performance challenges can gradually expand. As with other therapies we have discussed, exposure therapy may be even more effective when combined with other therapeutic approaches.

Now would be a good time to remind you of Susan Jeffers's "Five Truths about Fear" we share in chapter 2. Dr. Jeffers also recommends gradually expanding your comfort zone in general life experiences through incremental and increasingly empowering ways:

> I suggest that each day you do something that widens that space for you. Call someone you are intimidated to call, . . . ask for something you want that you have been too frightened to ask for before. Take a risk day—one small or bold stroke that will make you feel great once you've done it. Even if it doesn't work out the way you wanted it to, at least you've tried. You didn't sit back . . . powerless. Watch what starts to happen when you expand your comfort zone. . . .
>
> [W]ith each risk you take, each time you move out of what feels comfortable, you become more powerful. Your whole life expands to take in more of what there is in this world to experience. As your power builds, so does your confidence, so that stretching your comfort zone becomes easier and easier, despite any fear you may be experiencing. The magnitude of the risks you take also expands . . . but all at your own pace. As long as you are taking those risks—no matter how small—you are moving yourself to . . . power.[29]

ACTIVITIES: VISIONING AND RE-VISIONING

Reflection for Awareness: Creating a Mental Movie

The following reflection will help you to create a positive mental image of what you would like to occur in an upcoming performance. Many of us actually spend more of our time imagining the worst that might occur and miss the opportunity to envision the best! As discussed in this chapter, mental rehearsal is a powerful tool, and it is very important that we use it to create what we want, not what we don't.

1. Several weeks before an upcoming performance, write a description of the performance exactly as you wish it to unfold. Be as specific as you can be, as if you were writing a script for a theatrical production.
2. Read your description, and use your imagination to visualize the performance as you have written it. Make sure to imagine what it will sound like and look like, how you want to feel in your body as you perform, what the conditions are like in the performance venue, and a positive energy and reaction from your audience.
3. Feel free to update or enhance your description or visualization as you see fit.

Application and Integration to Practice: Monitoring Your Imagination

Now that you have programmed yourself for positive mental rehearsal, you will need to apply it to your practice. It will be helpful to remember that you are not adding something to your practice routine but are instead working to replace negative or unhelpful visualizations that you have been rehearsing. The purpose of this activity is not to find yet another mistake. Rather, it should feel like changing the channel on the television from a program you don't like to one that you do.

1. Practice the positive mental movie visualization before and after your actual practice sessions, while listening to recordings of your repertoire, or in situations where you need to pass time, such as during a commute.
2. Monitor your thoughts, emotions, and physical sensations using the flash scans you learned in the chapter 2 activity. Notice and then redirect any negative or anxious visualization that might occur and replace it with the description you have written. Change the channel!

Reflection for Awareness: Re-Storying a Past Performance

A variation on the first exercise, this activity focuses on breaking the cycle of memories of past negative experiences. Many people with MPA have a collection of negative past experiences that haunt them and feed the imagination with what-if scenarios. *What if I miss that high note again? What if I start shaking like I did last week? What if I forget where I am in the music?* In the chapter 3 activity, you learned

to replace individual thoughts and emotions and the importance of practicing the opposite thoughts, feelings, and physical sensations. This activity expands on this practice by transforming an entire memory.

1. Write down a description of a performance that did not go well. Be sure to write down as many details that you can remember, including what it sounded like and looked like, how you felt, details about the performance venue, the audience's reaction, and so on.
2. On a new page in your journal, rewrite the story with the outcome that you desire. Make sure to re-create the event in as much or more detail than your account from memory.
3. Once you have rewritten the story of this performance, use your imagination to visualize the new story as if it were taking place now. Make sure to use all of your senses to bring the new story to life, and allow yourself to feel the positive emotions that you would experience if this were actually occurring.

Application and Integration to Practice: Changing "What If" Statements

Similar to the previous practice, applying this to your practice routine involves noticing "what if" statements and rewording them to reflect the outcome that you want.

1. Monitor your thoughts using the flash scans you learned in the chapter 2 activity. Especially look out for "what if" statements.
2. When you have identified a "what if" statement, reword it. For example, change "What if I miss that high note?" to "What if I make that high note resonate?"
3. Take a few seconds to imagine that outcome in your thoughts, in your emotions, and allow yourself to feel it in your body.

JOURNEYS: SHIFT OF HEART

By Karin

Fear is a universal experience. Even the smallest insect feels it. We wade in the tide pools and put our finger near the soft, open bodies of sea anemones and they close up. Everything spontaneously does that. It's not a terrible thing that we feel fear when faced with the unknown. It is part of being alive, something we all share. We react against the possibility of loneliness, of death, of not having anything to hold onto. Fear is a natural reaction to moving closer to the truth.—Pema Chödrön[30]

One of my greatest joys is sharing music with others—expressing myself in ways beyond the scope of language yet in a way that everyone can understand. As a teenager, I had an opportunity to perform "Song of the Birds" by Pablo Casals on a European

tour with an area youth symphony. When the orchestra director informed me that he had programmed the piece and that I would be the soloist, my performance anxiety kicked in so much that I took a good two or three weeks to answer him, thinking very seriously about quitting the trip altogether to avoid the pressure. Largely due to the encouragement of my family and friends, I made the choice to go ahead.

We were scheduled to give around a dozen performances in both large and small cities throughout Europe, with our first stop in what was then known as West Germany. I was scared to the point that I didn't know if I could lift my bow to my cello, let alone handle that series of rising harmonics in the opening section of the piece. Before the performance, as my head began to spin as fast as the butterflies that swirled in my stomach and I was ready to dart for the restroom, a fellow orchestra member took me aside. In just a few words, she reminded me to get my head out of my own sense of inadequacy and focus my heart instead on sharing with others. Notes didn't matter, she said; the message did.

At the time, I knew nothing about Pablo Casals's humanitarian spirit, of his travels all over the world performing with a heart full of love, of his commitment to justice and world peace. I didn't know that he, too, suffered from performance anxiety yet reached out and shared his message anyway. All I knew is that my director picked out this song and asked me to play it as one of our performance pieces. In my seventeen-year-old version of self-absorption, I hadn't stopped to consider that I might be able to communicate with French, German, and Swiss audiences in a language that they would understand. But a gentle reminder from a friend created a shift in focus, and the self-centered teenager disappeared, allowing the voice of Casals to come through.

Before each concert, I separated myself from the rest of my peers. While they warmed up with scales, arpeggios, and a bit of a concerto here and there, I paced slowly through the warm-up space without playing, focusing more on gaining a mental, emotional, and spiritual state of communion with people whom I would soon meet. In each subsequent performance, I relied on my memory of connection from the previous one, and in a sense, I was already connected with the audience before we walked onstage. I knew nothing at the time of meditation and visualization techniques; I just knew that I could remember what it felt like to be in that special state of being and then rely on the physiological and emotional memory of the last experience to help me get back there in the next performance.

In this state, which I now know is called *flow*, I no longer kept track of time or even fingerings or phrasing. I just felt the music in a very meditative way. My fingers knew what to do, and thinking about them would only have distracted me from the experience. My only focus was on communicating a message to this European audience that was far beyond my vocabulary in any spoken language.

In one particular stop in a small town in Switzerland, we entered a cold, dark church that reminded me of very little from my own hometown or anything I had yet experienced. Culture shock hit, and I began to get scared again. I escaped to the bathroom and hid for a while in a restroom stall. In that dark and cramped space, I

went right to the core of my fear, and after a bit of wrestling with emotions, I grasped onto what I really wanted—to communicate—and just simply let go, allowing the fear to be whatever it would be (because I really couldn't control it anyway)—trusting that the musical message would still somehow get out.

There was silence after the performance and then applause. At the end of the concert, as the audience continued to clap and our set of encores were exhausted, the audience sent up an English-speaking representative to tell the director that they wanted to hear "Song of the Birds" again.

Of course I would play "Song of the Birds" for them again.

It wasn't the cellist but the music that they wanted to hear. I knew that—and as long as I have remembered that and kept that perspective throughout my life, a state of anxiety has been replaced with a state of flow. To this day, when I lose myself in the music and the message, I go back to that place of expression and connection. But when I focus on what's in it for me or what others might be thinking, then I become a bundle of nerves all over again.

Such was the case when we returned home from Europe and I was asked to perform the same piece for a hometown crowd, to perform for individuals who had unfairly and inappropriately set me up as the neighborhood musical wunderkind. The performance was talked up out of proportion before I played a single note, and I found myself replacing the humanitarian musical message with an opportunity to show off. The contrast was striking, as this time my shaking bow and body revealed to everyone just how weak I was when I lost perspective.

Since then, I have learned to select my audiences and performing circumstances carefully. If something isn't likely to be psychologically healthy for me, I just decline, choosing only to make music in the ways that I know will be uplifting for me as well as the audience. As an orchestral conductor and teacher, I find it much easier to forget myself and focus on the music when I have a baton in my hand because there are orchestral players with needs to meet. The podium feels much more like home to me because I have my back to the audience and my arms embracing the musicians. Others may see the role of director as a more narcissistic venture than solo performance, but for me, it is a humbling opportunity to facilitate a sense of musical community with people I love and admire.

I have come to believe that the anxiety we feel is not really the enemy to conquer after all but a true friend who nudges us when something—whatever it is—isn't quite right. If we can courageously go into that fear and figure out what is wrong, then perhaps we can then have the understanding and conviction we need to make any necessary shifts in our lives. In my case, the anxiety that plagued me as a young cellist told me that I should choose performance venues—and particularly a career—where I am less focused on myself and more focused on giving to others.

For me, performing freely is really a shift of mindset—or perhaps, better said, a shift of heart—from a desire to prove myself to a desire to share something special with people I care about. Since experiencing this self-awakening and becoming a music teacher myself, there is nothing more that I have wanted to pass on to my

students than this. It's a continual challenge to keep this perspective, but one worth every ounce of persistence.

FROM THE STAGE: ROOK NELSON

CEO of Skydive Chicago, Stunt Man, BASE Jumper,
World Champion, and Record Holder

People often ask me why I jump out of planes. I kind of reply, "Why not?" I'm one of those people that never wants to wonder, "What if?" That question drives me crazy; to think that people would rather wonder about something rather than going out and having a life experience! Of course, everyone will be into something different, and that's what makes all of us unique. My passion is skydiving/BASE jumping. I was pretty much born to jump out of planes. I completed my first jump when I was four years old (that's what happens when you forget to clean your room and your parents are skydivers).

Since that first jump, I have amassed more than 23,000 jumps. To put it another way, I've jumped out of a plane more times than a sixty-five-year-old person has woken up. When people hear that, they often ask if I still get a rush or am nervous while jumping. The short answer is, yes. That rush will never go away, and fear or being nervous is what will keep you alive. You can be extremely good at something

Figure 4.1. Rook Nelson in flight. *Photo courtesy of Rook Nelson*

and still be nervous. It's when you become too comfortable doing something that you drop your guard.

How can someone who excels at something look past their nerves? For me, I like the "scariness"; it's a sign that it's "game time." I become hyperfocused and am very aware of what's happening around me. Now, after so many jumps, I seek [that feeling] out. I know that, when my palms are sweating and I'm laser focused, I'm pushing myself to be the best. My nerves are what keep me in check. They tell you when to back down or not to push yourself too much. They're motivators as much as they are safety nets. The ultimate challenge is finding the balance.

NOTES

1. P. De Silva and S. Rachman, "Is Exposure a Necessary Condition for Fear-Reduction?" *Behaviour Research and Therapy* 19, no. 3 (1981): 227–32.

2. G. Ron Norton, Lynne MacLean, and Elaine Wachna, "The Use of Cognitive Desensitization and Self-Directed Mastery Training for Treating Stage Fright," *Cognitive Therapy and Research* 2, no. 1 (1978): 61–64.

3. Sylvia Appel, "Modifying Solo Performance Anxiety in Adult Pianists" (EdD diss., Columbia University, 1974).

4. Gerald Cooke, "The Efficacy of Two Desensitization Procedures: An Analogue Study," *Behaviour Research and Therapy* 4, no. 1 (1966): 17–24; I. M. Marks, "Exposure Treatments: Clinical Applications," in *Behavior Modification: Principles and Clinical Applications*, ed. Stewart Agras (Boston: Little, Brown, 1978), 204–42; Andrew M. Mathews, Michael G. Gelder, and Derek W. Johnston, *Agoraphobia: Nature and Treatment* (London: Tavistock, 1981).

5. Dianna T. Kenny, *The Psychology of Music Performance Anxiety* (New York: Oxford University Press, 2011).

6. Ibid.

7. Darlene L. Heinrich and Charles D. Spielberger, "Anxiety and Complex Learning," in *Series in Clinical and Community Psychology: Achievement, Stress, and Anxiety*, ed. Heinz W. Krohne and Lothar Laux (Washington, DC: Hemisphere, 1982), 145–65.

8. Paul Lehrer, "A Review of the Approaches to the Management of Tension and Stage Fright in Music Performance," *Journal of Research in Music Education* 45, no. 3 (1988): 143–53.

9. Ibid.

10. Michael Kent, ed., *The Oxford Dictionary of Sports Science and Medicine*, vol. 10 (New York: Oxford University Press, 2006).

11. Lanny R. Bassham, *With Winning in Mind* (London: Robert Hale, 2011), 74.

12. Ibid., 74–75; Robert L. Woolfolk, Mark W. Parrish, and Shane M. Murphy, "The Effects of Positive and Negative Imagery on Motor Skill Performance," *Cognitive Therapy and Research* 9, no. 3 (1985): 335–41.

13. Bassham, *With Winning in Mind*.

14. Ibid., 33.

15. Mary Jane Esplen and Ellen Hodnett, "A Pilot Study Investigating Student Musicians' Experiences of Guided Imagery as a Technique to Manage Performance Anxiety," *Medical Problems of Performing Artists* 14, no. 3 (September 1999): 127–32.

16. Daniel Gould, Robert Weinberg, and Allen Jackson, "Mental Preparation Strategies, Cognitions, and Strength Performance," *Journal of Sport Psychology* 2, no. 4 (1980): 329–39; Stewart L. Ross, "The Effectiveness of Mental Practice in Improving the Performance of College Trombonists," *Journal of Research in Music Education* 33, no. 4 (1985): 221–30; Woolfolk, Parrish, and Murphy, "Effects of Positive and Negative Imagery," 335–41.

17. Luigi Bonpensiere, *New Pathways to Piano Technique* (New York: Philosophical Library, 1953).

18. Eloise Ristad, *A Soprano on Her Head: Right Side Up Reflections on Life and Other Performances*. Boulder, CO: Real People Press, 1982.

19. Paul Broomhead, Jon B. Skidmore, Dennis L. Eggett, and Melissa M. Mills, "The Effect of Positive Mindset Trigger Words on the Performance Expression of Non-Expert Adult Singers," *Contributions to Music Education* (2010): 65–86; Paul Broomhead, Jon B. Skidmore, Dennis L. Eggett, and Melissa M. Mills, "The Effects of a Positive Mindset Trigger Word Pre-Performance Routine on the Expressive Performance of Junior High Age Singers," *Journal of Research in Music Education* 60, no. 1 (2012): 62–80.

20. Broomhead et al., "Junior High Age Singers."

21. Malva Susanne Freymuth, *Mental Practice and Imagery for Musicians* (Self-published, printed by Integrated Musicians, 1999).

22. Kato Havas, *A New Approach to Violin Playing* (London: Bosworth, 1961), 5.

23. William Trusheim, "Mental Imagery and Musical Performance: An Inquiry into Imagery Use by Eminent Orchestral Brass Players in the United States" (EdD diss., Rutgers University, 1987), 138.

24. Ibid., 142.

25. Ibid., 146.

26. Paul Severson and Mark McDunn, *Brass Wind Artistry: Master Your Mind, Master Your Instrument* (North Greece, NY: Accura Music, 1983).

27. Bassham, *With Winning in Mind.*

28. Lesley Ann Sisterhen, "The Use of Imagery, Mental Practice, and Relaxation Techniques for Musical Performance Enhancement" (PhD diss., University of Oklahoma, 2005); Richard M. Suinn, "Behavioral Methods at the Winter Olympic Games," *Behavior Therapy* 8, no. 2 (1977): 283–84; Richard M. Suinn, "Behavior Rehearsal Training for Ski Racers," *Behavior Therapy* 3, no. 3 (1972): 519–20; Richard M. Suinn, "Visual Motor Behavior Rehearsal: The Basic Technique," *Cognitive Behaviour Therapy* 13, no. 3 (1984): 131–42.

29. Susan Jeffers, *Feel the Fear and Do It Anyway* (New York: Ballantine, 1987), 43–45.

30. Pema Chödrön, *When Things Fall Apart* (Boston: Shambhala, 2002), 1–2.

5

Beta-Blockers and Anti-Anxiety Medications

While much progress can be made by assessing the psychological triggers of anxiety, many musicians still struggle with the physical side effects. It's not uncommon to overhear a mystified viola player complaining of a shaking bow arm or a flutist bemoaning the distraction of an emphatically pounding heart. Likewise, the pressures facing the performing musician can be emotionally overwhelming and psychologically debilitating, even with the aid of other therapies. Rather than wave the white flag, this chapter explores the relief some musicians have found in medicinal interventions and why the topic remains a sensitive subject.

BETA-BLOCKERS

Championed in the 1960s by Nobel Prize laureate for medicine Sir James Black, beta-blockers have been used extensively to offset the physical symptoms of stage fright, such as heart palpitations, hyperventilation, hand tremor, and nausea.[1] Nadolol (Corgard), alprenolol, oxprenolol (Slow-Trasicor), and propranolol (Inderal) are synthetic medications that block the effects of adrenaline and mediate the "fight or flight" response in the sympathetic nervous system by slowing heart rate, reducing blood pressure, and improving blood flow.[2] Theoretically, for the performing musician (or, really, anyone facing a pressured situation) this facilitates the maintenance of mental focus without all the impairing—and performance-compromising—physical symptoms of anxiety.

The first study investigating the use of beta-blockers by musicians was done in 1974 by Lidén and Gottfries. The researchers recruited nineteen professional orchestra musicians complaining of tremor, tension, and heart palpitations and assigned them to either a beta-blocker treatment group or placebo to be taken before a concert. Based on the self-rated anxiety reported by the musicians after the performance, it was

concluded that the beta-blocker not only helped to relieve the physical symptoms of anxiety but also bettered the musicians' concentration.[3]

These encouraging results caught the attention of another team of researchers, who investigated the effects of oxprenolol (a similar beta-blocker to alprenolol) on the stage fright of twenty-four musicians. Professional judges (who were also musicians themselves) were hired to assess performance quality before and after treatment, and it was agreed that beta-blockers had been pretty effective, especially in those with the most severe symptoms.[4] A comparable study found that not only was the quality of music performance bettered after beta-blocker use but the participants also reported a decrease in tension, stiffness, and tremor. Several more studies' findings also validate the effectiveness of beta-blockers in remedying physical symptoms, two of which specifically boded well for string players suffering from shaky bow arms.[5]

CONTROVERSY

Given all the accolades, it could be naïvely reasoned that the proverbial cure-all had been discovered: a "magic bean" of sorts to free even the most paralyzed of performers from physiological reflex. But in exorcising the demons behind what has been casually referred to as the jitters, some researchers and musicians believe the artistic spirit becomes a casualty in the process.

Barry Green, author of *The Inner Game of Music*, along with Don Greene, retired Olympic-diving-turned-audition coach, both describe musical performances on beta-blockers as technically sound but otherwise "soulless" and "inauthentic."[6] Angella Ahn, violinist for the Ahn Trio, suggests that some musicians on these medications can lack a noticeable intensity.[7] Robert Barris, former member of the Dallas and Detroit Symphony Orchestras, adds, "No one wants to listen to a secure, accurate, but disconnected performance."[8] Barris encourages his students to address the root of their anxieties instead and by means of holistic treatments over the convenience of the "quick fix" afforded by beta-blockers.

Since their application as a treatment for stage fright was first introduced in the late 1970s, musicians have been discreetly integrating beta-blockers into their preperformance routines. Given the controversy posed by their use, however, and the lingering stigma of what some view as an "unfair advantage," not everyone is open to discussing their personal experiences with the drugs. "Inderal is like Viagra," a professional woodwind player interviewed by the *New York Times* claimed.[9] And as of 1987, more than a quarter of professional symphony orchestra musicians admitted to using them.[10]

SURVIVAL OF THE FITTEST

Considering that the thrill of live performance—both experiencing and delivering it—should presumably not parallel the terror of a life-threatening situation, some performers argue that taking beta-blockers is simply a means of survival. But Dr. Jacque-

line Slomka in her article for the *Hastings Center Report*—a publication that discusses ethical issues in medicinal and health practices—suggests that beta-blocker use may be regarded as unfairly leveling the playing field that ability and work ethic otherwise clearly define. Success under pressure should be the result of diligent effort and drive, some may contend, and not by "taking the easy way out" in supplementing one's preparation with a pill.[11] Or, as Sara Sant-Ambrogio, cellist for the Eroica Trio, so frankly puts it, "If you have to take a drug to do your job, then go get another job."[12]

Yet, asserting that the use of beta-blockers ensures thousands of hours in preparation are protected from physiological annoyances is an opinion with which many would take issue. Kenneth Mirkin, a career violist for the New York Philharmonic, attributes his success in landing the position on the ten milligrams of beta-blockers he took an hour before the audition. As a student at Juilliard, Mirkin was relentlessly afflicted by a shaking bow arm that often landed him in the last seat of the viola section—that is, until he sought the help of beta-blockers. Mirkin claims, "I never would have had a career in music without Inderal."[13]

Opinions aside, what does scientific research say about the "zombifying" effect of beta-blockers? Are they the equivalent of what steroid use is to athletes? Can you get hooked? Are the side effects really so extreme that they do more harm than good?

Dr. Charles Brantigan, a vascular surgeon in Denver who also plays tuba with the Denver Brass, doesn't think so. In his research specifically focused on the use of beta-blockers by classical musicians, Inderal was simply shown to lower blood pressure and heart rates enough to negate their imposition on otherwise sound performances.[14] People who do experience adverse side effects, such as the fatigue that can be attributed to a "lifeless" performance, may simply be taking more than the appropriate dose. The most extreme cases of unpleasant side effects (e.g., depression, hallucinations, and sleep disturbance) were only observed in studies where patients received daily doses of 160 milligrams of beta-blocking medication, which is nearly eight times what Brantigan suggests is the recommended dose for the musician treating performance anxiety.

Preston Hawkes, concertmaster of the New England Symphonic Ensemble, vouches for the benefits of beta-blockers when the correct dose is taken. "The side effects are minimal," he tells the *Strad Magazine*. "With the right dose . . . I do not get dozy, nor do I feel mentally or emotionally disconnected. With the adrenaline under control, I still feel the excitement of being on stage, but never the debilitating effects of muscle locks."[15]

Furthermore, unlike steroids, beta-blockers are not used for enhancement so much as enablement. They do not create technical ability that hasn't been rightfully earned in the practice room, as demonstrated in studies that assessed the improvement or deterioration of fine motor skills versus basic motor function.[16] Flutist Emily DePalma, a music student at DePaul University, summarizes her stance on the beta-blocker ethics debate:

> Steroids make an athlete stronger, and thus better able to swing a bat, or throw a ball. However, it is impossible for beta-blockers to increase a player's technical abilities, if the skills are not already present. These skills are only present due to decades of practice

and to a lesser extent, talent, both of which science is currently unable to replace with a pill. Furthermore, beta-blockers only enable technique if there were physiological symptoms previously hampering already present technique, such as hand tremors and lack of saliva flow. This may seem a minor discrepancy, but is crucial in understanding that beta-blockers do not *create* good technique, but merely remove the physical symptoms inhibiting *already present* technique.[17]

In a 1986 study of competition pistol shooters, data evidenced an advantage for shooters who took beta-blockers to counteract hand tremor. Justifiably, then, the drug was banned from use in the sport, as performance and success is based entirely on physical aptitude. However, as long as music remains an endeavor of artistic merit, asserts Dr. Rosenthal, a neurosurgeon and hornist, "objected by subjective standards instead of hitting bulls-eyes, these factors should probably not apply."[18] Considering the perfectionist standard set by the recording industry and the continued progression of producing increasingly "perfect" performance artists, this statement may be outdated when orchestral auditions and competitions assume Olympic-level rubrics and start awarding metaphoric medals solely for sake of technical execution.

Rosenthal makes a pointed argument in asking how we would view the accomplishments of distinguished artists if we learned of their use of beta-blockers to manage the pressures of their careers:

> Many musical giants including [Vladimir] Horowitz and [Arthur] Rubinstein are recognized to have suffered disabling performance anxiety. Does this diminish our respect for their musical accomplishments? The musician who emulates fictional characters incapable of experiencing such fear, such as James Bond, probably suffers more profound problems than performance anxiety.[19]

Gerald Klickstein, performer, educator, and author of *The Musician's Way*, suggests that any condescension or judgment toward those who benefit from beta-blockers is unfounded. He told staff writers for the *Strad Magazine*, "I would like to see us destigmatize beta blockers so that the musicians who are having on-stage difficulties and have tried many things that haven't worked can explore taking these drugs under medical supervision without feeling ashamed."[20]

Cellist Adrian Bradbury agrees that the need to support fellow musicians in their quest for secure and enjoyable performances is only fair. "I'd never judge a musician by their choice of stage-fright intervention," he explains. "The judgment that really counts is how well they play, and if beta blockers help someone to overcome stage fright, then, medical safety permitting, so be it."[21]

ANTI-ANXIETY MEDICATIONS

Benzodiazepines, or anti-anxiety medications, are drugs typically used to treat anxiety and depression but have also been successful in treating general apprehen-

sion, muscle tension, and gastrointestinal distress. They are also prescribed for the treatment of epilepsy and alcohol withdrawal or used as a sedative. Common brand names include Valium (diazepam), Xanax (diazepam), and Ativan (lorazepam). The medication communicates with neural receptors in the subcortical areas of the brain to stabilize mood and emotional balance, which in turn can prevent heightened arousal in some areas of the brain. Benzodiazepines primarily affect the limbic system—the central location for emotional processing—but because of its effect on the cerebellum, the drug also initiates full-body relaxation.[22]

Benzodiazepines have been criticized for reasons similar to beta-blockers but not without some substantiation: The Mayo Clinic lists more than one hundred side effects to Xanax compared to Inderal, which has only nine.[23] Anti-anxiety medications may cause drowsiness, loss of coordination, and dependency from regular use.[24]

The advantages of beta-blockers over benzodiazepines seem quite obvious when comparing their benefits and side effects; several studies have been conducted to compare the two treatment options, the first dating back to 1974. In this study, researchers compared propranolol (beta-blocker), diazepam (benzodiazepine), and a placebo in the treatment of twelve anxious participants. Half were bothered primarily by the physical side effects of anxiety, while the other half were more troubled by psychological disturbance. Results found that, although diazepam was more effective in relieving subjective emotional anxiety than propranolol or placebo, the beta-blocking drug was more successful in treating physical symptoms.[25] A similar study run a decade later also compared beta-blockers and benzodiazepines, and interestingly, researchers found diazepam worsened technical accuracy in string musicians, specifically tempo, rhythm, and intonation.[26]

The consensus is that benzodiazepines may offer more of a risk than they're worth—at least for those suffering from more physical symptoms of anxiety. The specificity of brand names in relation to anti-anxiety medications should be considered, however, as the ingredients of each medication differ and could possibly render different results.[27]

It's important to keep in mind that, while beta-blockers may keep your lips from quivering or your bow arm from shaking, or while anxiety medications may restore a sense of emotional control, neither medication comes with the magical ability to hit high Cs or an up-bow spiccato to rival Joshua Bell's. They also don't address the destructive thought patterns experts maintain to be the root cause of most physical symptoms of anxiety.[28] As scientists of substance abuse and addiction would attest, inappropriate drug use is commonly associated with avoidance of uncomfortable emotions and feelings that could better be dealt with through therapy.[29]

That being said, if you choose to explore a medicinal option, amateur violinist and clinical pharmacologist Donald Singer stresses the importance of consulting your physician for the appropriate dose of the right medication: "Try a low dose *under the advice of your doctor* and work up if you need to, and always try them under rehearsal conditions first. Being made too relaxed or having unwanted effects could give a nasty surprise when your performance really matters."[30]

SUMMARY AND CONCLUDING THOUGHTS

Medicinal treatments are effective in alleviating physical manifestations of music performance anxiety, including increased heart rate, blood pressure, perspiration, and muscle tremor. Beta-blockers may be most helpful to individuals whose symptoms are less cognitive or psychological but center more in somatic responses. They may also be an effective complement to cognitive behavioral therapy for individuals who experience both physical and psychological symptoms.

While the use of drugs in musical performances does not carry the same stigma as in athletics, there are certainly still concerns with using drugs to influence musical performance. In addition to possible side effects, larger doses may inhibit a performer's energy, capability, and expressiveness. It is possible that performers may require lower doses in subsequent performances as self-confidence is developed.

Benzodiazepines, or anxiety medications, have been found to be less effective for the treatment of performance anxiety and also run the risk of chemical dependency. Experts suggest, therefore, that the potential risks of benzodiazepines outweigh the advantages. One should also remember that physical symptoms of stage fright are often caused by psychological concerns; therefore, addressing negative thought patterns may be more effective than relying on a medicinal "Band-Aid" to cover up a deeper fear that is never truly addressed.

Historically, music has been viewed primarily as an artistic pursuit, and therefore, the use of drugs to reduce anxiety has not been perceived as an unfair advantage. However, as perfectionism and virtuosity increase among performing artists, the use of beta-blockers to enhance performance may become more controversial.

Every performer comes to the stage with a unique mix of patterns, behaviors, and physical characteristics. While beta-blockers may be helpful to some performers, others might benefit more from practicing relaxation techniques or engaging in a blend of complementary therapies. We leave this up to each performer to determine, perhaps with the help of a therapist or performance coach. In the case of medicinal therapies, our only recommendation is to consult with a physician and never to use beta-blockers or other drugs without a doctor's recommendation. The unauthorized dispensing of prescription drugs is illegal and dangerous, and it is best left to doctors and pharmacists to work one on one with individual patients to account for correct dosage, potential side effects, and drug interactions.

We encourage our readers to first consider more individualized needs, addressing actual causes of anxiety rather than merely blocking the body's natural chemistry and working through stress without appropriate long-term interventions. In the chapter that follows, we introduce a number of natural approaches that may offer more universal, long-term relief and even promote a sense of well-being in music performance and beyond.

FROM THE STAGE: ANGELLA AHN

Violinist, Ahn Trio, and
Assistant Professor of Violin and Viola,
Montana State University

First of all, you have to be prepared. If you're not prepared, you're going to be unsure. Being unsure onstage is probably not something any performer wants to experience. You can't just be prepared 100 percent. You have to prepare 200 percent because you don't know what's going to happen when you get onstage. Your legs can shake. Your arms can shake. But if you're overly prepared, even if you completely panic you will go on automatic.

I tell my students that once they are well prepared and ready to perform, it's important to visualize the entire experience. This doesn't mean just standing onstage and playing through the piece. Visualize getting ready. Putting your concert clothes on, collecting your instrument, leaving your house. Visualize walking into the building, into the backstage area of the hall. Visualize the actual hall: what it looks like and who the audience is. Visualize walking out center stage, taking a bow, playing the piece. Try to feel the actual performance. Visualize the entire experience until you're back at home at the end of the night.

Figure 5.1. Angella Ahn, violinist. *Photo courtesy of Arthur Elgort*

I give my students breathing, meditation, and mindfulness exercises. Everyone has performance anxiety to some degree. No matter how prepared you are, you're going to have different kinds of feelings during performances, whether they are small butterflies in your stomach or complete terror. It's best to be prepared for how you're going to deal with it.

Let's say you're playing through a piece and all of a sudden your mind goes blank, or somebody in the audience coughs and you get distracted. What kinds of things can you do to get back on track? Being prepared and being mindful are good, but there are also exercises and tools to help you get through these difficult moments.

Learning to talk to yourself is helpful. Say there is an especially tricky passage in a piece, you've practiced it over and over, and still every time you get to this place your fingers get sticky with sweat and you get tense. What can you do? How about saying, "OK fingers, you know what to do. We've done this passage a hundred times." We work on getting to that point where you can easily have a conversation with yourself (or your fingers). It's like those little characters on either shoulder: "You can do it!" "No you can't!" It's important to know how to get rid of your own doubt. This takes practice.

The other important thing to remember is that making mistakes is part of a live performance. It's never going to be the same as when you're in a practice room. I remind my students constantly to find joy in what they're doing. To have fun. How lucky are we to get to re-create something a genius composer wrote two hundred years ago? One hundred years ago? One year ago? It's unfortunate that we often forget why we're playing music in the first place. We play music because we love the process of learning something beautiful and sharing that beauty with others. Try not to forget this just because there is a difficult section in the piece.

Joy is my number-1 word for my students. Find the joy. Find the passion. Remember why you're doing it. If you make a mistake, immediately forget it. Move on. I know it's easier said than done, but it's important not to dwell on something that can't be fixed. Let it go.

These are really life lessons. You can't dwell on your past. You must live in the present and you can't worry about the future. If you're enjoying the moment—the present, exactly what's happening in that moment, the beautiful passage that you're playing right now—I know you'll be less distracted.

Say you're so anxious that it's impossible to focus on finding the joy; this is when your breathing exercises come in handy. Sometimes with my freshmen students, we spend the bulk of the first several lessons just breathing. Then we graduate to open strings while breathing. I teach them to breathe, to get to that place where they're not thinking about anything except the weight of their arms, how the back is supporting them, how the head rests. I'm not an Alexander-certified teacher, but I encourage my students to incorporate breathing and mindfulness into their playing. If you can't find the joy because you're onstage and terrified, then you want to able to go to the place where you take deep breaths as you let go of the tension and the fear. It takes a lot of practice, but it's worth working on.

What we performers do is so detailed; everything has to be absolutely precise. We are trained to be self-critical—more so than other fields. We train ourselves to be

unsatisfied, always wanting to do better. We want the high E to be more in tune or the impossibly long note to ring perfectly. This is OK, but we must not forget the reason for playing music in the first place. As a more experienced musician, I can help my students to overcome the feelings of anxiety. We can learn life lessons from what kind of musicians we are. Instead of being critical of yourself, be positive about the things you're doing well. Instead of complaining about how difficult something is, try to change your attitude and find solutions. Being negative doesn't help you in life; it also doesn't help with violin playing. Practice being positive and, remember, no judgment. Find joy in what you do.

NOTES

1. Virginia Dee Hingley, "Performance Anxiety in Music: A Review of the Literature" (DMA diss., University of Washington, 1985); Ian Popple, "How Beta-Blockers Came to Be," *McGill Reporter* 37, no. 3 (October 14, 2004), accessed April 30, 2016, https://www.mcgill.ca/reporter/37/03/black.

2. "Drugs and Supplements: Propranolol (Oral Route)," *Mayo Clinic*, last modified January 1, 2016, accessed April 30, 2016, http://www.mayoclinic.org/drugs-supplements/propranolol-oral-route/side-effects/drg-20071164.

3. Sture Lidén and Carl-Gerhard Gottfries, "Beta-Blocking Agents in the Treatment of Catecholamine-Induced Symptoms in Musicians," *Lancet* 304, no. 7879 (1974): 529.

4. I. M. James, D. N. W. Griffith, R. M. Pearson, and Patricia Newbury, "Effect of Oxprenolol on Stage-Fright in Musicians," *Lancet* 310, no. 8045 (1977): 952–54.

5. C. O. Brantigan, T. A. Brantigan, and N. Joseph, "Effect of Beta Blockade and Beta Stimulation on Stage Fright," *American Journal of Medicine* 72, no. 1 (1982): 88–94; Ian James and Imogen Savage, "Beneficial Effects of Nadolol on Anxiety-Induced Disturbances of Performance in Musicians: A Comparison with Diazepam and Placebo," *American Heart Journal* 108, no. 4 (1984): 1150–55; Klaus Neftel, Rolf H. Adler, Louis Kappeli, Mario Rossi, Martin Dolder, Hans E. Kaser, Heinz H. Bruggesser, and Helmut Vorkauf, "Stage Fright in Musicians: A Model Illustrating the Effect of Beta Blockers," *Psychosomatic Medicine* 44, no. 5 (1982): 461–69.

6. Blair Tindall, "Better Playing through Chemistry," *New York Times*, October, 17, 2004, accessed May 1, 2016, http://www.nytimes.com/2004/10/17/arts/music/better-playing-through-chemistry.html?_r=0.

7. Ibid.; personal communication, May 1, 2016.

8. Ibid.

9. Tindall, "Better Playing."

10. Ibid.

11. Jacquelyn Slomka, "Playing with Propranolol," *Hastings Center Report* 22, no. 4 (1992): 13–17.

12. Tindall, "Better Playing."

13. Ibid.

14. Ibid.

15. "Is Popping Pills the Sure Way to Beat Performance Nerves?" *Strad Magazine*, last modified November 1, 2013, accessed April 30, 2016, http://www.thestrad.com/cpt-latests/is-popping-pills-the-sure-way-to-beat-performance-nerves.

16. Emily DePalma, "Beta Blocker Usage among Musicians: Removing the Stigma and Encouraging Education," research paper for DePaul University, last modified November 12, 2014, accessed May 1, 2016, https://depaul.digication.com/removing_the_stigma_from_betablocker_use/Research_Paper; Jacqueline Nube, "Beta Blockers: Effects on Performing Musicians," *Medical Problems of Performing Artists* 6, no. 2 (1991): 61–68.

17. DePalma, "Beta Blocker Usage," para. 9.

18. P. Rosenthal, "Inderal for Performance Anxiety: Better Living through Chemistry or Bargaining with Satan?" *Horn Call: Journal of the International Horn Society* 30, no 3 (2000): 70.

19. Ibid.

20. "Is Popping Pills the Sure Way?"

21. Ibid.

22. Michael O'Neil, ed., *The ADA Practical Guide to Substance Use Disorders and Safe Prescribing* (Malden, MA: John Wiley and Sons, 2015), 69.

23. "Drugs and Supplements: Propranolol." According to the site, these common symptoms include anxiety, dry mouth, hyperventilation, irritability, restlessness, shaking, sleepiness or unusual drowsiness, trouble sleeping, and unusual dreams. The site also lists more serious side effects that require immediate medical attention, including cough producing mucus, difficulty breathing, and tightness in the chest.

24. Karl Rickels, W. George Case, Robert W. Downing, and Andrew Winokur, "Long-Term Diazepam Therapy and Clinical Outcome," *Journal of the American Medical Association* 250, no. 6 (1983): 767–71.

25. P. J. Tyrer and M. H. Lader, "Response to Propranolol and Diazepam in Somatic and Psychic Anxiety," *British Medical Journal* 2, no. 5909 (1974): 14–16.

26. James and Savage, "Beneficial Effects."

27. Ibid.

28. Daniel Gould, Robert Weinberg, and Allen Jackson, "Mental Preparation Strategies, Cognitions, and Strength Performance," *Journal of Sport Psychology* 2, no. 4 (1980): 329–39; Graham E. Powell, "Negative and Positive Mental Practice in Motor Skill Acquisition," *Perceptual and Motor Skills* 37, no. 1 (1973): 312; Robert L. Woolfolk, Mark W. Parrish, and Shane M. Murphy, "The Effects of Positive and Negative Imagery on Motor Skill Performance," *Cognitive Therapy and Research* 9, no. 3 (1985): 335–41.

29. Steven C. Hayes, Kelly G. Wilson, Elizabeth V. Gifford, Victoria M. Follette, and Kirk Strosahl, "Experiential Avoidance and Behavioral Disorders: A Functional Dimensional Approach to Diagnosis and Treatment," *Journal of Consulting and Clinical Psychology* 64, no. 6 (1996): 1152–68. See also Steven C. Hayes, Kirk D. Strosahl, and Kelly G. Wilson, *Acceptance and Commitment Therapy: The Process and Practice of Mindful Change* (New York: Guilford Press, 2011).

30. "Is Popping Pills the Sure Way?" para. 10, emphasis added.

6

Natural and Holistic Approaches

In recent decades, the United States has witnessed a surge in popularity of alternative and holistic approaches to wellness. Many of these methods are timeless, stemming from Eastern and indigenous cultural practices that precede modern medicine. The philosophy of alternative medicines is grounded in maintaining a general state of well-being and aiding the body's own natural healing process, in contrast to traditional Western medicine that is primarily concerned with treating symptoms of disease.[1] Published research on the effects of alternative medicine is not as prevalent when it comes to music performance anxiety; however, we introduce several approaches here because of their noted success in helping many individuals reduce general anxiety, gain mind-body balance, or enjoy overall wellness.

EXERCISE AND DIET

Let's start with the basics: Of course, we know we feel better in a whole host of ways when we eat right and get up and move our bodies. However, diet and exercise are two things that busy performing artists and teachers often neglect. No matter your choice of other approaches for managing MPA, you may find it beneficial to start here and to supplement any other strategies with good, old-fashioned self-care.

Exercise has been called a "highly promising treatment for anxiety."[2] The anxiety-reducing effects of exercise are well known,[3] and research suggests that aerobic exercise may even be as effective as anti-anxiety medication.[4] Based on a thorough review of related research, exercise scientists from Arizona State University and the University of Maryland have suggested that at least twenty-one minutes of exercise is needed to reduce both state (temporary, situational) and trait (enduring, dispositional) anxiety.[5]

The US Office of Disease Prevention and Health Promotion recommends at least 150 minutes of exercise per week for full health benefits.[6]

Here's an added bonus for those battling an endless cycle of self-defeating thoughts: How about spending some time in nature? Recently, researchers from Stanford and Sweden discovered that study participants who walked for ninety minutes in a natural setting with grassland, trees, and birds experienced a reduction in thought rumination that was not similarly experienced by those who walked for the same amount of time in an urban environment.[7] This freedom from compulsive and repetitive thoughts was reported by participants directly and was also observed in brain scans.

Medical research on the effectiveness of diet (including herbal remedies) on anxiety reduction is mixed and complex,[8] and it is far beyond our level of medical expertise to diagnose any of our readers with particular dietary deficiencies or to recommend certain foods for certain people. With this in mind, we note a few general trends found between diet and anxiety as evidenced in scientific studies and other published resources, while also inviting you to consider working with a nutritionist to obtain recommendations that are personalized for your individual needs.

Different people will likely gravitate toward different foods with varied results. For example, anxiety is higher in women who cannot effectively digest gluten (wheat, barley, rye, and some oats),[9] and lifelong adherence to a gluten-free diet can result in reduced anxiety among gluten-intolerant people.[10] Meanwhile, men who are at risk of cardiovascular disease are more likely to experience anxiety from smoking and unhealthy eating habits,[11] and in women, the "traditional" diet of vegetables, fruit, meat, fish, and whole grains has been linked to a lower level of anxiety disorders than the "Western" diet of processed or fried foods, refined grains, sugary products, and beer.[12]

Speaking of alcohol, while some individuals use it as a means of temporarily reducing anxiety, documented research suggests that this is an unwise strategy: Prolonged alcohol use may actually lead to greater anxiety in the long term,[13] and medical researchers have recommend that people with anxiety disorders "should avoid alcohol altogether."[14] Avoidance of caffeine, found in coffee, tea, cola drinks, and some medications, may also help.[15] Researchers in Australia and the United States deemed lifestyle choices that include moderate exercise and avoidance of caffeine, alcohol, and nicotine as encouraging solutions for managing anxiety.[16]

Nutritionists may recommend eating foods rich in calcium, magnesium, phosphorus, potassium, and B vitamins to alleviate anxiety.[17] Alternative and holistic practitioners may encourage you eat organic foods and avoid certain additives, such as dyes and genetically modified foods (GMOs), which are currently banned in thirty-eight countries.[18] Some may further recommend herbal supplements (e.g., bilberry, milk thistle, catnip, chamomile, cramp bark, hops, linden flower, motherwort, passionflower, skullcap, and valerian root)[19] or aromatherapy (e.g., lavender, rose, orange, bergamot, lemon, sandalwood, clary sage, Roman chamomile, and rose-scented geranium).[20]

Results of any dietary approach may vary depending on body type and metabolism. According to Dr. Robert Baritz, a nationally recognized chiropractor, author, and speaker on holistic health and nutrition, the complexity of human bodies requires complex and natural solutions not offered by pharmaceutical drugs, where a focus on treating isolated symptoms may actually cause long-term detriment to the body's natural healing processes:

> Single agents (drugs) have a blunt effectiveness, overriding the body's natural balance to produce results. They work by blocking the natural complexity of human physiology and dictating an artificial regime. While drugs may be life-saving, they tend to weaken the body's natural control mechanisms over time, reducing health and producing unwanted side effects. The complexity of human physiology is well complemented by the complexity found in plants. Just as our bodies thrive on chemically complex foods, many physical problems respond well to the complexity of herbs.[21]

Pharmaceuticals such as beta-blockers, while potentially effective at reducing symptoms of anxiety, do not take into account a body's other needs or hormonal/nutritional imbalances that might be causing anxiety in the first place. Dr. Baritz explains, "Really it runs counter to the symphony of events that occur in the human body. Simply to send a storm trooper in and say, 'This is the way it's going to go,' that's not the most physiologically sound method of doing it. . . . When calming the anxious musician, it would probably be good to understand what the problem is [and work there]."[22]

Despite a history that spans thousands of years in Eastern cultures, the positive effects of herbal remedies on anxiety reduction are currently not as well documented by medical research[23] as are those for pharmaceutical drugs, perhaps due in part to the funding priority given to prescription medications. Varying results of herbal remedies may likely also be due to the unreliable quality and efficacy of herbal supplements that are available for purchase. Dr. Baritz lists a number of factors to consider in herbal quality, which include (but are not limited to) the quality and source of the plant; the part of the plant harvested; contaminants in the soil, air, and water where the herb was grown; freshness of the herb; and use of potential fillers or other cost-reducing chemicals.[24] For best effects, then, the highest quality of herbs is recommended.

Similar to the medicines discussed in chapter 5, the use of certain supplements without monitoring from a licensed doctor, nutritionist, chiropractor, or naturopath could lead to unwanted side effects, drug interactions, and dangerous levels of toxicity.[25] We encourage you to try certain supplements only under the care of a qualified practitioner and emphatically discourage self-medicating in any form, whether it be with pharmaceutical drugs, herbal remedies, alcohol, or recreational drugs. There are far too many safe strategies out there and far too many licensed practitioners to offer you help for anyone to resort to any potentially dangerous substance or unmonitored activity.

ACUPUNCTURE, ACUPRESSURE, AND TAPPING

For those of you who don't freak out at the sight of needles, you may be interested in acupuncture, which has been found to be effective with individuals with confirmed anxiety neuroses, especially when combined with behavioral desensitization therapy.[26] This traditional Chinese medicine, which involves the insertion of needles into specific points on the body, is regulated by the Food and Drug Administration in the United States to ensure certain standards of sterility and is recommended for use with qualified practitioners only.[27] There is at present no definitive research on the effectiveness of acupuncture for reducing anxiety symptoms for the general population, as more research is needed with larger samples.[28] However, millions of Americans use acupuncture each year to deal with pain and other related issues.[29]

If needles aren't your thing, then there are other similar options, including acupressure and emotional freedom technique (EFT), or tapping, which, once learned, can be practiced alone.[30] In her book *Energy Medicine*, Donna Eden offers various tapping strategies for emotional health, including an exercise for fear that involves tapping for one minute on the backside of the hand, "halfway between your wrist and fingers, aligned with the point where your fourth and fifth fingers converge,"[31] switching to the other hand if fear persists. A number of EFT videos and other acupressure resources are available online with a simple Internet search.

MASSAGE

Massage is the therapeutic manipulation of the body's soft tissue to promote relaxation, blood circulation, pain reduction, alertness, and immune function. It is one of the oldest forms of therapy in human existence and was one of the most popular forms of medicine in the United States until it was eclipsed by the pharmaceutical movement in the 1940s.[32] The medical benefits of massage are many and include (but are not limited to) reducing pain, headaches, and neuromuscular problems; enhancing attentiveness; assisting with immune disorders; and alleviating anxiety.[33] Researchers have also found it useful in dealing with burn injuries,[34] eating disorders,[35] pregnancy,[36] and the effects of sexual abuse.[37] Massage helps people relax in part through its effectiveness in lowering blood pressure,[38] reducing cortisol (stress hormone) levels,[39] and increasing levels of the "happy" neurotransmitters dopamine and norepinephrine.[40]

On a personal note: Karin swears by deep-tissue massage as a way to enhance her musical performances, as it keeps her muscles loose, mind focused, and breathing more relaxed. She finds that a deep-tissue massage approximately two days before a performance is optimal in that it allows enough time for the initial soreness that often follows a massage to go away but for the relaxation effects to still be delightfully present. Aromatherapy and self-administered foot massages are another viable option for reducing anxiety.[41]

Many massage therapists also offer services in energy work, such as Reiki, a Japanese hands-on, spiritual approach to relaxation,[42] or craniosacral therapy, developed by Dr. William Sutherland in the early-twentieth century to release memories of trauma stored in the body.[43] Research on the effectiveness of these energy approaches is limited, and while craniosacral therapy is presently questioned among the medical profession,[44] a recent meta-analysis of Reiki suggests that it may be effective in reducing pain and anxiety.[45] As the authors of this book know individuals who claim success with both approaches, we include them here for your consideration.

ALEXANDER TECHNIQUE

The effectiveness of biofeedback (discussed in chapter 3) has often been compared to that of the Alexander technique, a method of kinesthetic education in which a new model of poise is associated with verbal instructions and where habits of tension are challenged with intentionally directed action.[46] It is a favorite therapeutic method of orchestral musicians.[47] The technique was first developed by actor Frederick Matthias Alexander in the nineteenth century as a means to address his periodic hoarseness and respiratory trouble while performing. Tired of heeding advice to simply rest his voice (which he found only helped if he didn't perform), Alexander sought out his own cure, concluding that he must be doing something while reciting to cause the problem.

Alexander, like many musicians and performers, spent time in self-observance. Standing in front of a mirror, he noticed tension in certain parts of his body and poor breathing habits, which was evident not only when reciting but in ordinary speech as well. Alexander resolved to personally guide the redefinition of his default mannerisms, a concept he later coined as "use." Hilary King, a psychologist, former ballerina, and Society of Teachers of the Alexander Technique (STAT)–certified teacher, explains, use is the "habitual and characteristic manner in which a person moves and uses their body, all the time, whatever they are doing. . . . [It is] influenced by our thinking and by our emotions and to bring about changes in our use, we need to allow changes to take place in our thinking and reaction to things."[48]

The Alexander technique as a method advocates economy of effort and balance, helping participants to replace common practices of muscle tightness and restriction with more efficient and liberating habits, which can then be more easily channeled when under stress.[49] Instruction in the approach is offered at a large number of universities in their performing arts programs.[50]

Studies spanning the last four decades have validated the effectiveness of the Alexander technique in decreasing anxiety and improving attitudes and performance quality.[51] Meagan Johnson, American Society for the Alexander Technique (AmSAT)–certified teacher and instructor of Alexander technique at the Indiana University Jacobs School of Music, offers these insights:

> The Alexander Technique has allowed me, as a singer and conductor, to find the Use
> that best supports my musical work. Before Alexander Technique training, I suffered

from jaw and neck tension that led to chronic headaches and impaired my singing abilities, as well as back pain after conducting concerts. Now, I not only have "physical" freedom for energized breath, easy voice production, and strength in my back and arms for supported, expressive conducting, but also "mental" freedom: a calm presence without anxiety, and creativity that leads to more intentional music-making. It helps me as an educator as well, informing the way I teach my chorus singers and private students. Because the Alexander Technique can underlie all vocal and instrumental techniques, it is appropriate for musicians of all backgrounds, skills, and training.[52]

FELDENKRAIS METHOD

According to the Feldenkrais Educational Foundation and Feldenkrais Guild of North America, the Feldenkrais method is a "form of somatic education that uses gentle movement and directed attention to improve movement and enhance human functioning."[53] The approach helps individuals to become aware of tense habits and to develop an expanded repertoire of ways to move freely and flexibly. Advocates of the method suggest that work with a Feldenkrais teacher can lead to increased range of motion and improved flexibility and coordination and help you "rediscover your innate capacity for graceful, efficient movement."[54]

A number of studies have linked Feldenkrais practice to improved health and wellness, including decreased pain[55] and anxiety[56] as well as improved mobility,[57] balance,[58] perception of quality of life,[59] body awareness and attitudes,[60] and mood.[61] Although we are unaware of any research that directly investigates the connection between Feldenkrais and music performance anxiety, we note these general benefits, as well as the following music-specific literature, to suggest how the Feldenkrais method might be beneficial to musicians who are seeking greater ease and freedom in performance.

Baroque violinist and educational researcher M. Anne Rardin conducted a study of 130 high school string orchestra students, treating half of them to a ten-week intervention that consisted of pain prevention education and warm-ups based on Feldenkrais, Alexander technique, and physical therapy.[62] In comparison to the control group, those students who received treatment reported having reduced pain when they performed. Notably, these same students also reported increased tension, which Rardin suggests may have been a result of their increased *sensitivity* to body inflexibility because Feldenkrais and Alexander approaches increase awareness of rigid body states. This finding highlights the potential for Feldenkrais and the Alexander technique to complement other relaxation approaches, such as progressive muscular relaxation therapy (as described in chapter 3).

Stephen Paparo, choral director and assistant professor of music education at the University of Massachusetts Amherst, is a certified Feldenkrais practitioner who views the method as a means of promoting holistic awareness in singing. In his research with high school singers, he found that guided somatic exploration in choral rehearsals helped students "move beyond the traditional conception of the body as a

mechanical or technical component of performance toward a holistic understanding of [musical] embodiment."[63] Paparo found that students who enhanced their body awareness through Feldenkrais-based activities were able to identify and change unproductive habits, enhance singing development, reduce muscular tension, and sing with less effort.

Saxophonist Stephen Duke similarly notes the holistic awareness that is possible through musical embodiment and advocates Feldenkrais instruction as a means to promote freedom of expression and more natural musical performances:

> Seeing an action or a skill as an extension of the person exchanges traditional linear, right-or-wrong logic for a non-linear, spontaneous interplay. The quality of this inter-play is determined by the teacher's awareness of effortless action and the function of movement. With this awareness, the teacher leads the student to realize how to perform with greater ease and quality, and thus how better to do what the student intends.[64]

Duke also describes the importance of weight and breath awareness in the Feldenkrais method:

> Sensing your weight through your feet to the floor and feeling the quality of your breath are often used at the end of a lesson in the Feldenkrais Method. Before I perform, I make a point to check-in with how I feel my weight and breath as ways to become present and let go of tension. This simple routine taps into the awareness that one accumulates from studying the method.[65]

YOGA

Yoga is a spiritual, mental, and physical practice that originated in India and has gained popularity all over the world for its therapeutic capacity to alleviate stress, anxiety, mood disturbance, and musculoskeletal problems. As music performance is largely dependent on the execution of motor skills, yoga offers a particularly applicable mode of therapy for those with music performance anxiety due to its emphasis on physical balance and stretching.[66]

In preliminary research on yoga as an intervention for music performance anxiety, Dr. Sat Bir S. Khalsa and colleagues found yoga-practicing musicians to have a significant reduction in solo performance anxiety in comparison to a control group.[67] In a later study, stage-frightened conservatory students evidenced a significant reduction in music performance anxiety after a nine-week yoga camp.[68] Khalsa and colleagues have also found promising results when pairing yoga with meditation.[69]

Like meditation, the effectiveness of yoga in the treatment of anxiety aside from musical performance is well established. While research specific to music is limited, the findings of existent studies are still valid in demonstrating its promise as a treatment for musical artists. Any therapy that promotes inner serenity and the

psychological equipment with which to maintain it would be of powerful benefit to performing artists of all fields. Metropolitan Opera singer Cynthia Lawrence shared with us the role that yoga plays in her preperformance preparation:

> I understand that I'm not the best at yoga but the yoga that I do is based on breath, on core, and centering. As I work through my Yoga routine I try to find the tension points, and then let them go. I address them by stretching and breathing. Eventually it balances you. Then any performer can go out on stage and can play the entire sonata or the etude or singing half of an aria standing on one foot and nothing is a problem. So that's why I do it, and that's how I've always done it.
>
> [Yoga] is a whole core exercise, and it's amazing what happens when you're in a warrior or a tree pose, or a long extended breath, lift and release with the core energized and balanced. It's amazing how long your phrases become. I'm not singing full out during Yoga, but what I'm doing is managing breath and managing energy. That always centers my body and my brain to be able to receive what I ask it to do in the rehearsal and in the performance venue.
>
> The other thing about yoga is that you find the point of tension: your jaw, your neck, your head, the middle of your brain. Can you feel the tension in the middle of your brain? Absolutely. Can you feel it in your gut, core, ribs, back, shoulders, fingertips and joints? Yes, you can. If you do yoga regularly, you'll understand what the routine is. I do it outside of performing as well, but I absolutely do it before performing and rehearsing.[70]

MEDITATION

Meditation is a practice rooted in the principle of self-regulating the mind. While the definition and purpose of meditation varies across religious practices and spiritual contexts, it generally promotes relaxation, spiritual balance, and a steadfast sense of well-being, even in the face of chaotic or nerve-racking circumstances. Just as progressive muscular relaxation trains us to proactively identify and mediate physical tension, meditation works in a comparable way by empowering the mind to manage intrusions spanning from trivial distraction to anxiety, fear, panic, and anything that may compromise our inner peace.[71]

To meditate effectively takes a honed sense of discipline only attained through diligent practice, but even beginners can benefit from training, especially those facing uniquely stressful situations like performing. Psychologist Gary Schwartz agrees, explaining that the mental and physical state of being relaxed but alert as attained in meditation is ideal for performance, as it allows the performer to focus on the technical without disengaging from the artistic.[72]

In her 2005 review of music performance anxiety therapies, music psychologist Dianna Kenny mentions that, of the thousands of studies conducted on meditation, only one evaluated its effectiveness in treating music performance anxiety.[73] In this early investigation on the topic, "Effects of Meditation on Music Performance Anxiety," authors Joanne Chang, Elizabeth Midlarsky, and Peter Lin recruited music students from

the Manhattan School of Music, Mannes College of Music, Yale, and State University of New York Purchase for a study involving a series of eight meditation classes over a two-month period. Those who participated in the meditation classes showed a significant reduction in music performance anxiety in comparison to those who didn't.[74]

A follow-up to this study, however, revealed an intriguing finding: *Both* groups (meditation and nonmeditation) experienced heightened anxiety in the performance, yet those in the meditation group performed with better quality. The authors concluded that "enhanced concentration . . . cultivated by [meditation] might enable one to channel performance anxiety to improve musical performance."[75] This is a crucial insight yet likely not surprising to those who practice meditation: Many meditative approaches emphasize that fear is not something to eliminate but something to face head-on, know intimately, and even embrace. Tibetan Buddhist nun Pema Chödrön explains, "What we are talking about us getting to know fear, becoming familiar with fear, looking it right in the eye—not as a way to solve problems, but as a complete undoing of old ways of seeing, hearing, smelling, tasting, and thinking."[76]

The relationship between music performance anxiety and mindfulness—or the practice of noticing one's internal and external experiences in the present moment— is fascinating yet complex. According to Dr. Frank Diaz, associate professor of music education at the Indiana University Jacobs School of Music, not everyone is equally affected by meditation practice, and effects may not be long lasting. And similar to the finding described earlier, meditation effects may not be as much about anxiety *reduction* as they are about anxiety *redirection.*

In one of his early mindfulness studies, Dr. Diaz observed how people responded to music they heard after engaging in a fifteen-minute mindful body scan meditation.[77] What he found interesting was the fresh, new way that listeners approached music following meditation. He reports:

> They felt like this was music they had heard so often, but all of a sudden, because the exercise they had just done, they were more inclined to hear things that they had not heard before. So their enjoyment came from this novel response, what I call the ability to "reset," and not look at something habitually. So it's not so much to do with performance anxiety, but more to do with changing your disposition toward your experience.[78]

This insight led Diaz to investigate how mindfulness practice might affect performance anxiety, including among individuals with a tendency toward social perfectionism (or a fear of being judged by others, as we explained in chapter 2). Considering mindfulness as both an innate and learnable trait, Diaz set out to answer two questions. The first: "If you're predisposed to be mindful, how does that affect your performance anxiety and your social perfectionism?" His answer: "People who are more mindful are less anxious, and they're less worried about what people think about them. So their perfectionism is still there, and they can still be self-critical, but they're not necessarily worried about what other people think about them."[79] In other words, the naturally mindful folks were able to separate their musical perfectionism from a fear of social shame.

Diaz's second question involved those who might not be naturally mindful but who practiced such mindfulness exercises as meditation, prayer, or tai chi before performance. How did mindfulness training affect these individuals? Not nearly as effectively: The study yielded no significant relationship between mindfulness practice and a mindful disposition.[80] Diaz concluded that meditation practice might foster mindful qualities *while* meditating but that the effects are neither long lasting nor transferred to performance situations unless a person already has a mindful disposition. This might suggest that one can't merely try on a meditation exercise and be "cured" of performance anxiety; one must foster mindfulness as a way of life.[81]

It all boils down to this: First, a disposition for mindfulness can be developed through devoted practice in various ways that work best for each individual. Second, those with a mindful personality are more successful in managing performance anxiety—not by reducing the stress itself but by *redirecting* that energy into something positive and productive. Finally, meditation is much more likely to be a successful means of managing MPA among those who practice it as a part of a mindfulness *lifestyle* and not merely as a quick fix before a performance. This should not surprise us: After all, a brief fifteen-minute exercise is unlikely to counteract the effects of a lifetime of practicing self-defeating thoughts. To be effective, mindfulness practice must carry over into all aspects of our life, permeating the ways we think and act. Then, as many who have developed a mindfulness approach can attest, the benefits may likely extend far beyond music performance.

SO, TAKE A DEEP BREATH . . .

Natural and holistic approaches, along with nearly every other MPA management strategy, are most effective when extended beyond the practice room or performance venue to become a way of life. Researchers tell us this, as do the artists in our "From the Stage" series: Angella Ahn reminds us that "these are really life lessons," while Cynthia Lawrence suggests that "taking care of our . . . health and mental peace is what will keep us performing and teaching for a very long time."

No matter what strategies you implement, you will undoubtedly agree that nothing is more innately connected with our lived experience than breathing. Fundamental to relaxation, breathing is an underlying theme among the therapies and approaches we share in this book. It is also a common thread among the performing artists we consulted when writing this book: Trombonist Jeremy Moeller focuses on breathing during his fifteen-minute morning meditation, soprano Cynthia Lawrence uses yoga to manage her breath, and saxophonist Stephen Duke focuses on his breath to become more present and relaxed before he performs. Angella Ahn considers breathing so crucial to violin and viola playing that she devotes the majority of the first few lessons with new students to teaching them to breathe when they play.

Breathing is fast, shallow, and centered in our chest when we are stressed and anxious; on the other hand, the friend of relaxation is deep, slow breathing that centers

in our belly.[82] In addition to the many strategies we have mentioned—which, if you tried them all, could lead you on quite a liberating journey with the breath—there are a number of resources directly associated with breathing that we recommend in chapter 9. In the meantime, as you read on, we invite you to take note of your breath without judging yourself or trying to change it and just be aware of the quality of that breath. Rather than trying to breathe "perfectly," just notice where you are right now. As breathing expert Dr. Gay Hendricks[83] would invite you to do, you might simply say to yourself, "Hmm, I wonder what it would be like to breathe with ease." And just let that question be.

ACTIVITY: BODY AWARENESS

Reflection for Awareness: Body Scan

The following exercise expands on the third type of flash scan that was introduced in the chapter 2 activity. There we suggest that you quickly check your body from head to toe to notice any discomfort, stress, pain, or agitation. In this activity, we take a different approach. We slow down the process in order for you to be able to become more aware of the areas where you are feeling well, relaxed, healthy, and fully of vitality as well as the opposite. This is important so that you understand the parts of your body where you may be habitually holding stress and pain as well as the areas of your body that tend to feel healthy and strong. Having a deeper awareness allows you to have more information about your experience as it changes in various situations.

1. Find a safe space where you can be undisturbed for at least fifteen to twenty minutes. Lie down on the carpet, a yoga mat, the grass, or any other place where you can do so comfortably.
2. Close your eyes, and take a few deep breaths. With each one, release your awareness of the outside world and other people near you or with whom you have recently interacted.
3. Start by noticing the top of your head. Notice if there is any tension or pain or if it feels open and relaxed. Release any tension or pain as you breathe out. When you feel ready, move on to each part of your body (forehead, ears, jaw, eyes, nose, neck, etc.), slowly repeating this process of noticing and releasing with the breath. This activity can be expanded by noticing each and every part of the body or shortened if needed by focusing on more general areas of the body.
4. Once you have traveled down through the entire body and ended with the bottom of your feet, take a few minutes to just enjoy the relaxed state you are in. When you are ready, gently open your eyes.
5. Take a few minutes to write down anything you noticed about this experience. Were there areas that felt especially healthy? Were there areas where you were

holding tension? Were you in any pain? Do you feel healthier than the last time you did a body scan?

6. Repeat this exercise regularly when you can as a way to monitor your overall wellness, and start to note any patterns or changes.

Application and Integration to Practice: Deep Scans

Now that you have taken the time to do slow and detailed scans of your body, it is more likely that, when you do flash scans, you will gather more information about your body due to your expanded awareness. As you go about your routine of individual practice sessions, group rehearsals, ensemble rehearsals, and performances, find moments that serve as regular cues to conduct a deep scan (described below). For example, you could do one whenever you are sitting in rehearsal waiting to play, you could set a timer to remind you to conduct a scan halfway through your practice session, or you could do one when you are putting your instrument back into the case. Find moments when it works best for you and can be done so easily and regularly.

1. Do a flash scan but in slow motion. A deep scan might take ten to thirty seconds. Notice any areas where you are holding tension or pain, and let them go with the out breath. If you need to stretch or move your body, do so as you are able.
2. The more regularly you establish this habit, the more aware you will become and the more opportunities you will have to reset your body, which can lead to improved overall wellness.

JOURNEYS: TURKEYS, POWER POSES, AND THE "FLUSH" OF VULNERABILITY

By Karin

My New England home is on the edge of several acres of woods. As a result, I have all sorts of animal neighbors, including foxes, coyotes, white-tailed deer, and eighteen wild turkeys who frequent the feeders that are intended for much smaller birds. The turkeys are magnificent and strange creatures that look both ridiculous and menacing as they strut around the yard, peck at the ground, and then fly onto tiny tree branches that nearly break under their massive weight.

Presiding over the congregation of turkeys is one particularly fascinating bird, whom I have naturally named Tom. He is very easy to pick out from the crowd, as he puffs up his feathers and opens his back tail fan to make himself look twice his actual size. Tom appears to move in slow motion in these moments of self-aggrandizement, with those tiny, wrinkled, plodding feet scarcely noticeable in comparison to the smooth, flowing motion of his feathered body.

Tom is the king of the backyard—that is, until I peek through the patio door to capture a picture of him. Once he notices me with my camera, his feathers drop and the puffy form deflates so that he no longer stands out from the rest of the group. Perceiving me as an enemy, he transitions from his dominant posture and demonstrates one of the "fight, flight, or freeze" responses to fear by either flying away, stiffening, or preparing to attack. I step back, give Tom his space, and attempt the photo again through a less obvious window. Eventually his feathers rise again, and he resumes his regal stature as he watches over his rafter of hens.

Not only do humans similarly experience fight, flight, or freeze in fearful situations, but we also routinely hold our bodies in positions of power or powerlessness. As Amy Cuddy explains in her TED talk and book *Presence*, the way we carry ourselves when interacting with others says much about the power we carry or give away: An open and outstretched stance signals power, while a closed or tight position signals weakness.[84]

The exciting part about Cuddy's research is that, while we carry our bodies in response to how we feel, we can conversely *change how we feel* by changing the way we carry our bodies. Find yourself in a position of retreating inward while talking with a domineering alpha? Just strike one of Cuddy's "power poses" (my favorite is to imitate Peter Pan, with hands on hips and feet spread shoulder width). After two minutes in this new stance, hormone levels will have literally changed so that you're not only looking powerful but also *feeling* powerful.[85]

Over the past year I have experimented with power poses in various settings, such as public performances, faculty meetings, and even wine and cheese receptions. Whenever I find myself standing in a protective position (arms folded and stomach tightened), I now slowly open up my arms, extend my stance, and gently exhale. With a breath, a bit of movement, and a shift of intention, my body opens up to a state of ease. Sure enough, within minutes I forget all about the power pose exercise and find myself naturally interacting with a crowd—even taking surprising yet liberating risks in performance or in conversation.

Shifting from a pose of powerlessness to one of power is an emboldening experience. However, in workshops I lead, I have learned to alert others to what I call the "flush," or a rush of hormones that can fill the body when we shift from a "freeze" position to one that is indeed more powerful—yet also more vulnerable. For just a moment, the sensations of pulsing heart and trembling legs might get worse before they get better.

I have come to understand that my own habitual freeze response was my ingrained way of avoiding frightful feelings: I believed subconsciously that, by tensing up my body, I wouldn't have to feel and deal with some very uncomfortable emotions. Instead, in potentially scary moments, I would hold my breath and stiffen my muscles, hoping the emotions I had trapped inside would eventually just go away. As you likely presumed, they didn't—in fact, the more I tried to shove them down, the more I experienced what eventually became chronic and debilitating pain.

Now, as I allow myself to relax, the feelings I was trying to avoid first "flush" through me. After moments of discomfort, these prickly sensations are followed by a

sense of ease and freedom. I have come to understand that my feelings of anxiety sit at the threshold of honest emotion and true connection. As I have learned to trust the liberation that waits on the other side of this energetic rush, I note the feelings, let them happen, keep breathing, and let myself be vulnerable. As social psychologist Brené Brown[86] would tell us, only when we allow ourselves to be open about our feelings—even the scary ones—can we be truly open to experiences of connection, freedom, power, and joy. In the words of Pema Chödrön, when we truly face our fears and allow ourselves to feel them, "we also encounter our heart."[87]

FROM THE STAGE: JEREMY MOELLER

Principal Trombone, Lyric Opera of Chicago

I went through a lot of mental work over the years I was taking auditions; the audition for the Lyric Opera was about the forty-fifth audition I'd taken. I'd been coming close (making semis and finals pretty often) for the few years leading up to that, but I couldn't figure out how to be the last person standing at the end. It's all about trusting yourself. Most of us in music practice very hard; that's not the issue. The issue usually ends up being the ability to truly trust yourself when it comes time to perform or audition. You have to turn off your brain to *all* of the little things you think about while practicing (technique, etc.) and just make music.

Figure 6.1. Jeremy Moeller, Trombone. *Photo courtesy of Jeremy Moeller*

Most golfers hit the ball better at the driving range than they do when they're on the course because they aren't thinking and overanalyzing everything. Yet, when they get on the course, they start thinking about every little detail. It's counterproductive. When on the practice range (or practice room), you do all of the detailed work. But when you get to the course (or recital hall or audition stage), it's time to trust the work you've done. You pick out your target (in golf, maybe it's the green or a tree down the fairway; in music, it's playing something beautifully) and go for it!

I also point out that *nobody* has ever played a perfect game of golf. Much in the same way, nobody plays their instrument perfectly. So, to expect perfection in a performance or audition isn't fair to ourselves. Anything less than that seems like a failure. All we can do is practice to be the best player we can become and then play to that potential. Rather than trying to play perfectly, all we can really do is try to play our best.

The other thing I got into a little is meditation. I have a colleague at the opera (horn player) that runs his own meditation company called Windy City Meditation. It's not a religious or spiritual meditation; it's just a rhythmic breathing meditation aimed at learning how to control our breathing and focus.

Everyone gets nervous. If an artist doesn't get nervous, then they need to check how much they really love it! For me, one of my biggest problems in auditions or recitals was staying focused the entire time. Even a twenty-second lapse of focus in an audition can be enough to be cut, even if the rest of the audition is solid. It took a few weeks to improve at it, but just a fifteen-minute meditation in the morning (really tuning out everything and focusing on the breathing and heartbeat) made a *huge* difference for me. The biggest thing I learned was what I needed to do to focus, calm my mind, and trust that I could play my best when I needed to.

Jeremy recommends Don Greene's Fight Your Fear and Win[88] *and Bob Rotella's* Golf Is Not a Game of Perfect[89] *for valuable, mental management tips.*

NOTES

1. "Holistic Medicine," *American Cancer Society*, 2013, accessed April 22, 2016, https://web.archive.org/web/20150217103045/http://www.cancer.org/treatment/treatmentsand-sideeffects/complementaryandalternativemedicine/mindbodyandspirit/holistic-medicine.

2. Anthony F. Jorm, Helen Christensen, Kathleen M. Griffiths, Ruth A. Parslow, Bryan Rodgers, and Kelly A. Blewitt, "Effectiveness of Complementary and Self-Help Treatments for Anxiety Disorders," *Medical Journal of Australia* 181, no. 7 (2004): S36.

3. See, for example, A. Byrne and D. G. Byrne, "The Effect of Exercise on Depression, Anxiety and Other Mood States: A Review," *Journal of Psychosomatic Research* 37, no. 6 (1993): 565–74.

4. Jorm et al., "Effectiveness of Complementary and Self-Help Treatments."

5. Steven J. Petruzzello, Daniel M. Landers, Brad D. Hatfield, Karla A. Kubitz, and Walter Salazar, "A Meta-Analysis on the Anxiety-Reducing Effects of Acute and Chronic Exercise," *Sports Medicine* 11, no. 3 (1991): 143–82.

6. "2008 Physical Activity Guidelines for Americans," *US Office of Disease Prevention and Health Promotion*, accessed April 25, 2016, http://health.gov/paguidelines/guidelines/summary.aspx.

7. Gregory N. Bratman, J. Paul Hamilton, Kevin S. Hahn, Gretchen C. Daily, and James J. Gross, "Nature Experience Reduces Rumination and Subgenual Prefrontal Cortex Activation," *Proceedings of the National Academy of Sciences* 112, no. 28 (2015): 8567–72.

8. See Jorm et al., "Effectiveness of Complementary and Self-Help Treatments."

9. Winfried Häuser, Karl-Heinz Janke, Bodo Klump, Michael Gregor, and Andreas Hinz, "Anxiety and Depression in Adult Patients with Celiac Disease on a Gluten-Free Diet," *World Journal of Gastroenterology* 16, no. 22 (2010): 2780–87.

10. G. Addolorato, E. Capristo, G. Ghittoni, C. Valeri, R. Mascianà, C. Ancona, and G. Gasbarrini, "Anxiety but Not Depression Decreases in Coeliac Patients after One-Year Gluten-Free Diet: A Longitudinal Study," *Scandinavian Journal of Gastroenterology* 36, no. 5 (2001): 502–6.

11. Fabrice Bonnet, Kate Irving, Jean-Louis Terra, Patrice Nony, François Berthezène, and Philippe Moulin, "Anxiety and Depression Are Associated with Unhealthy Lifestyle in Patients at Risk of Cardiovascular Disease," *Atherosclerosis* 178, no. 2 (2005): 339–44.

12. Felice N. Jacka, Julie A. Pasco, Arnstein Mykletun, Lana J. Williams, Allison M. Hodge, Sharleen Linette O'Reilly, Geoffrey C. Nicholson, Mark A. Kotowicz, and Michael Berk, "Association of Western and Traditional Diets with Depression and Anxiety in Women," *American Journal of Psychiatry* 167, no. 3 (2010): 305–11.

13. Jorm et al., "Effectiveness of Complementary and Self-Help Treatments."

14. Ibid. See also Ricardo Castaneda, Norman Sussman, Robert Levy, Mary O'Malley, and Laurence Westreich, "A Review of the Effects of Moderate Alcohol Intake on Psychiatric and Sleep Disorders," in *Recent Developments in Alcoholism*, ed. Mark Galanter (New York: Kluwer Academic Publishers, 1998), 197–226.

15. Jorm et al., "Effectiveness of Complementary and Self-Help Treatments."

16. Jerome Sarris, Steven Moylan, David A. Camfield, M. P. Pase, David Mischoulon, Michael Berk, F. N. Jacka, and Isaac Schweitzer, "Complementary Medicine, Exercise, Meditation, Diet, and Lifestyle Modification for Anxiety Disorders: A Review of Current Evidence," *Evidence-Based Complementary and Alternative Medicine* 2012 (2012): 1–20, doi:10.1155/2012/809653. For more information regarding nicotine avoidance and anxiety reduction, see Jorm et al., "Effectiveness of Complementary and Self-Help Treatments."

17. Phyllis A. Balch, *Prescription for Nutritional Healing*, 5th ed. (New York, Penguin, 2010), 207–8.

18. "EFT Is an Effective Tool for Anxiety," *Mercola.com*, last modified January 15, 2015, accessed April 22, 2016, http://articles.mercola.com/sites/articles/archive/2015/01/15/eft-tapping-anxiety.aspx; "GM Crops Now Banned in 38 Countries Worldwide," *Sustainable Pulse*, October 22, 2015, accessed April 30, 2016, http://sustainablepulse.com/2015/10/22/gm-crops-now-banned-in-36-countries-worldwide-sustainable-pulse-research/#.VyVPNG-NizVp; Rachel Hennessey, "Living in Color: The Potential Danger of Artificial Dyes," *Forbes*, August 27, 2012, accessed April 22, 2016, http://www.forbes.com/sites/rachelhennessey/2012/08/27/living-in-color-the-potential-dangers-of-artificial-dyes/#faca8b332132.

19. Balch, *Prescription for Nutritional Healing*, 208.

20. William N. Setzer, "Essential Oils and Anxiolytic Aromatherapy," *Natural Product Communications* 4, no. 9 (2009): 1305–16.

21. Robert W. Baritz, *Herbal Therapy, Quality Issues* (Brockton, MA: Baritz Wellness Center, 2010), 1.

22. Personal communication, April 25, 2016.

23. Jorm et al., "Effectiveness of Complementary and Self-Help Treatments."

24. Baritz, *Herbal Therapy*, 1.

25. Jorm et al., "Effectiveness of Complementary and Self-Help Treatments."

26. Ibid.

27. "Acupuncture," *National Center for Complementary and Integrative Health*, last modified April 7, 2016, accessed April 22, 2016, https://nccih.nih.gov/health/acupuncture.

28. Jorm et al., "Effectiveness of Complementary and Self-Help Treatments"; Karen Pilkington, "Anxiety, Depression and Acupuncture: A Review of the Clinical Research," *Autonomic Neuroscience* 157, no. 1 (2010): 91–95; Karen Pilkington, Graham Kirkwood, Hagen Rampes, Mike Cummings, and Janet Richardson, "Acupuncture for Anxiety and Anxiety Disorders: A Systematic Literature Review," *Acupuncture in Medicine* 25, nos. 1–2 (2007): 1–10.

29. "Acupuncture."

30. For example, see "EFT Is an Effective Tool," and Michael Reed Gach and Beth Ann Henning, *Acupressure for Emotional Healing* (New York: Bantam, 2004).

31. Donna Eden, *Energy Medicine: Balancing Your Body's Energies for Optimal Health, Joy, and Vitality* (New York: Penguin, 2008), 45.

32. Tiffany M. Field, "Massage Therapy Effects," *American Psychologist* 53, no. 12 (1998): 1270–81.

33. Ibid.

34. Tiffany Field, Michael Peck, Maria Hernandez-Reif, Scott Krugman, Iris Burman, and Laura Ozment-Schenck, "Postburn Itching, Pain, and Psychological Symptoms Are Reduced with Massage Therapy," *Journal of Burn Care and Research* 21, no. 3 (2000): 189–93.

35. Sybil Hart, Tiffany Field, Maria Hernandez-Reif, Graciela Nearing, Seana Shaw, Saul Schanberg, and Cynthia Kuhn, "Anorexia Nervosa Symptoms Are Reduced by Massage Therapy," *Eating Disorders* 9, no. 4 (2001): 289–99.

36. See, for example, Tiffany Field, "Pregnancy and Labor Massage Therapy," *Expert Review of Obstetrics and Gynecology* 5 (2010): 177–81.

37. Tiffany Field, Maria Hernandez-Reif, Sybil Hart, Olga Quintino, Levelle A. Drose, Tory Field, Cynthia Kuhn, and Saul Schanberg, "Effects of Sexual Abuse Are Lessened by Massage Therapy," *Journal of Bodywork and Movement Therapies* 1, no. 2 (1997): 65–69.

38. Maria Hernandez-Reif, Tiffany Field, Josh Krasnegor, Z. Hossain, Hillary Theakston, and I. Burman, "High Blood Pressure and Associated Symptoms Were Reduced by Massage Therapy," *Journal of Bodywork and Movement Therapies* 4, no. 1 (2000): 31–38.

39. Stella Leivadi, Maria Hernandez-Reif, Tiffany Field, Maureen O'Rourke, Susan D'Arienzo, Daniel Lewis, Natasha del Pino, Saul Schanberg, and Cynthia Kuhn, "Massage Therapy and Relaxation Effects on University Dance Students," *Journal of Dance Medicine and Science* 3, no. 3 (1999): 108–12.

40. Hart et al., "Anorexia Nervosa Symptoms."

41. Eri Eguchi, Narumi Funakubo, Kiyohide Tomooka, Tetsuya Ohira, Keiki Ogino, and Takeshi Tanigawa, "The Effects of Aroma Foot Massage on Blood Pressure and Anxiety in Japanese Community-Dwelling Men and Women: A Crossover Randomized Controlled Trial,"

PLOS One 11, no. 3 (2016): e0151712, accessed April 22, 2016, http://dx.doi.org/10.1371/journal.pone.0151712.

42. See "What Is Reiki?" *Reiki.org*, last modified 2016, accessed April 22, 2016, http://www.reiki.org/faq/whatisreiki.html.

43. See Michael Kern, "Introduction to Byodynamic Craniosacral Therapy," *Byodynamic Craniosacral Therapy Association of North America*, last modified 2013, accessed April 22, 2106, https://www.craniosacraltherapy.org/Whatis.htm.

44. Carolyn Green, C. W. Martin, K. Bassett, and A. Kazanjian, "A Systematic Review of Craniosacral Therapy: Biological Plausibility, Assessment Reliability and Clinical Effectiveness," *Complementary Therapies in Medicine* 7, no. 4 (1999): 201–7.

45. Susan Thrane and Susan M. Cohen, "Effect of Reiki Therapy on Pain and Anxiety in Adults: An In-Depth Literature Review of Randomized Trials with Effect Size Calculations," *Pain Management Nursing* 15, no. 4 (2014): 897–908.

46. Elizabeth R. Valentine, David F. P. Fitzgerald, Tessa L. Gorton, Jennifer A. Hudson, and Elizabeth R. C. Symonds, "The Effect of Lessons in the Alexander Technique on Music Performance in High and Low Stress Situations," *Psychology of Music* 23, no. 2 (1995): 129–41.

47. P. Watson and Elizabeth Valentine, "The Practice of Complementary Medicine and Anxiety Levels in a Population of Musicians," *Journal of the International Society for the Study of Tension in Performance* 4, no. 2 (1987): 26–30.

48. Hilary King, "Glossary: Use," *Hilary King, MSTAT: Alexander Technique Teacher in North London*, last modified 2016, accessed April 30, 2016, http://www.hilaryking.net/glossary/use.html.

49. Elizabeth Valentine, "Alexander Technique," in *Musical Excellence: Strategies and Techniques to Enhance Performance*, ed. Aaron Williamon (New York: Oxford University Press, 2004), 179.

50. For a partial list, see "AT in Educational Institutions Nationwide," *American Society for the Alexander Technique*, last modified 2016, accessed April 30, 2016, http://www.amsatonline.org/educational-institutions-nationwide.

51. Sabine D. Klein, Claudine Bayard, and Ursula Wolf, "The Alexander Technique and Musicians: A Systematic Review of Controlled Trials," *BioMed Central Complementary and Alternative Medicine* 14, no. 1 (2014), accessed May 1, 2016, http://bmccomplementalternmed.biomedcentral.com/articles/10.1186/1472-6882-14-414, doi:10.1186/1472-6882-14-414.

52. Personal communication, April 27, 2016.

53. "What Is the Feldenkrais Method?" *Feldenkrais Educational Foundation of North America and Feldenkrais Guild of North America*, last modified 2016, accessed April 22, 2016, http://www.feldenkrais.com/whatis, para. 1.

54. Ibid.

55. David Bearman and Steven Shafarman, "The Feldenkrais Method in the Treatment of Chronic Pain: A Study of Efficacy and Cost Effectiveness," *American Journal of Pain Management* 9 (1999): 22–27; M. Anne Rardin, "The Effects of an Injury Prevention Intervention on Playing-Related Pain, Tension, and Attitudes in the High School Orchestra Classroom" (PhD diss., University of Southern California, Los Angeles, 2007).

56. Gregory S. Kolt and Janet C. McConville, "The Effects of a Feldenkrais® Awareness through Movement Program on State Anxiety," *Journal of Bodywork and Movement Therapies* 4, no. 3 (2000): 216–20.

57. Bearman and Shafarman, "Feldenkrais Method"; Karol A. Connors, Mary P. Galea, and Catherine M. Said, "Feldenkrais Method Balance Classes Improve Balance in Older Adults: A Controlled Trial," *Evidence-Based Complementary and Alternative Medicine* (2011): 1–9, accessed April 30, 2016, http://dx.doi.org/10.1093/ecam/nep055.

58. Connors, Galea, and Said, "Feldenkrais Method Balance Classes."

59. Gloria M. Gutman, Carol P. Herbert, and Stanley R. Brown, "Feldenkrais versus Conventional Exercises for the Elderly," *Journal of Gerontology* 32, no. 5 (1977): 562–72.

60. Amanda Lundvik Gyllensten, Charlotte Ekdahl, and Lars Hansson, "Long-Term Effectiveness of Basic Body Awareness Therapy in Psychiatric Outpatient Care: A Randomized Controlled Study," *Advances in Physiotherapy* 11, no. 1 (2009): 2–12.

61. Yael Netz and Ronnie Lidor, "Mood Alterations in Mindful versus Aerobic Exercise Modes," *Journal of Psychology* 137, no. 5 (2003): 405–19.

62. Rardin, "Effects of an Injury Prevention Intervention."

63. Stephen A. Paparo, "Embodying Singing in the Choral Classroom: A Somatic Approach to Teaching and Learning," *International Journal of Music Education* (2015): 1–11, doi:10.1177/0255761415569366, 8.

64. Stephen R. Duke, "Application of the Feldenkrais Method in Learning Music Performance," *Steve Duke: Saxophone*, accessed April 22, 2016, www.steveduke.net/pdf/feldenkrais-music-performance.pdf, 3.

65. Personal communication, April 30, 2016.

66. Sat Bir S. Khalsa, Stephanie M. Shorter, Stephen Cope, Grace Wyshak, and Elyse Sklar, "Yoga Ameliorates Performance Anxiety and Mood Disturbance in Young Professional Musicians," *Applied Psychophysiology and Biofeedback* 34, no. 4 (2009): 279.

67. Sat Bir S. Khalsa and Stephen Cope. "Effects of a Yoga Lifestyle Intervention on Performance-Related Characteristics of Musicians: A Preliminary Study." *Medical Science Monitor* 12, no. 8 (2006): CR325-CR331.

68. Judith R. S. Stern, Sat Bir S. Khalsa, and Stefan G. Hofmann, "A Yoga Intervention for Music Performance Anxiety in Conservatory Students," *Medical Problems of Performing Artists* 27, no. 3 (2012): 123–28.

69. Khalsa et al., "Yoga Ameliorates Performance Anxiety."

70. Personal communication, April 13, 2016.

71. Roger Walsh and Frances Vaughan, "Meditation: Royal Road to the Transpersonal," in *Paths beyond Ego: The Transpersonal Vision*, ed. Roger Walsh and Frances Vaughan (New York: Penguin Putnam, 1993), 47–55.

72. Daniel J. Goleman and Gary E. Schwartz, "Meditation as an Intervention in Stress Reactivity," *Journal of Consulting and Clinical Psychology* 44, no. 3 (1976): 456.

73. Dianna T. Kenny, "A Systematic Review of Treatments for Music Performance Anxiety," *Anxiety, Stress, and Coping* 18, no. 3 (2005): 195.

74. Joanne Chang, Elizabeth Midlarsky, and Peter Lin, "Effects of Meditation on Music Performance Anxiety," *Medical Problems of Performing Artists* 18, no. 3 (2003): 126–30.

75. Peter Lin, Joanne Chang, Vance Zemon, and Elizabeth Midlarsky, "Silent Illumination: A Study on Chan (Zen) Meditation, Anxiety, and Musical Performance Quality," *Psychology of Music* 36, no. 2 (2008): 139.

76. Pema Chödrön, *When Things Fall Apart* (Boston: Shambhala, 2002), 2–3.

77. Frank M. Diaz, "Mindfulness, Attention, and Flow during Music Listening: An Empirical Investigation," *Psychology of Music* 41, no. 1 (2013): 42–58.

78. Personal communication, March 4, 2016.

79. Ibid.

80. Frank M. Diaz, "Relationships between Mindfulness Disposition, Perfectionism, Performance Anxiety, and Self-Reported Meditation Practice among Collegiate Musicians," paper presented at the NAfME Biennial Research Conference, Atlanta, GA, March 2016.

81. Personal communication, March 4, 2016.

82. For more information about practice with the breath, see Gay Hendricks, *The Breathing Box* (Louisville, CO: Sounds True, 2005); Gay Hendricks, *Conscious Breathing* (New York: Bantam, 1995); Jon Skidmore, *Relax the Body and Focus the Mind*, CD, Orem, UT: Jon Skidmore, 2003. Available at www.jonskidmore.com.

83. See Gay Hendricks, *The Big Leap* (New York: HarperCollins, 2009).

84. Amy Cuddy, *Presence* (New York: Little, Brown, 2015); Amy Cuddy, "Your Body Language Shapes Who You Are," filmed June 2012, TEDxGlobal video, https://www.ted.com/talks/amy_cuddy_your_body_language_shapes_who_you_are?language=en.

85. Dana R. Carney, Amy J. C. Cuddy, and Andy J. Yap, "Power Posing: Brief Nonverbal Displays Affect Neuroendocrine Levels and Risk Tolerance," *Psychological Science* 21, no. 10 (2010): 1363–68.

86. See Brené Brown, "Shame Resilience Theory: A Grounded Theory Study on Women and Shame," *Families in Society* 87, no. 1 (2006): 43–52.

87. Chödrön, *When Things Fall Apart*, 3.

88. Don Greene, *Fight Your Fear and Win* (New York: Random House, 2001).

89. Bob Rotella, *Golf Is Not a Game of Perfect* (New York: Simon and Schuster, 2012).

7

Expressive Arts Therapies

Expressive arts therapies (also referred to as creative arts therapies) draw on principles of humanistic psychology, supporting the idea that healing can be attained through the creative process.[1] Expressive therapies are also based on the work of psychologist Carl Jung, whose writings on "active imagination" have led to a number of therapies that work with the symbolic or archetypal material of the unconscious mind.[2] Because musicians are artists who regularly engage in nonverbal expression, these therapies may resonate more deeply or prove helpful in cases where conventional talk therapies fall short. In this chapter, we introduce a wide range of expressive arts therapies: Some are intermodal, involving multiple art forms or practices within one therapeutic context, while others are discipline specific, such as art, poetry, dance and movement, drama, or music therapies. We provide an overview of various expressive therapies but focus primarily on music therapy and guided imagery therapies, as they have been applied most specifically to the treatment of MPA and have been studied more extensively through research.

According to the International Expressive Arts Therapy Association, "Expressive arts therapy is the practice of using visual arts, movement, drama, music, writing and other creative processes to foster deep personal growth and community development."[3] While the practice of integrating multiple expressive therapies is relatively new as compared to the field of psychology, the demonstrated effectiveness of expressive arts therapies as a general treatment for anxiety,[4] social phobia,[5] and trauma[6] suggests that it may also appropriately address MPA, as these conditions may be similar to or coexist with MPA.[7]

Expressive arts therapy is sometimes practiced between a single client and therapist, but it is more commonly offered as a group therapy. In therapy sessions, the therapist facilitates a series of creative processes in order to promote self-expression, active participation, imagination, and mind-body connection.[8] For example, after

"checking in" with the client or group, the therapist might initiate a group music improvisation in conjunction with movement that transitions to a reflective drawing or journaling activity.[9] These activities promote nonverbal self-awareness and can facilitate an awareness or deeper understanding of emotional, mind-body, or previously unconscious material. The arts processes provide a means of expression and an artistic container for capturing the surfacing emotional material or repressed memories so that the therapist can then assist the client in integrating them more permanently in conscious awareness. Once the new awareness is integrated, clients may be better able to heal from the pain of repressed emotional or physical trauma or better understand how an unconscious memory or belief has been influencing their behavior. Expressive arts approaches are unique in that they allow a person to work through issues in a nonverbal way, an especially beneficial option for those whose apprehension was caused by trauma that occurred before language development.

DISCIPLINE-SPECIFIC EXPRESSIVE ARTS THERAPIES

For each artistic medium (visual art, poetry, dance, etc.), there is also a relative expressive arts therapy with its own history of practice and research. These therapies differ from expressive arts therapy because they typically focus on a single form of artistic expression in the therapeutic process. Like expressive arts therapy, they can be practiced in both an individual or group therapy context.

According to the American Art Therapy Association, "art therapy is a mental health profession in which clients, facilitated by the art therapist, use art media, the creative process, and the resulting artwork to explore their feelings, reconcile emotional conflicts, foster self-awareness, manage behavior and addictions, develop social skills, improve reality orientation, reduce anxiety, and increase self-esteem."[10] In *art therapy*, a wide variety of activities (including but not limited to drawing, painting, sculpture, and collage) are used toward a therapeutic end. For example, one art therapy study found that the process of creating mandala, or circle drawings, to induce a meditative state was effective at reducing anxiety.[11] Interestingly, these mandala drawings were the very type of expression that Carl Jung experimented with as he developed his active imagination techniques that became the foundation of his work.[12]

In another study, the process of visual journaling, or a series of drawings in conjunction with written journal entries, was found to reduce anxiety among medical students.[13] Drawing images of feared social situations was found to help those with social phobia, as the treatment helped them gain new insights and challenge their distorted perceptions.[14] Similarly, art making combined with cognitive-behavioral therapy was found to be effective in reducing generalized anxiety.[15] In this case, an art component was integrated with education, abdominal breathing training, cognitive restructuring, and a series of desensitization exercises. In each of the sessions, the art served as a way to process the activities nonverbally and gave the participants visual

records of their progress. This benefit may be important specific to art therapy, as a drawing or image made during a therapy session serves as an ongoing reminder of the content covered in sessions and continues to provide new awareness. Art therapist Shaun McNiff suggests that images can continue to communicate information from the unconscious over time, even outside of the context of the therapy session.[16] In other words, when the images are seen regularly over time, they can cause someone to remember something or have additional insights even weeks or months following therapy.

Like art, *journaling* may also provide a means to capture thoughts, feelings, and emerging symbolic material for continued benefit. In her dissertation titled "Why Did It Sound Better in the Practice Room?" Tess Miller shares thirty journaling exercises to help musicians focus on such relevant topics as personal history or autobiography, practice, achieving goals, and facing fear and self-doubt.[17] While these exercises were used as self-reflection outside of the therapy context, they do represent a way to use creative expression to increase personal awareness, process emotional and mental issues, and release blocked emotions.

Journaling and other forms of writing are commonly used in therapy. For example, in *poetry therapy*, the act of writing poetry or reflecting on poetry are both used toward therapeutic ends. According to the Institute for Poetic Medicine, "Poetry therapy is an interactive process with three essential components: literature, a trained facilitator, and the client(s). A trained poetry/biblio therapist selects a poem or other form of media to serve as a catalyst, to evoke feeling reactions for discussion and encourages writing."[18] A typical poetry therapy session might involve the reading of a piece of poetry that is carefully selected by the therapist to address a particular issue. After listening to the poem, the client is encouraged to reflect on it, write a response, and discuss it with the therapist, whose role is to assist the client in integrating their new awareness into daily life.[19]

Dance and movement therapy and *drama therapy* are other expressive therapies that may also provide benefits for the musician, as they are performing arts similar to music. Unlike visual art or writing, where the creative process is individual and focused on a creative product, dance, drama, and music more often involve a collective or group creative process that unfolds over time. The American Dance Therapy Association (ADTA) defines *dance/movement therapy* as the "psychotherapeutic use of movement to promote emotional, social, cognitive and physical integration of the individual."[20] Dance and movement therapy may be especially helpful to those who have difficulty accepting or relating to their bodies and would benefit from learning how to embody their emotions or integrate their mind-body-spirit. Dance movement therapy has been found to reduce short- and long-term stress and promote emotion-oriented and problem-oriented coping strategies among individuals who suffer from stress.[21]

According to the North American Drama Therapy Association, "Drama therapy is the intentional use of drama and/or theater processes to achieve therapeutic goals."[22] Drama therapy and psychodrama involve role-play and other forms of dramatic play

in a therapeutic context. In *psychodrama*, individuals play the role of themselves as the protagonist in a difficult situation they have faced in their lives, and other members in the therapy group take on the roles of that person's family members, coworkers, or friends who are involved in that situation. This allows the therapist to guide a replay of the situation in different scenarios, which can help the individual to understand new ways of approaching the situation or to empathize with others' feelings or points of view. In contrast, *drama therapy* may also include fictional enactments and imaginary stories in addition to psychodrama techniques. Drama therapy that utilizes enactments of fairy tales to promote a cathartic release of emotion has been used to treat children with anxiety.[23] It has also been used to treat students with mathematics anxiety[24] and has been used in conjunction with systematic desensitization to reduce test anxiety.[25]

MUSIC THERAPY

Music therapy may be the type of expressive therapy most commonly known among musicians. It is described as the "skillful use of music and musical elements by an accredited music therapist to promote, maintain, and restore mental, physical, emotional, and spiritual health."[26] Music therapists incorporate a variety of participatory exercises to work through emotional and physical ailments, including listening to, creating, and moving to music. Musical improvisation is one of the most commonly used treatment approaches and might occur between the therapist and client or in a larger group setting. Like the other art therapies, it is research based, scientifically supported, and ideal for those who struggle to express themselves verbally.[27]

Music therapy became more prevalent following World Wars I and II, as it was used to treat veterans who had experienced physical trauma and developed post-traumatic stress disorder (PTSD).[28] In addition to treating trauma, a number of recent studies demonstrate its effectiveness for alleviating anxiety. For example, music therapy involving music with guided muscle relaxation was found to be an effective treatment for anxiety among female graduate students,[29] and generalized anxiety disorder has been successfully treated with a combination of music-listening and music-making activities,[30] as well as with clinical improvisation.[31]

Music therapy has been studied as a treatment for musicians in a number of settings. For example, music therapy was administered to music therapy students in South Korea to see if it affected their job engagement, trait anxieties, mood states, and self-efficacy beliefs.[32] The study compared two treatment groups, where one was administered mindfulness meditation and drumming, while the other included meditation and musical imagery. While both treatment groups demonstrated positive effects on some of the measures tested, the music and imagery group was found to be most effective (music and imagery are discussed in more detail later this chapter). In another study of music therapists who experienced MPA in therapy sessions, breathing combined with an Orff-Schulwerk improvisation was found to reduce state anxiety that occurred when they performed music with clients.[33]

Over two decades ago, Louise Montello, Edgar Coons, and Jay Kantor explored the potential benefits of music therapy for those suffering from music performance anxiety. After twelve music therapy sessions, results showed a remarkable increase of personally reported performance confidence in the treatment groups, as well as decreased stress, better focus, and a more developed sense of musicality.[34] The same researchers followed up this investigation with another study, and the results were the same: Those who received group musical therapy became noticeably more musical, more confident, and less stressed.[35] Like any therapy, variation of approach and individual needs may render different results.[36]

GUIDED IMAGERY AND GUIDED IMAGERY AND MUSIC

Although guided imagery (GI) is not specifically regarded as an expressive therapy, it is an important related therapy that has received similar scholarly consideration for its potential benefits to anxiety cases, particularly in athletes. Guided imagery is a psychotherapeutic method employing a client's own internal imagery to uncover and resolve emotional conflicts.[37] In imagery therapy, the therapist walks the patient through a series of fantasies, meditations, dreams, and other imaginary scenarios to address emotional disturbance.[38]

Guided imagery and music (GIM, also called the Bonny method), unlike GI, is considered a music therapy approach. Helen Bonny began the development of GIM in the 1960s as a way to explore expanded states of consciousness through a guided music-listening experience.[39] While it is most commonly practiced by music therapists or other certified mental health professionals, it has its own independent credentialing process. GIM is usually practiced in a group, but it has been adapted for individual music therapy sessions as well. A typical GIM session includes a *prelude*, or conversation to introduce the process and set goals for the session, and is followed by an *induction* to facilitate relaxation and focus. The *music program* is the longest phase and involves listening to music selected by the therapist that may or may not include a voiceover provided by the therapist to evoke imagery. During the *postlude*, the therapist guides the participants back to a normal state of consciousness and assists them to emotionally process the material that may have surfaced during the experience. Mandala drawings and verbal sharing are typically used to facilitate this final integration of previously unconscious material into conscious awareness.

One of the first applications of GIM was for drug crisis intervention. Since then, it has been expanded for use as a treatment for a wide range of conditions, including anxiety.[40] While one study found it to be effective in reducing state anxiety,[41] another showed mixed results but attributed this to the fact that the treatment involved classical music, which was not the preferred music of the participants. This highlights the importance of selecting music to which clients can relate.[42] In some cases, classical musicians may find that listening to music is less effective, as we see in the following study.

While therapists and performers may use GIM as a treatment for MPA, very little research has been conducted to demonstrate its effectiveness with music performers. In one study, however, Soo Young Kim tested GIM versus GI alone as a treatment for MPA among university music students preparing for juries.[43] Eighteen music students were divided into two groups: one that experienced guided imagery for ten minutes followed by nearly six minutes of silence and another group that experienced guided imagery followed by their choice of relaxation music.

Notably, while study participants preferred to listen to music rather than silence, those who sat in silence following GI experienced significantly reduced anxiety, while those who listened to music after GI did not. Was the postimagery music actually a distraction to the musicians? According to the researcher, some participants did suggest that listening to music did help them visualize a safe jury exam setting. Participants also reported that the more they practiced with the guided imagery tape, the more they could increase their positive outlook and reduce their anxiety. Future research may shed further light on the effectiveness of GI versus GIM as a treatment for MPA.

SUMMARY AND CONCLUDING THOUGHTS

Imagine the joy of bringing *art* back into your music making! This chapter touches on possibilities for using the expressive arts as a therapeutic way to liberate your performances by engaging a creative spirit. The expressive therapies provide a nonverbal way of healing the unconscious mind, which may be ideal for musicians. Due to the media used in therapy, art and poetry therapy may help to capture and integrate the insights gained in therapy for ongoing benefits. However, dance and movement, drama, and music therapies may be beneficial, as they are often collaborative performative expressions that unfold over time, which may offer opportunities to work directly with one's experience of MPA in the therapy setting.

In the following vignette, Tawnya shares a description of the expressive arts workshop she created for musicians who had MPA both in performance and while improvising. While the workshop was educational in nature, the description brings to life what an expressive art experience might be like and includes some of the findings of the research she conducted. Following the story, you will have a chance to do an activity that is based on the study.

JOURNEYS: EXPRESSIVE ARTS WORKSHOP

By Tawnya

After studying expressive arts therapy at Lesley University, I decided to integrate some of the practices I had learned into an educational workshop for classically

trained musicians who had experienced MPA during improvisation. I created a series of four two-hour workshops that were held over the course of six weeks as a part of my dissertation research at the University of Illinois.[44] While this workshop was not a therapeutic treatment, as an educator I believed that I could adapt specific ideas from the expressive arts to empower participants by promoting greater self-awareness of the mental, emotional, and physical aspects of MPA.

In a previous study, I had found three self-referents (or labels) to describe particular states of consciousness during music making. The *self-conscious witness* is experienced when you are filled with self-judgmental thoughts, are overly worried about what others think, and only see what is wrong in a situation. The *nonjudgmental witness* is experienced when you are focused and centered and are able to notice your strengths and weaknesses equally. The *creator witness* refers to a flow state, where you are fully immersed in what you are doing. I introduced these three "witnesses" to help participants notice the states they experienced during music making and to be more aware of the events or thoughts that caused them to change over time.

In the workshops, we engaged in free improvisation followed by journaling. After the journaling, I played a recording I had made of the improvisation and had the participants draw a picture with oil pastels, markers, or colored pencils as a way to reflect on the music. In their journals, the participants wrote about the times during the workshop that the different "witnesses" showed up. The one that participants most often noted was the self-conscious witness: They mentioned that, when in this state, they were not able to listen or respond to the other musicians in the improvisation because their own negative self-talk blocked them from doing so. Often this state was triggered by a note or sound that they didn't think belonged.

Interestingly, when the participants listened to the playback of the recording, none of them noticed these "bad-sounding" moments. They were surprised to hear that the recording sounded better than they expected! This was likely because they were listening to it from the "nonjudgmental" state, where they could hear the improvisation as a whole within an evolving soundscape rather than just one note that sounded off.

During the workshops, I encouraged the participants to open up their awareness beyond their inner dialogues: I asked them to also notice their emotional states and the physical sensations that they had in their body when they experienced each of these three states. We practiced starting each improvisation from a focused and centered state (nonjudgmental witness). Several reported that they felt they were learning how to notice when they shifted from the nonjudgmental to the self-conscious state during practice sessions or rehearsals and that, if they caught it soon enough, they were able to stop themselves from a downward spiral of self-judgmental thoughts and feelings. Some of the participants were able to recognize that their thoughts had shifted, while others were more aware of their feelings or signs of physical stress.

Toward the end of the workshop, I had the participants imagine each of their three witnesses or inner voices as little children sitting in front of them. I had them imagine themselves as an adult who was much larger than the children.

This helped the participants realize not only that they were capable of experiencing each of those states but also that they were able to witness them happening (which they had been doing in journals and art reflection). This new awareness was a profound realization for several of the participants, who, for the first time, realized that their self-conscious inner thoughts and emotions were "not them." This higher level of awareness, which I began to call the *observer witness*, is a constant and permanent presence within us that remains stable no matter our passing state of mind.

The participants' experiences helped me to understand that, when people are caught in self-conscious thoughts and emotions, they may not be able to fully engage in music making with others. When in the self-conscious state, we may not be able to hear all of the music that is being created, but when we listen from a nonjudgmental state, a more holistic and accurate understanding may be possible. Additionally, the participants helped me to understand the power of realizing that the "observer witness" represents our reality and that we are not the self-conscious voices that we hear in our heads.

By returning over and over to a focused and centered place in our minds and by becoming more aware of self-conscious thoughts and the emotions and physical sensations that accompany them, we can intentionally practice a different state of mind. Many of us have been practicing a self-conscious state of mind for years. Perhaps if we routinely practice becoming aware of the states we are experiencing, then we can eventually transform our mental habits and in time become more apt to experience precious moments of flow and creativity.

ACTIVITY: IDENTIFYING AND WORKING WITH YOUR INNER VOICES

Reflection for Awareness: Inner Awareness Exercise

As with the activities in the last chapters, the following exercises will help you to identify and become more aware of what is going on inside. By practicing the flash scans, you are learning how to identify your individual thoughts, emotions, and sensations quickly. Now you are ready to become more aware of your distinct inner voices, their effect on your train of thought, and their connection to the physical sensations in your body. While you may ultimately find that you have more than the three inner voices introduced here, we suggest that you start noticing these first:

1. *Self-Conscious Voice:* This voice is harshly negative and might make judgmental statements in the form of personal attacks by yourself or projected onto others. For example, "That sounded terrible. *I am* an awful musician," or "That was horrible. I bet they think I stink!" These statements tend to be highly emotional and cause strong physical sensations in the body, such as muscle tension or an anxious stomach.

2. *Nonjudgmental Voice:* This voice notices both the positive and negative aspects of your performance and helps to correct issues and celebrate successes. This voice communicates with little emotional charge, and the sensations in the body include a sense of both physical and mental alertness. For example, "That note was out of tune. I need to adjust more there," or "My intonation in this section has improved since the last rehearsal."

3. *Creator Voice:* This voice is usually silent (or nonverbal) because you are so immersed in playing, or are in a flow state, that you are communicating only nonverbally through the expression of the music. You likely feel relaxed or exhilarated by what you are playing and may feel very positive, and your physical sensations may be pleasant or above average.

Learning to "Catch" Your Voices

1. *Recollecting Memories:* Write down short descriptions from your memory when you experienced the self-conscious, nonjudgmental, and creator voices (two to three of each). Try to recall as many details as possible from your memory, including the people you were with, the environment, what you were performing, your age, your level, and other details as relevant.

2. *Practice Journal:* Keep a journal with you during your next practice session (or if possible at all of your practice sessions during one week). Every time you move from one activity to the next or when you notice a change in your mood or sensations, stop and identify which voice is dominant in your thoughts. Write down any specific thoughts that are going through your mind, or jot down a general phrase or word to describe what you are thinking. Also, scan your body from head to foot, and note any tension or discomfort and where it is located in your body. At the end of each practice session, review what you wrote in your journal, and reflect on any patterns you notice or instances that trigger the self-conscious voice.

3. *Performance Journal:* Plan ahead so that, following a rehearsal, lesson, master class, or performance, you can visit a quiet place where you can be alone for a few minutes. Draw a timeline across one page of your journal, and mark hash marks indicating important moments during the performance or session. Label all of these moments with the inner voice (self-conscious, nonjudgmental, or creator) you recall was present. Reflect on the timeline and your overall impression of the performance. If there was a memorable moment in the performance, pay particular attention to whether your thoughts became more negative or positive and why.

Application and Integration to Practice: Integrating Self-Awareness

Learning to identify the inner dialogue in your history is an important step in developing mindfulness that can support more effective and less anxious practice and

performance. Once you become accustomed to "catching your self-conscious voice in the act" of taking you on a downward spiral of thinking, you will be more capable of intervening and returning your thoughts to more neutral and supportive ones.

1. *Flash Scans:* Like the flash scans introduced in the chapter 2 activity, stop what you are doing, and quickly identify which voice (self-conscious, non-judgmental, creator) is active. Notice, take a deep breath, and return to the nonjudgmental state.

2. *Establishing an Observer Witness:* After a practice session or performance, recall briefly which voices surfaced throughout. Imagine those voices as characters sitting in front of you. Now imagine that the self-conscious, nonjudgmental, and creator voices are all small children. Imagine that they are toddlers, and notice that you are an adult and much larger in size. It is now your responsibility to supervise these children (your voices) and make sure that they are getting along with one another. Think about what it feels like in your body knowing that you are the one in authority and can manage the messages that each one of these voices might bring to you. You now have the authority to encourage or discourage any one of these voices, correct or dismiss comments that are in error, or simply return to silence until you become calm again and can begin again from a neutral place.

With a clear intention and commitment to practice and perform with the guidance of your "Observer Witness," it will become easier over time to notice when your thoughts become negative and your physical symptoms of anxiety increase. Noticing when this happens and taking the time during practice sessions to return to a calm and neutral state will retrain your mind gradually. Like physical conditioning, the more you practice and rehearse in a calm or neutral state, the more likely you will be able to replicate this in performance. It will also be more likely that your "Observer Witness" will be able to intervene during performance if something distracts you.

Just for Fun

In Tawnya's workshop, one of the activities that helped the musicians to be less self-conscious was to draw or move during a recording of the music they created.[45] Listening while drawing or moving helped the musicians to listen more holistically or artistically, perhaps because they were listening to the music as an inspiration for their expression rather than listening only to detect errors or flaws. If you dread listening to recordings of your playing or have difficulty hearing what you are playing well, then you might try the following exercise.

1. Record a performance or a rehearsal of music you are about to perform. Find a place you will feel safe, be undisturbed, and have a table big enough to place a large piece of paper. You will need paper (18" × 24" or larger, if possible),

markers, oil pastels, colored pencils, or tempera paint (pick the one you enjoy the most). Play the recording using the best-quality speakers you can, and make sure the sound is at the same level or louder than it would be if you were actually performing in the room. If this is not possible (if you are outside or if there are not speakers in the room you choose), consider using headphones. Listen to the recording, and draw whatever comes to mind. It doesn't matter what you draw; it can be abstract, realistic, or even stick figures. After the recording is finished, take a few moments to journal about what you noticed during the experience. What did you notice about the music? How do you feel now after this experience as compared with how you felt immediately after making the recording? How did you feel as you were making the drawing?

2. Record a performance or a rehearsal of music you are about to perform. Find a place you feel safe and have some open space to move around, like an empty stage, a large living room, or even an empty garage. Play the recording using the best-quality speakers you can, and make sure the sound is at the same level or louder than it would be if you were actually performing in the room. If this is not possible (if you are outside or if there are not speakers in the room you choose), consider using headphones. Play the recording and move your body to the music in any way that feels good to you. There are no right answers, and no one else is watching. Let yourself be free. After the recording is finished, take a few moments to journal about what you noticed during the experience. What did you notice about the music? How do you feel now after this experience as compared with how you felt immediately after making the recording? How did you feel as you were moving to the music?

FROM THE STAGE: JESUS FLORIDO

Violinist, Educator, Composer, Producer

This past April, I turned fifty years old, which means I've been playing the violin for forty-four years. As a little boy, I started playing the violin because my mom said I had to, and a year after that, I played my first recital. I practiced because I did want to do well, but I didn't care much about the opportunity to perform. When I was called onstage, I closed my eyes and played my piece—to my astonishment, I got a standing ovation. I stood in awe of the cheers and applause—I couldn't stop smiling. I wanted to do it again! In my first lesson after the recital, I told my teacher that I had had a great time and was looking forward to the next performance. He smiled, told me he was proud of me, but that now the work was going to get harder.

He was right: The music got harder, and more practicing was required of me. I was looking forward to the next performance until one day, in passing, another student's mother congratulated me on my first recital, saying, "You played so well! It was such a hard piece and you were not afraid, even though it was a full house!"

Figure 7.1. Jesus Florido performing with jazz-fusion group Nima Collective. *Photo courtesy of Jesus Florido*

I was caught completely off guard. It hadn't occurred to me until then that I had to be afraid or that my piece was difficult. Was I supposed to be afraid? Was I supposed to care what the audience thought of me? Performing was just fun, and I was simply showing the progress I had made in my playing.

After that, I couldn't shake the idea that the stage was something to be feared. I was afraid to play anything in front of anybody. I second-guessed every note and started to hate performing in public. My anxiety levels went through the roof, and I started to show physical signs, like extreme sweats and muscle spasms, when I performed. Playing the violin had become a nightmare.

Because both my parents and my teacher were firm in not allowing me to quit, I suffered through the process of learning to play, though I found some comfort in other kids who had the same problem. Then, when I was ten, my dad bought me a skateboard. In no time I was flying through the streets with no fear—eventually skateboarding led to BMX bikes, roller skates, and surfboards. I became a thrill seeker. I loved the adrenaline rush and the wind in my face.

One time, I performed on TV, and one of my skateboarding buddies saw me. He said, "You were so good! I didn't know you could play violin so well!" But what really changed my life was when he said, "You are such an amazing thrill seeker: You skateboard and you perform on stages, both adrenaline-seeking activities."

Until then, I'd never thought about violin being a thrill-seeking activity. But once I understood there was no difference between the street and the stage, I embraced my music making in the same way as I did my passion for skating. I became

Figure 7.2. *Photo courtesy of Jesus Florido*

a professional violinist and a performer who loves the stage. I have performed all over the world and continue to explore many other activities, like flying ultralight planes and rappelling.

At the age of forty-six, I was diagnosed with a brain tumor. It took a complicated surgery to remove it, and I lost my sense of balance in the process, but I am grateful for the continued opportunity to make music and enjoy my violin every day of my life.

Figure 7.3. *Photo courtesy of Jesus Florido*

NOTES

1. Carl R. Rogers, *On Becoming a Person: A Therapist's View of Psychotherapy* (New York: Houghton Mifflin, 1961); Carl R. Rogers, *A Way of Being* (New York: Houghton Mifflin, 1981).

2. Joan Chodorow, *Jung on Active Imagination* (Princeton, NJ: Princeton University Press, 1977).

3. "About Expressive Arts," *International Expressive Arts Therapy Association*, last modified 2014, para. 1, accessed April, 30, 2016, http://www.ieata.org/index.html.

4. Jennifer S. Price, "Creative Healing: An Expressive Art Therapy Curriculum Designed to Decrease the Symptoms of Depression and Anxiety" (master's thesis, Prescott College, 2009).

5. Falk Leichsenring, Manfred Beutel, and Eric Leibing, "Psychodynamic Psychotherapy for Social Phobia: A Treatment Manual Based on Supportive-Expressive Therapy," *Bulletin of the Menninger Clinic* 71, no. 1 (2007): 56–84.

6. Stephen K. Levine, *Trauma, Tragedy, Therapy: The Arts and Human Suffering* (Philadelphia: Jessica Kingsley, 2009).

7. Wendy J. Cox and Justin Kenardy, "Performance Anxiety, Social Phobia, and Setting Effects in Instrumental Music Students, *Journal of Anxiety Disorders* 7, no. 1 (1993): 49–60; Dianna T. Kenny, *The Psychology of Music Performance Anxiety* (New York, Oxford University Press, 2011); Joann Marie Kirchner, Arvid J. Bloom, and Paula Skutnick-Henley, "The Relationship between Performance Anxiety and Flow," *Medical Problems of Performing Artists* 23, no. 2 (2008): 59–65; Margaret S. Osborne and John Franklin, "Cognitive Processes in Music Performance Anxiety," *Australian Journal of Psychology* 54 (2002): 86–93; Andrew Steptoe and Helen Fidler, "Stage Fright in Orchestral Musicians: A Study of Cognitive and Behavioural Strategies in Performance Anxiety," *British Journal of Psychology* 78 (1987): 241–49; Inette Swart, "Overcoming Adversity: Trauma in the Lives of Music Performers and Composers," *Psychology of Music* 42, no. 3 (2013): 386–402.

8. Cathy A. Malchiodi, "Expressive Therapies: History, Theory, and Practice," in *Expressive Therapies*, ed. Cathy A. Malchiodi (New York: Guilford Press, 2007), 1–15.

9. Paolo J. Knill, Helen Nienhaus Barba, and Margo N. Fuchs, *Minstrels of Soul: Intermodal Expressive Therapy* (Toronto: EGS Press, 2004); Natalie Rogers, *The Creative Connection: Expressive Arts as Healing* (Palo Alto, CA: Science and Behavior Books, 1993).

10. "What Is Art Therapy?" *American Art Therapy Association*, last modified 2013, accessed April, 30, 2016, http://www.arttherapy.org/upload/whatisarttherapy.pdf.

11. Nancy A. Curry and Tim Kasser, "Can Coloring Mandalas Reduce Anxiety?" *Art Therapy: Journal of the American Art Therapy Association* 22, no. 2 (2005): 81–85.

12. Carl G. Jung, *The Red Book: Liber Novus*, ed. Sonu Shamdasani, trans. Mark Kyburz, John Peck, and Sonu Shamdasani (New York: W. W. Norton, 2009).

13. Amanda Mercer, Elizabeth Warson, and Jenny Zhao, "Visual Journaling: An Intervention to Influence Stress, Anxiety and Affect Levels in Medical Students," *Arts in Psychotherapy* 37 (2010): 143–48.

14. Emily E. Rosaio, "How Do Individuals with Fears of Social Situations Experience Making Art of Their Feared Situation?" (master's thesis, Drexel University, 2013).

15. Frances J. Morris, "Should Art Be Integrated into Cognitive Behavioral Therapy for Anxiety Disorders?" *Arts in Psychotherapy* 41, no. 4 (2014): 343–52.

16. Shaun McNiff, *Art as Medicine: Creating a Therapy of the Imagination* (Boston: Shambhala, 1992).

17. Tess A. Miller, "Why Did It Sound Better in the Practice Room? A Guide to Music Performance Anxiety and How to Cope with It through Journal Writing" (DMA diss., Michigan State University, 2004).

18. "What Is Poetry Therapy?" *Institute for Poetic Medicine*, last modified 2008, accessed April, 30, 2016, http://poeticmedicine.org/about.poetrytherapy.html.

19. Kenneth Gorelick, "Poetry Therapy," in *Expressive Therapies*, ed. Cathy A. Malchiodi (New York: Guilford Press, 2007), 117–40.

20. "What Is Dance/Movement Therapy?" *American Dance Therapy Association*, last modified 2016, accessed April, 30, 2016, https://adta.org/faqs.

21. Iris Brauninger, "Dance Movement Therapy Group Intervention in Stress Treatment: A Randomized Controlled Trial (RTC)," *Arts in Psychotherapy* 39 (2012): 443–50.

22. "What Is Drama Therapy?" *North American Drama Therapy Association*, last modified 2016, accessed April, 30, 2016, http://www.nadta.org/what-is-drama-therapy.html.

23. Calli Armstrong, "Finding Catharsis in Fairy Tales: A Theoretical Paper Exploring the Roles Catharsis Plays When Fairy Tales Are Used in Drama Therapy for Children with Anxiety" (master's thesis, Concordia University, Montreal, Quebec, 2007).

24. Gstrein Dorothea, "Effectiveness of Psychodrama Group Therapy on Pupils with Mathematics Anxiety," *Zeitschrift für Psychodrama und Soziometrie* 15 (2016): 197–215.

25. David A. Kipper and Daniel Giladi, "Effectiveness of Structured Psychodrama and Systematic Desensitization in Reduction of Test Anxiety," *Journal of Counseling Psychology* 25, no. 6 (1978): 499–505.

26. "Music Therapy Definition," *Music Therapy Association of Ontario*, last modified 2016, accessed April, 30, 2016, http://www.musictherapyontario.com/page-1090464.

27. "What Is Music Therapy?" *American Music Therapy Association*, last modified 2016, accessed April, 30, 2016, http://www.musictherapy.org/about/musictherapy.

28. William B. Davis, Kate E. Gfeller, and Michael H. Thaut, *An Introduction to Music Therapy: Theory and Practice* (Boston: McGraw Hill, 1999).

29. Chang-Chi Musetta Fu, "Music Therapy and Women's Health: Effects of Music-Assisted Relaxation on Women Graduate Students' Stress and Anxiety Levels" (master's thesis, Michigan State University, 2008).

30. Enrique Octavio Flores Gutiérrez and Víctor Andrés Terán Camarena, "Music Therapy in Generalized Anxiety Disorder," *Arts in Psychotherapy* 44 (2015): 19–24.

31. Rebecca Zarate, "Clinical Improvisation and Its Effect on Anxiety: A Multiple Single Subject Design," *Arts in Psychotherapy* 48 (2016): 46–53; Rebecca Zarate, "The Sounds of Anxiety: A Quantitative Study of Music Therapy and Anxiety" (PhD diss., Lesley University, 2012).

32. Min-Jeong Bae, "Effect of Group Music Therapy on Student Music Therapists' Anxiety, Mood, Job Engagement and Self-Efficacy" (PhD diss., University of Kansas, 2011).

33. Michael R. Detmer, "Effect of Orff-Based Music Interventions on State Anxiety of Music Therapy Students" (master's thesis, University of Kansas, 2010).

34. Louise Montello, Edgar E. Coons, and Jay Kantor, "The Use of Music Therapy as a Treatment for Musical Performance Stress," *Medical Problems of Performing Artists* 5, no. 1 (1990): 49–57.

35. Ibid.

36. Jennifer Usry, "Effect of Music Therapy Relaxation Techniques on the Stress and Anxiety Levels of Music and Music Therapy Students and Music and Music Therapy Professionals" (master's thesis, Florida State University, 2006).

37. Bruce W. Scotton, Allan B. Chinen, and John R. Battista, *Transpersonal Psychiatry and Psychology* (New York: Basic Books, 1996).

38. Lesley Ann Sisterhen, "The Use of Imagery, Mental Practice, and Relaxation Techniques for Musical Performance Enhancement" (PhD diss., University of Oklahoma, 2005).

39. Helen Lindquist Bonny, *Music Consciousness: The Evolution of Guided Imagery and Music* (Gilsum, NH: Barcelona, 2002).

40. Bryan J. Muller, "Guided Imagery and Music: A Survey of Current Practices" (PhD diss., Temple University, 2010).

41. Susan E. Hammer, "The Effects of Guided Imagery through Music on State and Trait Anxiety," *Journal of Music Therapy* 33, no. 1 (1996): 47–70.

42. Jesse Hanson, "The Bonny Method of Guided Imagery and Music: Does It Reduce Anxiety in the General Toronto Population?" (PhD diss., Chicago School of Professional Psychology, 2015).

43. Soo Young Kim, "The Effect of Guided Imagery and Preferred Music Listening versus Guided Imagery and Silence on Musical Performance Anxiety" (master's thesis, Texas Woman's University, 2002).

44. Tawnya D. Smith, "Using the Expressive Arts to Facilitate Group Music Improvisation and Individual Reflection: Expanding Consciousness in Music Learning for Self-Development" (PhD diss., University of Illinois at Urbana–Champaign, 2014).

45. Ibid.

8

Especially for Teachers

Preventing Music Performance Anxiety

In this chapter we speak directly to music teachers, offering research-based insights to prevent and manage student anxiety. We first provide a brief overview of four psychological concepts (flow, self-efficacy, mindset, and cognitive self-regulation), providing specific applications to music learning and performance. Next, we look at a number of commonly used teacher statements in order to deconstruct their meanings and consider various ways in which they might be interpreted by students. We close by stressing the importance of talking openly about emotional health and making these discussions a higher priority in music learning communities. Although this chapter may help teachers prevent performance anxiety in young students from the outset of their musical careers, other performers at any stage of musical maturity may find these ideas useful for developing new habits of thought.

FLOW

Flow theory, developed by Hungarian psychologist Mihaly Csikszentmihalyi, assumes that we enter a certain flow state when participating in activities that we enjoy and do well but that still challenge us in some way.[1] The optimal state of flow (also called the *zone* by other writers[2]) involves a feeling of enjoyment, focus, and full immersion in an activity. While in a flow state, we experience such an intense focus that we lose an awareness of time and experience a sense of effortless technical control.

When not inhibited by anxiety, these flow experiences can be so powerful—yet feel so easy—that they are intrinsically rewarding. In other words, people are likely to engage in an activity simply because it feels so good to do it—no stickers, no praise, no cash prize necessary—they just do it because they love the way it makes them feel.

According to flow theory, it takes an optimal balance of personal skill and challenge to reach a state of mental and physical ease. Flow is attainable when performing within the realms of our competence, but anxiety results if an activity surpasses our technical ability. As our technical skills increase, so, too, must the level of challenge increase for us to experience this same enjoyment: Repetition of the same techniques without any variation leads to boredom.

As music teachers, it is important that we assign repertoire that appropriately matches and challenges a student's technical skills at each stage of development. When performers assume an endeavor that is ill matched for their skill set, they may face unexpected failure and suffer emotional and psychological distress. A history of flopped performances, especially early on, can be a stubborn impediment to developing confidence even as skills improve. Aware of the extra challenge that performances bring, many music teachers promote student confidence by assigning performance pieces that are one or two grade levels lower than the difficulty level of repertoire that the student is learning in lessons. This way, the student is well equipped to demonstrate technical and expressive mastery for an audience yet can also freely explore technical growth in the safety of a practice room.

As students progress and find repetition of previously learned repertoire to be increasingly boring, they can experience flow-evoking challenges by exploring new technical and expressive aspects of the same pieces they already know well. The possibilities are endless: Baroque cello virtuoso Anner Bylsma, who performs the same Bach suites several times a week—year after year—has stated that every performance of Bach is for him a different and uniquely inspiring event.[3] By teaching our students to focus on making each performance a brand new musical experience, we can help prevent their imaginative minds from using that same mental space to dream up a brand new catastrophe.

SOURCES OF SELF-EFFICACY

One potential limitation in flow theory, as described earlier, is that there may be a difference in *perceived* and *actual* ability. While students may have the skills they need to meet a challenge, they may still experience anxiety if they underestimate those abilities in their own minds.[4] Self-efficacy theory, developed by Stanford psychologist Albert Bandura, offers ways in which we can help students foster a more authentic sense of their capabilities.[5] Different than self-esteem, self-efficacy belief is task specific. We may have a high sense of self-efficacy in math, for instance, but a low sense of self-efficacy in cooking. Self-efficacy belief is also separate from our overall beliefs in ourselves as persons (although a high sense of self-efficacy in enough activities would naturally boost our overall self-concept). For this reason, a teacher's attempts to build a student's self-esteem are futile for remedying performance anxiety if they don't simultaneously fortify the student's confidence in the performance-specific skill set.

Bandura outlined four sources of self-efficacy, or ways in which we can develop a stronger belief in our activity-specific abilities:

1. *Enactive mastery experience*, or prior task-specific achievement. A continuous, intentional focus on past activity-specific successes can help students to practice positive mental rehearsal (as we describe in chapter 3). Self-efficacy research tells us that the more specifically related a past success is to a future undertaking, the more confident a student will be about the upcoming performance.[6]

2. *Vicarious experience*, or watching others succeed. This source is most effective when the observed model is similar in age and ability and is particularly helpful when a student already has a high sense of self-efficacy in the particular task. Research suggests that observation of peers builds confidence among those who already boast a history of success but can be detrimental to students with less confidence or experience in that particular activity.[7] Teachers should, therefore, be careful and selective when comparing students to one another and, in any case, create cooperative environments in which successes of others are honestly and accurately celebrated.[8]

3. *Verbal/social persuasion*, or encouragement from others. Encouragement can come through words of affirmation from teachers, parents, or peers but also through nonverbal persuasion, such as the trust that we place in students and the extra opportunities we provide (e.g., solos, leadership spots, etc.). Unfortunately, however, even the most well-intentioned comments are subject to individual emotional filters and therefore run the risk of being misinterpreted or subconsciously reframed, depending on a student's personal history. If you've ever wondered why the encouragement you give only goes so far in helping a student reduce anxiety, see the "messages to students" activity later in this chapter, where we examine and discuss what students might actually take away from even the most sincere forms of encouragement.

4. *Physiological and affective states.* Unsurprisingly, our physical and emotional conditions make a difference in how we feel when we go onstage. This book goes far beyond recommending that you eat bananas before a performance to increase potassium and lower blood pressure, but then again, doing everything we can to ensure our mental and physical health is conducive for positive performance experiences is certainly warranted. We have addressed strategies and therapies throughout this book to improve physiological and affective states because doing so is of particular importance to musicians.[9]

In addition to these four sources, other factors, such as gender, nationality, and individual values, affect self-efficacy beliefs.[10] In other words, not all students will respond the same way to the same kinds of teacher encouragement. We found in our own research with high school honors orchestra participants that male self-efficacy beliefs may be more positively influenced by achievement, while female self-efficacy

beliefs may be better boosted by social support.[11] This difference leads us back to the issue of competition, which turns out not to be as effective or healthy a boost for all students as some educators have been led to believe.[12]

MINDSET

According to the mindset principle developed by Stanford psychologist Carol Dweck, people with a *fixed* mindset believe that they either have what it takes to succeed at something or they don't, while people with a *growth* mindset believe that seemingly insurmountable accomplishments can be made in time with the help of effort and appropriate strategies.[13] Focusing a student's attention on sheer talent or luck, therefore, paints an inaccurate picture of the student's potential and simultaneously limits his or her sense of control over performances. Dr. Dweck explains,

> If, like those with the growth mindset, you believe you can develop yourself, then you're open to accurate information about your current abilities, even if it's unflattering. What's more, if you're oriented toward learning, as they are, you *need* accurate information about your current abilities in order to learn effectively. However, if everything is either good news or bad news about your precious traits—as it is with the fixed-mindset people—distortion almost inevitably enters the picture. Some outcomes are magnified, others are explained away, and before you know it you don't know yourself at all.[14]

On the other hand, when students are reminded of the potential that they have for growth, they can develop a more accurate sense of their abilities and be able to fairly assess each of their performances in terms of progress toward long- and short-term goals. As teachers, therefore, it is crucial to provide activities, model behaviors, and choose words that encourage and empower students to take personal charge of their musical futures. We provide more specific examples of how to promote a growth mind-set in the "Messages from Teachers to Students" section later in this chapter.

COGNITIVE SELF-REGULATION

Cognitive self-regulation involves training our minds to focus on positive and healthy outcomes. Psychologists have come to believe that we have more control over our thoughts than we once realized: We are not mindlessly conditioned to respond to whatever our environment dictates but instead empowered with agency and control over our experiences—and even our own beliefs.

Scholars have developed a model by which they show how our behaviors, personal beliefs, and environments all interact with one another.[15] In figure 8.1, we draw your attention specifically to the feedback loop under the "person" box. The

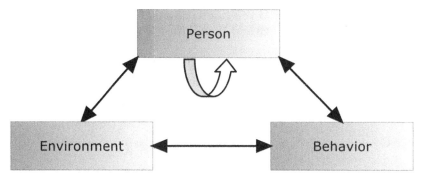

Figure 8.1. A simplified representation of Bandura's model of triadic reciprocal causality with Zimmerman's added self-regulated functioning loop. *Source: Karin S. Hendricks, "Relationships between the Sources of Self-Efficacy and Changes in Competence Perceptions of Music Students during an All-State Orchestra Event" (PhD diss., University of Illinois at Urbana–Champaign, 2009, 15).*

loop suggests that, as individuals learn to honestly and fairly self-assess their performances, they will be able to compare their present achievement with the ultimate goal, adjusting effort and challenges as they deem necessary. Self-efficacy belief, then, acts as a means to help individuals regulate their goal-oriented efforts as well as their thoughts.

In contrast to the experience of catastrophizing (as described in chapter 2), cognitive self-regulation involves honestly and fairly assessing each performance situation and then choosing to focus on the thoughts that would produce the most positive outcome. In previous research, Karin discovered that high-achieving musicians fostered the ability to manage and control their own cognition by giving more credence to those experiences or thoughts that would increase their self-efficacy beliefs rather than those experiences or thoughts that might undermine them.[16]

With consistent monitoring and diligence, cognitive self-regulation can be fostered through meditation, rational emotive therapy, and other approaches outlined throughout this book. As we have stated previously, we cannot instantly change years of negative thoughts that have developed into habit. It is imperative, then, for teachers to model positive thoughts and teach students to accurately assess their abilities from the beginning and throughout their music-learning lives.

We add a caveat here: While most students may be able to practice cognitive self-regulation with proper instructional support, some students who have experienced trauma may have a more difficult time teaching the mind to process in new ways (see chapter 2 for a further discussion on trauma and its effects). In this case, students may be in need of a more structured therapeutic intervention that extends beyond the capacity of a teacher. As cases vary, teachers need to be sensitive to various needs and levels of anxiety and not impose or force any particular approach on students who are not ready to receive it.

MESSAGES FROM TEACHERS TO STUDENTS:
WHAT ARE YOU *REALLY* SAYING?

Each of the following quotes is something we have heard a teacher say (or, admittedly in some cases, have said ourselves). The statements are generally well intentioned but may actually increase anxiety in certain students and in certain situations. As you read each quote, complete the following steps:

1. Conduct a body scan. Is there any place that becomes tense or irritated in reaction to the quote?
2. Consider the point of view of the student. Is there anything positively motivational in the quote? Is there anything hurtful?
3. Consider the point of view of the teacher. Why might the teacher have said this? What might have been the intended purpose behind these words?
4. Consider alternative words or approaches that the teacher could use.
5. After completing each of these steps on your own, turn to the pages that follow and consider our thoughts as well.

Teacher Quotes

"You won't get it unless you practice."
"Our band always gets a superior rating."
"If we get second place after Big News High School, that's like getting first."
"I have no patience for students who play out of tune in first position."
"Your sister gets up early to practice. Maybe you should try that."
"Wow, you always nail that shift! You're so talented."
"Just relax!"
"You just need to keep practicing. You'll get it."
"Why do you always miss that entrance?"
"Come on, man. I expect more from you."
"Good."
"I think you're a wonderful person no matter how you do in this performance."

Teacher Quotes: Some Thoughts

"You won't get it unless you practice."

This quote appears to be an attempt to motivate a student to practice; however, stating the obvious without technical insight is unlikely to encourage anyone to enthusiastically pull out an etude book and metronome. Furthermore, motivating through fear can hamper productivity and limit the potential for the student to find creative solutions to technical problems.[17] Instead, a teacher might offer the student a wealth of *ways* to practice, thus making repetition and the path to progress more enjoyable and strategic.

"Our band always gets a superior rating."

This quote is common in programs with traditions of success and is likely stated in a rehearsal room where decades of trophies and plaques are displayed. It can boost an ensemble's sense of collective efficacy to belong to such an award-winning group. However, for the student prone to performance anxiety, the pressure of keeping superior group prominence can become burdensome and shift the focus of performance from music making to status maintaining. From another perspective, could such a statement also cause some students to inappropriately doubt their own worthiness to belong to this group in the first place? Karin's research on females in high-achieving ensembles suggests that it might.[18] Because festival ratings are given by an outside source (e.g., external judge) and are not in the students' control, this statement could wreak havoc on a student who is already grasping for a sense of musical purpose.

We recommend shifting the focus from an externally given rating to particular performance qualities that the student *can* control, such as richness of tone, accuracy of pitch, expressiveness, and so on. The students might be asked what goals they have for a performance, both individually and collectively, after which the teacher can provide specific suggestions for helping the students to reach these goals. Supporting students in achieving their own self-set goals and aspirations can foster a kind of intrinsic motivation that is likely to have longer-lasting effects than an external rating.[19]

"If we get second place after Big News High School, that's like getting first."

We mentioned how the previous quote shifts the focus from musicianship to an external evaluation. This quote goes one step further by making the external evaluation socially comparative, one in which students are ranked against one another and there is a clear "winner."

First, let's contextualize this quote a bit: If said *before* the competition, this is setting up students for a "second-best" attitude, as it implies that even the most solid of efforts on their parts would not be of competitive quality, perhaps discouraging students from giving their all. On the other hand, this comment could be slightly less problematic if offered as encouragement *after* students have received second place behind BNHS, as it might help to establish a sense of accomplishment in their own achievements despite the overall outcome.

Regardless, a comment ground in comparison still places the ceiling of success below Big News High for future events. The comment focuses student attention away from technical aspects of musicianship, expressiveness, and self-mastery, instead making the goal about placing above someone else. While contests may help prepare students for the competitiveness of professional careers across many disciplines, the risk lies in educational contexts where teachers favor competition as a motivation to practice over the sheer satisfaction of technical mastery, the latter

of which is crucial in adequately equipping a student to participate in competitions more confidently.

Competition may not be as motivational as we think in the long term; we have found that ratings and placements—even subjective ones—speak louder than encouraging words in environments that are set up to compare students against one another.[20] As with the previous quote, this comment may shift student focus from elements of the performance that they can regulate and maintain to things that are beyond their control. We recommend, therefore, that teachers guide students in self-assessment that compares the performance to personal best, asking such questions as

1. Was this your personal best?
2. If yes, how did you achieve it?
3. If no, how you can you achieve this next time?

This approach shifts the focus of "win or lose" to personal and collective accomplishment and emphasizes technical means for improvement that will better empower the student with skills for future success.

"I have no patience for students who play out of tune in first position."

This quote says more about the teacher's limited patience than the student's ability. While we commend this teacher for at least admitting to having a lack of patience, we encourage this teacher to shift the focus away from the teacher's disappointment and instead think of creative ways to help the student develop proper technique.

"Your sister gets up early to practice. Maybe you should try that."

This quote needs a bit of context before we consider how helpful or problematic it is. Did the student ask for feedback that was specific to the student's sister, or is the teacher simply offering a comparison that the student didn't ask for? Unsolicited comparison between students (in this case, siblings) is rarely helpful to either of them. Being singled out as the model might initially boost our sense of accomplishment but can also put undue pressure on us to perform or maintain that status. Social comparisons are especially detrimental to students who are already struggling or behind their peers,[21] which suggests that this kind of educational approach is anything but helpful to students in need of guidance.

Perhaps the teacher might shift the focus to the students' own musical goals and values and help them to determine whether present practice strategies align with the steps necessary to reach those goals. Once students have had an opportunity to determine their own hopes for performance, they will be more likely to welcome suggestions for prioritizing and time management from someone else. Asking questions rather than telling students what to do gives them a sense of ownership and au-

tonomy, as well as fosters independent problem-solving skills that will pay dividends when students find themselves under pressure.

"Wow, you always nail that shift! You're so talented."

This comment is intended to be encouraging but is problematic and potentially hurtful in a number of ways. First, inherent in this comment is a suggestion that the shift might be difficult or might be regularly missed by other people. If the student is always nailing it, then it is likely that the student has never considered the possibility that it could be missed.

Second, praise may be just as controversial as competition and is certainly complex in its influence on students. Hundreds of studies have found that extrinsic rewards undermine intrinsic motivation,[22] and praise can be detrimental if it shifts the educational focus from mastery of skills to the receipt of a reward or to pleasing a teacher.[23] Furthermore, the word *always* sets up a perfectionistic expectation that doesn't allow room for human error.

Third, telling the student, "You're so talented!" suggests that there is no rhyme or reason to the success—as if chance, fate, or innate ability has made it so rather than effort or intelligent execution. This shifts the locus of control away from the student to some external force over which the student has no influence. By focusing on the student's natural ability rather than on the effort or skills necessary to accomplish the task, the comment promotes a fixed mindset rather than a growth mindset.

We recommend instead to praise the effort and strategy behind an accomplishment (in our example, the shift) with specific, instructional words, such as "Yes, leading that shift with your elbow really makes it relaxed, doesn't it?" Conversely, depending on the student, even bringing up the mechanics behind something that is going well might unnecessarily interrupt a state of flow and "psych out" students who are prone to obsessing. Know your student's needs, praise only as instructionally helpful and appropriate, and then let it go.

"Just relax!"

This quote is laughable to anyone who lives in a chronic state of tension (actually, if they did laugh, then that would be one step in the right direction). While some people can simply relax on request, many students who are prone to performance anxiety have encoded trauma or have developed habits of physical stiffness that are not so easily dismissed by a simple reminder or word of encouragement. In fact, telling students to *just* relax can, in some cases, be yet another devastating affirmation of failure that they can't perform the way they're supposed to—when they simply *don't know how* to do so.

When it is clear that a student struggles to "just" relax, we recommend that the teacher provide specific tools and strategies that the student can practice. While they may take some time to become habitual, these tools can have long-lasting positive effects

when practiced regularly. These might include breathing exercises, such as those recommended in the self-help resources (chapter 9); body scanning (the chapter 6 activity); and monitoring thoughts, as described throughout the book.

"You just need to keep practicing. You'll get it."

Of course repetition is important; in many cases, students really do need to simply drill technical passages rather than wait for the talent gods to appear at their doorstep. Whether you're a believer in the "10,000-hour rule,"[24] ten years of deliberate practice,[25] or Suzuki's "knowledge plus ten thousand times,"[26] you'll likely agree that telling students to practice over and over without more specific direction is unlikely to promote mastery and confidence. Instead, it may serve to reinforce improper technique and, in turn, encourage anxious performances.

Researchers have uncovered characteristics of "deliberate practice" that create optimal conditions for learning. These include:

- motivation to attend to the task and exert effort to improve,
- the ability to transfer prior knowledge to the new task so that it can be quickly and correctly understood,
- immediate informative feedback, and
- repetition of same or similar tasks.[27]

This list reveals many conditions for effective practice that can be supported by the teacher, who has the opportunity to set the student up with developmentally appropriate, achievable steps to practice that can then be regulated through teacher feedback. "Just practice" may, therefore, be as ineffective as "Just relax" if a student lacks knowledge about *how* to practice.

Students need more specific tools to take with them into the practice room. These might include breaking down a technique into smaller steps or, alternatively, using analogies or technical strategies that they already know from other realms of experience. We offer one example to illustrate what we mean: If a brass player's aperture (where the air flows through the lips) is too small or too large, then it is often helpful to call upon the student's memory of sensations by asking the student to imagine that there is a large milkshake straw or a small coffee stirring straw between the lips. When students recall those feelings, it is more likely that they will be able to adjust their aperture by transferring knowledge from a previous experience to their playing.

"Why do you always miss that entrance?"

Most of us will spot the hurt in this statement from a mile away; unfortunately, this kind of impatient teaching is still a reality in many studios and rehearsal rooms. Furthermore, when yelled at a student, this quote is potentially damaging and only effective with a small portion of resilient individuals who thrive off

military-style motivation.[28] No matter the tone used, it is possible to turn this question into one that is more constructive, such as "What do you think are some ways that you could ensure that you make this entrance?" or "I want to make sure you are clear about where to enter here. Can we talk through the specifics and make sure you're set up with a good strategy?" The difference may merely require a deep breath, patience, and thoughtful consideration, coming from a place of instruction rather than reaction.

As addressed earlier, it may also be that the student needs more specific guidance or smaller steps to practice. For example, it is possible that the student has not had an opportunity to listen to enough recordings of the piece to understand her part within the context of the piece. Taking time in class or lessons to listen to sections of the recording with students, pointing out important clues about themes and form, might help them make better sense of what is going on in the larger context. In ensemble situations, it might also be helpful to point out other performers who are playing the same pitch or a reference pitch prior to this entrance, so that the student is not attempting to make an entrance solely on embouchure or feel.

"Come on, man. I expect more from you."

With a student whose sense of self-efficacy is already high, this statement can be motivational and encouraging and might be heard as, "I know you can do this with some additional focus." However, with a student whose sense of self-efficacy is low, this statement is likely to further diminish a sense of mastery rather than enhance it. In Karin's research of high-achieving orchestra students, for example, she found that students with higher beliefs about their own abilities were more positively influenced by negative conductor feedback and were able to interpret negative feedback as a means for reaching personal potential. The opposite was true for those with lower self-beliefs, who reported that negative conductor feedback was diminishing to their sense of self-efficacy.[29]

So, what to do? First, be sensitive to your students. When working with an individual or collective group who you *know* has a high sense of self-efficacy, you might consider reminding them that you know that they are capable of more. Note, however (because humans by nature fluctuate in mood and self-belief), that what motivates a student one day might send the same student into a panic another day. Notice in each moment how your students respond, and be willing to shift gears when necessary.

Also, this quote personalizes musical accomplishment, making it more about the individual's success rather than about execution of a particular task. This kind of ego driving might get a fast reaction from a student in the moment but may cause long-term damage if the student begins to equate performance—either good or bad—with self-worth. As a wise mentor once said, "Perfectionism should be about things, not people." Therefore, consider focusing your comments on techniques and musical approaches rather than on students themselves.

"Good."

This is perhaps the most commonly used word in music teaching. While intended to be encouraging and complimentary, overuse of *good* can send this word into the category of extraneous and time-wasting statements, such as *um* and *like*. At best, it will still be perceived as positive praise; at worst, its overuse will start to equate with "OK, stop, I've heard enough." We recommend using praise in a specific, honest, efficient, and instructional way—following a performance that is truly praiseworthy. Examples include, "Your tone really improved that time," "Those dynamics added to the expression of the piece," or "Those rhythm exercises you did last week seem to have helped the facility in this passage."

Some teacher educators speak about the "compliment sandwich," in which instruction is placed between two compliments, perhaps to lighten the blow of the impending critique. While we certainly encourage being positive, compliments need to be authentic and useful to the student to be meaningful and worth the instructional time. Merging compliments and instructions together can be the best use of teaching time. Examples include "Increasing the bow speed really helped that crescendo! What are some other ways that you can raise the volume even more?" or "Listening to the flute soloist really improved the intonation and phrasing; now listen to the percussion section to make sure it holds together rhythmically."

An alternate approach is to serve as a self-assessment facilitator and ask the student what went well or what needs to improve. For example, by asking students to identify their strengths, the teacher gains important information about the quality level the students find acceptable and their ability to hear discriminately. If the students erroneously identify weak aspects as strengths, then it would be important to help them to learn how to listen and discriminate more carefully. Additionally, when students are asked to identify weaknesses for themselves (rather than having a teacher point them out), they might feel more empowered to make changes and take risks, as they have a greater sense of control.

"I think you're a wonderful person no matter how you do in this performance."

As described earlier, self-esteem and self-belief in your ability to perform are different things; one might be a complete mirror-fawning narcissist but still not believe in one's ability to perform arpeggios on the flute. While self-efficacy belief can encourage general self-esteem,[30] it is less likely that self-esteem will lead to a higher belief in a specific task-based ability. Whereas this teacher's quote might help students know that they are loved, these words may do little to help them feel confident about a performance.

Second, similar to the statement "No matter what happens, you're still a winner to me," some students might interpret these words as the teacher giving up hope on their abilities to perform. The comment might then discourage some students from taking risks now or in the future. Furthermore, even though the teacher is stating that self-worth and performance are not related, by bringing this up in the first place, it might suggest the opposite to a student whose self-esteem is already low.

We suggest, therefore, that teachers keep their comments about the person separate from those about the performance. For more ideas, please see the following textbox.

Considerations for Creating a Safe Space

- Listen and be emotionally present with students. Recognize how needs differ and change from day to day and from student to student.
- Use ability-appropriate and challenging situations to stimulate students.
- Focus on the challenge at hand rather than causing students to compare themselves with others.
- Be sensitive to the relationship between students' musicality and their personal lives.
- Do not equate student achievement (either positive or negative) with student worth.
- Some instruction must be unconventional. Be willing to think creatively, and allow students space to try things out in their own ways.
- Educate others (e.g., parents, other students) about creating a safe space, both through words and through modeling.

Source: Adapted from Karin S. Hendricks, Tawnya D. Smith, and Jennifer Stanuch, "Creating Safe Spaces for Music Learning," *Music Educators Journal 101*, no. 1 (2014): 38–39. Please see the complete article for more information and insight.

PRIORITIZING EMOTIONAL HEALTH IN MUSIC LEARNING COMMUNITIES: HOW TEACHERS AND ADMINISTRATORS CAN HELP

Music performance anxiety is often a taboo subject in music education circles. This is possibly due to a number of issues, including the stigma of performance anxiety as a mental illness and cultural values and perceptions that make performance about the "survival of the fittest" rather than expressive intent. The myth that seeking treatment for MPA (or any other mental health issue, for that matter) is a sign of personal weakness may keep people from talking openly about their fears or pursuing the professional help they need.[31] In truth, stage fright is a common issue—one that has affected even the greatest performers—and we believe it should be as openly discussed and addressed as are embouchure, bow hold, and diction.

Music teachers and administrators of music schools could do a great service to students by not only openly discussing MPA but also offering workshops and group classes in particular therapies, such as yoga, Alexander technique, and progressive muscle relaxation, among others. Guest lectures and workshops by performance coaches could not only expose students to the effectiveness of performance psychology but also may potentially ease the discomfort typically associated with mental and emotional health. Music psychotherapist Julie Nagel recommends that traditional

music curricula be balanced with such courses as the psychology of stage fright, performer physiology, audition strategies, career guidance, and nutrition.[32] If the mission of conservatories is to equip students with the tools necessary for a successful career in performance, then offering classes and guidance of this nature would better ensure its accomplishment.

We also encourage proactive administrative involvement to monitor and promote emotional wellness among students and teachers. In 1978, Rober Nideffer and Nancy Hessler outlined a variety of proactive steps the Eastman School of Music was taking at that time to ensure student mental well-being. Interestingly, the authors found the student profile of greatest concern to be those who reacted to anxiety "by quiet withdrawal":

> Often these individuals drift along, performing at an acceptable level, but not achieving their potential and not getting needed feedback from instructors. They feel too anxious to ask for feedback and interpret the fact that it is not given as either rejection or a lack of concern. They see other (more demanding and vocal) students getting the time and attention. Their anger, resentment, and anxiety build and their confidence decreases. . . . [U]ltimately the blame may be directed inward, accompanied by a feeling of unworthiness, and then the student may drop out entirely.[33]

More open communication about music performance anxiety may encourage these students to seek the help they need before they drop out, develop more serious mental health issues, or experiment inappropriately with self-medication.

The emotional need for a student to feel positive support from a private instructor may be crucial to some students' success. Because musicians typically begin studying their instruments at an early age, students spend these critically formative years in lessons with "metaphorical parental surrogates."[34] Julie Nagel suggests that teachers and administrators would benefit from becoming increasingly sensitive to their role in each student's development; they must be "emotionally present" but at the same time have a clearly defined referral network to call upon when needs extend beyond the instructor's professional capabilities.[35]

Using satire, Nagel describes "how to destroy creativity" in students:

> Do not think of a career in music in the context of the whole person. Insist on better technique, winning competitions, and earning awards to enhance the reputation of the teacher and the school. . . . Maintain the attitude that more hours spent practicing will eventually pay off in better performances, performance opportunities, and higher earnings. One just has to become "good enough."[36]

As we know, however, the fear of *not* being good enough only perpetuates anxiety. And, as Nagel contends, the relentless "work harder" ethic rarely renders the same results on stage as it does in the practice room.

As discussed in chapter 2, perfectionist tendencies (projected on yourself as well as others) often foster inhumanly flawless standards, which are only made worse when perfection becomes a higher priority than expression. As Cynthia Lawrence says in

her "From the Stage" interview in chapter 1, the task at hand is not getting approval; it's telling the story. How much more effective and empowering is an emphasis on creativity and distinctive voice? "Be expressive" isn't simply a line to give students or performers who aren't technically sound. It isn't an excuse for avoiding hard work. It's the reason we do what we do. Performance coach and psychologist Jon Skidmore reminds us that, with every performance, there comes a time to accept where we are in our musical journeys and to just get out there and do it.[37]

SUMMARY AND CONCLUDING THOUGHTS

This chapter offers teachers new ideas for helping students to prevent and manage music performance anxiety. We introduce psychological concepts of flow, self-efficacy, mindset, and cognitive self-regulation to provide specific strategies for aiding students in developing a more accurate sense of their capabilities and to promote positive musical growth. In the "Messages from Teachers to Students" section, we challenge commonly used phrases in order to help teachers rethink and reflect on the ways in which their words might influence student self-beliefs. Finally, we offer a plea to music teachers and administrators to talk openly with students about the realities of MPA and to offer supports that promote mental and emotional health.

We cannot end this chapter without emphatically encouraging teachers to similarly practice self-awareness and healing of their own mental and emotional health. As in every caregiving profession, teachers who are constantly in service to others often neglect themselves and their own physical and emotional needs. Not only can this lead to teacher burnout, but it also can wreak havoc on personal lives and make well-meaning teachers less effective in caring for students in the ways that they need. We know this because we have personally experienced it, having turned to many of the therapies in this book out of a love for our students and a desire for better answers. As teachers, we have learned that we can model anxiety, stress, and reactive behavior, or we can model self-care, mindfulness, and creative problem solving. The choice is ours, but as Stephen Sondheim reminds us, "children will listen."[38]

ACTIVITY: REDUCING THE STIGMA OF MPA

Reflection for Awareness: How Do Language and Actions Contribute to a Culture of Music Performance Anxiety?

The following questions will increase your awareness of systemic and cultural practices that can reinforce conditions of anxiety and discourage others from seeking help. It is important to identify these issues in order to create a culture around music performance that is healthy, inclusive, and supportive of everyone.

1. List words or phrases that people (you or others) often say in the following situations:

 - Going into an audition
 - Coming out of an audition
 - About other performers with whom you are competing
 - When motivating yourself (or others) to practice
 - Talking about performers or students when they are not present
 - When a public performer shows obvious signs of anxiety
 - When describing anxiety

Other Thoughts for Consideration

 - In competitive situations, do you hear others make judgmental comments about other performers? Are these personal attacks on their overall musicianship or more neutral comments about the positive and negative aspects of a specific performance?
 - What language is commonly used when discussing someone's anxiety? Is it supportive or judgmental?
 - What kinds of words make you or others feel anxious?
 - What kinds of words make you or others feel powerful?
 - When, where, or with whom is a discussion of MPA taboo? When, where, or with whom can you openly discuss MPA?
 - When or with whom is it safe to reveal your own feelings of anxiety?
 - When or with whom is it not safe to reveal your own feelings of anxiety?
 - In what ways do you (or others) try to control a situation rather than face feelings associated with anxiety?
 - In what ways do you (or others) try to avoid feelings associated with anxiety?

Additional Questions for Teachers

 - What kinds of fears are your students manifesting? Is it healthy excitement? Discomfort? Dread? What are appropriate responses to each of these kinds of fear? (Is this a serious case where students need to talk with a counselor or simply a moment to channel energy into greater expression?)
 - What labels do students prefer to use to describe their own nerves?
 - When a soloist shows obvious signs of anxiety, how much specific commentary about the anxiety is appropriate? When is it too much? When is it not enough?
 - How can the stigma around music performance anxiety in your studio, school, or work environment be reduced?
 - What conditions, cultural practices, or situations can be changed or eliminated to create a more supportive environment for musician health and well-being?
 - What can you do to make resources available to students or colleagues?

Application and Integration to Practice: Choosing to Speak Up or Act

Perhaps now you have a few ideas about how you could change the way people talk or act in your studio, school, or performance environment to create a healthier, more uplifting, and inclusive environment for everyone. Make a list in your journal of things you can say, change, or do differently.

JOURNEYS: TODAY DOESN'T HAVE TO BE TOMORROW

By Tawnya

Jenny's Journey

As a teacher, I have worked with students with varying levels of MPA. I could share many stories, but I will share Jenny's story here because it helps us to see how MPA can be influenced or even caused by difficult life circumstances. This story starts when I got a call from Jenny's mother. She was very concerned because Jenny was skipping school on the days of band quizzes, and she was afraid that absences from school were starting to hurt her otherwise reliable academic performance. Jenny's mom, who was recently divorced and working long hours, had approached me in hopes that private lessons would help equip her daughter with the musical skills and courage she needed to walk through the door on band quiz days.

When Jenny came to her first lesson, her energy was low, she looked down at the floor, and she made little eye contact. When we talked about her next band quiz, she seemed a bit defensive and ashamed to know her mother had told me that she had skipped school. As I got to know Jenny and her mother those first weeks, I learned that Jenny's dad had left and her parents were going through a tough divorce. Both of them were in a fragile state, and I could sense the rejection, hurt, and vulnerability.

I kept Jenny's lessons focused on learning the basics and made certain she was adequately prepared for quizzes and performances so that she could build up a sense of mastery. As her grades improved on the quizzes, her anxiety lessened, and the overwhelming feelings of dread she'd once experienced eventually subsided.

After only a few months of working together, I surprised Jenny one day by suggesting she prepare a solo for contest. With my encouragement and the support of her band teacher, she eventually agreed to participate and went on to earn a superior rating. At the contest, I ran into Jenny in the hallway near the bulletin board where they posted the ratings. When she saw her rating, her face lit up with excitement, and her energy was suddenly strong! At least in this moment, it seemed she had forgotten to be sad, scared, or self-conscious.

Jenny was certainly building confidence. However, as her self-esteem improved, she had to confront and break "mental spells," or deep patterns of self-judgment that she had learned from others who were extremely critical. For example, when she said

that her playing "sucked" during a lesson, I reminded her of her success at the contest earlier that year and that the music she was playing now was much more challenging than the required band quizzes. Providing this perspective helped her to redirect her negative thinking and start to question negative feelings when they came up. While modeling a neutral voice (that was honest about her strengths and weaknesses) was helpful to Jenny, I realized that she carried negative thought patterns that ran much deeper than those related to her playing. This came out in comments she made about her week, how she was doing in school, or about her family life. Knowing that I was not qualified to help her with these issues, I recommended that she also work with a therapist. Over time, this did help Jenny to heal and to gradually regain more of her confidence. By the middle of high school, she sat at the top of her section and was a strong leader. Later, she went on to study music therapy as an undergraduate.

Jenny's story is important because it demonstrates how an intervention can change one's course and foster healing. Had Jenny's mother not been able to enroll her in lessons or take her to a therapist, it is likely she would have dropped out of band and would be on a very different career path. I also share this story to show that mental healing is as real as physical healing. While we rarely talk about this in our society, our mental health is constantly influenced by our life events, and we all go through periods when we are more or less mentally healthy. Just like we consult a physician for medical care, most people at some point in their lifetime find therapy or psychiatric interventions needful to restore their mental health.

Everything at the Proper Time

I grew up in a rural area without a qualified horn teacher, and as a result, I started my undergraduate studies largely self-taught. Realizing my deficiencies, I spent the first two years in college working to catch up to my peers. By my junior year, I had won the principal horn position in the university's top wind ensemble.

While my abilities were progressing and I was gaining confidence in my playing, during that semester I started to feel that my personal life was going in a direction that would ultimately not be accepted or understood by my religiously conservative family: I was "coming out" as a lesbian. In facing these changes to my identity, I fell into a serious depression, and though I had historically been an honor student, by December I had failed most of my classes and was too emotionally distraught to perform.

The following semester my audition did not go well. I earned a principal chair but in the second ensemble. Because this was the same seat I auditioned as a freshman, I felt humiliated and discouraged. All of the confidence I had gained on account of hard work and diligent practice quickly dissipated, and I felt I had lost the respect of my teachers and peers. During that time, I had a great deal of confusion about my identity and was too vulnerable to share my story with anyone. This isolation only intensified my self-conscious thoughts and fears of rejection. Eventually, I sought the help of a counselor and began the difficult process of rebuilding my playing, my academic performance, and my self-esteem.

To make up for what I had lost musically and academically, I decided to stay a fifth year at the university. While my self-confidence did slowly improve and I was able to restore my grades, I was still depressed and did not have the energy to work as diligently as I had in the past. My progress was much slower, and my studio teacher became frustrated, as there was little he could do to help me. When it came time for my senior recital jury, I barely passed. Looking back, I realize now that I was poorly prepared but was under pressure to perform in order to graduate on time. My performance was mediocre and at a much lower level than I knew I was capable had I not been depressed. After I graduated, I took a position as a band director and stopped performing on my instrument. It took me eleven years before I was ready to pick up my instrument again to further strengthen my musicianship. At that point in my life, my identity had stabilized, and I had recovered from the depression, so I prepared an audition and entered graduate school. Two years later, I performed a successful graduate recital, and as a result, finally felt like a competent horn player again. While my career goal has never been to make a living as a performer, I now feel I can demonstrate solid musicianship as a teacher, which is very important to me. More importantly, I now enjoy performing again and have organized several benefit recitals in my community.

While my story may not seem at first to be related to performance anxiety, I share it here as a way to show how mental health challenges can impact our abilities to perform up to our potential and can cause situational episodes of performance anxiety. During the time of my depression, I was very self-conscious and overly preoccupied with what others thought of me. This caused me to experience performance anxiety when previously it had not been a serious problem. Because I had experienced "failure" for the first time in my academic life, my confidence was seriously shaken, and because I feared my family and community would reject me, I felt vulnerable and alone. These overwhelmingly self-conscious feelings made the conditions right for me to experience intense feelings of performance anxiety.

I also share this story to show how important it is to be adequately prepared, especially when performing as a soloist, in chamber ensembles, or in any situation where your playing is very exposed to the audience. Performing my senior recital was a humiliating experience, not because it was a total flop but because I knew that I wasn't ready emotionally and was not prepared musically to perform at my best. Looking back, I wish that I had waited to perform until I was more emotionally stable. Even a few months could have made an important difference, as the outcome of the recital may have strengthened rather than weakened my confidence.

Our Mental Health Fluctuates

Like Jenny, I had experienced a situational challenge to my mental health that had an impact on my ability to face performance situations. If things are not going well in your life, then performing can be an extremely vulnerable experience. When I performed my senior recital, I felt everyone in the room could see (or hear) how

awful I felt about myself. The last thing I wanted to do was to perform in front of an audience. Whether a person is living with ongoing mental health issues or is working through situational depression, grief, or anxiety, these conditions typically do have an effect on one's ability to perform at peak levels. As performers, teachers, and learners, we need to be aware of this and respond in a healthy way. In cases like these, delaying a performance until the performer has stabilized mentally or giving a performer longer to prepare as they navigate ongoing challenges may prevent deeper, more challenging mental hurdles that result when musicians perform before they are prepared.

JOURNEYS: LESSONS

By Casey

One of the most valuable things specific to music study is the role of a private teacher. While I can't speak from experience of parallels in other disciplines, I rarely notice a similar opportunity for weekly, one-on-one time with an expert in the field. And being that music is such a personal, emotionally driven endeavor, we often find that our musical mentors provide just as much guidance in performance practice as they do in living a purposeful life.

Figure 8.2. Larry Shapiro, violinist and artist-in-residence at Butler University, coaches Casey on orchestral excerpts. *Photo courtesy of Casey McGrath*

I met my first teacher in my late teens. His name is Jesus Florido, and he held an adjunct position in music at the university where I rehearsed for youth symphony. I approached him one night and asked if he could teach me Vivaldi's Spring concerto because I hoped to go to into music. To his credit, he didn't laugh, though he rightfully should have: I hadn't had private lessons until then and so remedial that he had once commented to my conductor after hearing one of my auditions, "If you cover your ears, she's great!"

Admittedly, my sense of rhythm was embarrassing. I couldn't play in tune, and most of the time, I had no idea what note was coming out of my violin. But Jesus taught me anyway, and though I was far too behind for a timely conservatory audition, I did end up being accepted to his alma mater, Butler University, where he passed me onto the colorful, dedicated, and most patient soul I've ever known, Larry Shapiro.

Larry is the kind of teacher who didn't flinch when I told him I had no idea what a 4/4 meant. He waited without exasperation for me to bring a metronome into my practice room. He observed over my shoulder as I played, pointing out tiny solutions and responding with a knowing shrug when it remedied each respective technical impairment. With every performance breakthrough, he would fold me into a path-affirming hug, offering his congratulations for every single baby step forward, be it the one shift I finally nailed or the fact I was playing more confidently and with more poise and assurance than ever. He never looked surprised, just quietly validated—it was all part of the process, he advised me early on, of becoming the musician I was destined to be. And while I know I still had—and continue to have with each new goal—an overwhelmingly challenging climb before realizing my musical aspirations, the uncompromising encouragement Larry provided at that pivotal time will invariably heal my spirit from what has already proven to be a ruthlessly distressing process.

When I graduated with my doctorate, I wrote him a letter of thanks, saying,

> I could barely stay in one key or count my way through six measures, but you encouraged me despite all of my technical shortcomings, all of my self-doubt and negativity, all of the moments any other teacher would have rightfully written me off. . . . Whenever I solo with an orchestra, I always think about how impossible it would have been to get there without you. I knew exactly two pieces of repertoire when I came to you, but you believed in me, anyway.

To which he responded, "Of course I always believed in you: With your passionate emotional instrument, incredible intensity, and dogged determination, how could I have done otherwise?"

Larry Shapiro was not just a teacher—to me, he was a lighthouse, a beacon to remind me of everything worth pursuing in this world, including the dreams we have when we are still too young to consider logic and limitation. To have crossed such intimate paths with a person who celebrates the wealth of good in every moment and every student, to have had the privilege of spending a short but formative time in the company of someone with so much faith in his heart that he inspires those

Figure 8.3. Casey performs a solo concerto with the Fox Valley Orchestra. *Photo courtesy of Tom Bahar*

around him to cultivate their own, I was more than lucky—I was blessed. And while I may have many more failures and moments of question ahead of me, I need only think of my early years with Larry to reason with dejection, take a deep breath, and put my violin back under my chin where it belongs.

NOTES

1. Mihaly Csikszentmihalyi, *Flow: The Psychology of Optimal Experience* (New York: Harper and Row, 1990).

2. See, for example, Jon Gorrie, *Performing in the Zone* (Self-published, printed by CreateSpace, Charleston, 2009).

3. Personal communication, Fall 1995.

4. Karin S. Hendricks, "The Sources of Self-Efficacy: Educational Research and Implications for Music," *Update: Applications of Research in Music Education* (2016): 34.

5. Albert Bandura, *Self-Efficacy: The Exercise of Control* (New York: W. H. Freeman, 1997).

6. Ibid.

7. Ibid.; Karin S. Hendricks, "Relationships between the Sources of Self-Efficacy and Changes in Competence Perceptions of Music Students during an All-State Orchestra Event" (PhD diss., University of Illinois at Urbana–Champaign, 2009). See also Hendricks, "Sources of Self-Efficacy."

8. See Hendricks, "Sources of Self-Efficacy"; Karin S. Hendricks, Tawnya D. Smith, and Jennifer Stanuch, "Creating Safe Spaces for Music Learning," *Music Educators Journal* 101, no. 1 (2014): 35–40.

9. Hendricks, "Relationships between the Sources of Self-Efficacy."

10. Hendricks, "Sources of Self-Efficacy."

11. Karin S. Hendricks, "Changes in Self-Efficacy Beliefs over Time: Contextual Influences of Gender, Rank-Based Placement, and Social Support in a Competitive Orchestra Environment," *Psychology of Music* 42 (2014): 347–65. See also Karin S. Hendricks, Tawnya D. Smith, and Allen R. Legutki, "Competitive Comparison in Music: Influences upon Self-Efficacy Belief by Gender," *Gender and Education* (2015), accessed November 23, 2015, doi:10.1080 /09540253.2015.1107032.

12. James R. Austin, "Competition: Is Music Education the Loser?" *Music Educators Journal* 76, no. 6 (1990): 21–25; James R. Austin, "The Effect of Music Contest Format on Self-Concept, Motivation, Achievement, and Attitude of Elementary Band Students," *Journal of Research in Music Education* 36 (1988): 95–107; Charles P. Schmidt, "Relations among Motivation, Performance Achievement, and Music Experience Variables in Secondary Instrumental Music Students," *Journal of Research in Music Education* 53, no. 2 (2005): 134–47; Albert Lee Wood, "The Relationship of Selected Factors to Achievement Motivation and Self-Esteem among Senior High School Band Members" (PhD diss., Louisiana State University and Agricultural and Mechanical College, 1973).

13. Carol S. Dweck, *Mindset: The New Psychology of Success* (New York: Random House, 2006).

14. Ibid., 11.

15. Bandura, *Self-efficacy*; Albert Bandura, *Social Foundations of Thought and Action: A Social Cognitive Theory* (Englewood Cliffs, NJ: Prentice Hall, 1986); Barry J. Zimmerman, "A Social Cognitive View of Self-Regulated Academic Learning," *Journal of Educational Psychology* 81, no. 3 (1989): 329–39.

16. Hendricks, "Relationships between the Sources of Self-Efficacy."

17. Bill Breen, "The 6 Myths of Creativity," *Fast Company*, December 2004, accessed April 25, 2016, http://www.fastcompany.com/magazine/89/creativity.html; Eric Jensen, *Teaching with the Brain in Mind*, 2nd ed. (Alexandria, VA: Association for Supervision and Curriculum Development, 1998); Joseph LeDoux, *The Emotional Brain: The Mysterious Underpinnings of Emotional Life* (New York: Touchstone Books, 1996); Joseph LeDoux, "The Emotional Brain, Fear, and the Amygdala," *Cellular and Molecular Neurobiology* 23, nos. 4–5 (2003): 727–38.

18. Hendricks, "Changes in Self-Efficacy Beliefs."

19. Edward L. Deci and Richard M. Ryan, *Self-Determination* (Indianapolis: John Wiley and Sons, 2010); Rebecca A. Roesler, "Musically Meaningful: The Interpersonal Goals of Performance," *Music Educators Journal* 100, no. 3 (2014): 39–43; Richard M. Ryan and Edward L. Deci, "Self-Determination Theory and the Facilitation of Intrinsic Motivation, Social Development, and Well-Being," *American Psychologist* 55, no. 1 (2000): 68–78.

20. Hendricks, "Changes in Self-Efficacy Beliefs"; Hendricks, Smith, and Legutki, "Competitive Comparison in Music"; Hendricks, Smith, and Stanuch, "Creating Safe Spaces."

21. Hendricks, "Relationships between the Sources of Self-Efficacy"; Susan A. O'Neill, "Flow Theory and the Development of Musical Performance Skills," *Bulletin of the Council for Research in Music Education* 141 (1999): 129–34.

22. Edward L. Deci, Richard Koestner, and Richard M. Ryan, "A Meta-Analytic Review of Experiments Examining the Effects of Extrinsic Rewards on Intrinsic Motivation," *Psychological Bulletin* 125, no. 6 (1999): 627–68.

23. Alfie Kohn, *Punished by Rewards: The Trouble with Gold Stars, Incentive Plans, A's, Praise, and Other Bribes* (Boston: Houghton Mifflin,1999).

24. Malcom Gladwell, *Outliers: The Story of Success* (New York: Little, Brown, 2008).

25. K. Anders Ericsson, Ralf T. Krampe, and Clemens Tesch-Römer, "The Role of Deliberate Practice in the Acquisition of Expert Performance," *Psychological Review* 100, no. 3 (1993): 363–406.

26. "Suzuki Principles in Action," *Suzuki Association of the Americas,* accessed February 16, 2015, https://suzukiassociation.org/teachers/training/spa/, para. 1.

27. Ericsson, Krampe, and Tesch-Römer, "Role of Deliberate Practice," 367.

28. Although the question doesn't have to be yelled to be hurtful, we take this opportunity to emphasize that yelling is alive and well in some studio and rehearsal spaces—as is the throwing of music stands, forcing students to do push-ups for infractions during marching band rehearsals, and so on. These extreme cases stem from a tradition where teachers motivate through fear and strive to "toughen up" players, which we personally believe to be the opposite of what students need to become sensitive, authentic performers.

29. Hendricks, "Relationships between the Sources of Self-Efficacy."

30. Bandura, *Self-Efficacy.*

31. Anne M. McGinnis and Leonard S. Milling, "Psychological Treatment of Musical Performance Anxiety: Current Status and Future Directions," *Psychotherapy: Theory, Research, Practice, Training* 42, no. 3 (2005): 357–73.

32. Julie J. Nagel, "How to Destroy Creativity in Music Students: The Need for Emotional and Psychological Support Services in Music Schools," *Medical Problems of Performing Artists* 24, no. 1 (2009): 16.

33. Robert M. Nideffer and Nancy D. Hessler, "Controlling Performance Anxiety," *College Music Symposium* 18, no. 1 (1978): 151.

34. Julie J. Nagel, "Treatment of Music Performance Anxiety via Psychological Approaches: A Review of Selected CBT and Psychodynamic Literature," *Medical Problems of Performing Artists* 25, no. 4 (2010): 142.

35. Nagel, "How to Destroy Creativity," 17.

36. Ibid., 15.

37. Jon Skidmore, *Relax the Body and Focus the Mind,* compact disc, recorded 2003, Orem, UT: Jon Skidmore, available at www.jonskidmore.com.

38. Stephen Sondheim, *Into the Woods* (New York: Rilting Music, 1989).

9

Self-Help Books and Other Resources

In addition to scholarly articles and experimental studies (as cited throughout this book), a number of notable texts and other resources have been published that offer help for musicians dealing with MPA. Several of these resources have been developed by professional musicians who have successfully confronted their own performance anxiety and who have particular insight relating to specific instruments or performance situations. Other resources, while not music specific, provide valuable strategies for managing anxiety and promoting overall wellness.

This chapter includes brief descriptions of self-help books, CDs, DVDs, websites, and TED talks that supplement various approaches we describe in earlier chapters. We created this list after a thorough review of available resources—some that we have used ourselves, some recommended to us by others, and some that we found by means of an intensive search. This list is by no means exhaustive and includes only those resources that we considered to be most practical, relevant, realistic, research based, approachable, and well respected. We avoided titles that claim to offer instant cures or that lack empirical grounding.

Antony, Martin M., and Richard P. Swinson. *When Perfect Isn't Good Enough: Strategies for Coping with Perfectionism.* 2nd ed. Oakland, CA: New Harbinger Publications, 2009. In chapter 2, we address how perfectionism goes hand in hand with performance anxiety. *When Perfect Isn't Good Enough* provides further insight into the nature and manifestations of perfectionism, while also offering approaches and exercises for coping with a fear of making mistakes. While not focused specifically on music performance, this book features strategies based on cognitive-behavioral therapy (see chapter 3) that could be applied to music-specific settings. The text may be helpful to those who wish to break self-defeating patterns of perfectionism in music performance and in any area of life.

Brown, Brené. "The Power of Vulnerability." Video. TEDxHouston, June 2010. https://www. ted.com/talks/brene_brown_on_vulnerability?language=en. In one of the most-watched TED talks on the Internet, Dr. Brené Brown presents her own research on feelings of shame, worthiness, and courage. In this discussion, she addresses how embracing our vulnerability, or having the "courage to be imperfect," is the key to joy, creativity, and connection. Dr. Brown describes how an attempt to block undesired feelings results in the numbing of all feelings—good or bad—and how those people who risk emotional or psychological pain are also those who open themselves to the greatest joy. We have written about vulnerability (and even experienced it ourselves) while sharing our personal vignettes, and we recommend this talk to anyone in need of a reminder about the importance of being "real" when facing anxiety head on.

Brown, Richard P., and Patricia L. Gerbarg. *The Healing Power of the Breath: Simple Techniques to Reduce Stress and Anxiety, Enhance Concentration, and Balance Your Emotions*. Boston: Shambhala, 2012. This award-winning book and accompanying instructional CD instructs and inspires readers in the practice of breathing. Utilizing techniques from yoga, meditation, qigong, and other traditions, Drs. Brown and Gerbarg provide strategies and exercises to reduce stress, heal trauma, and promote peak performance. This book supplements our discussions of body work, yoga, and meditation in chapter 6 and is an excellent companion to *The Breathing Box* by Dr. Gay Hendricks (described later this chapter).

Buswell, David. *Performance Strategies for Musicians*. London: MX Publishing, 2006. With a clear focus on mental well-being and peak performance, this book offers techniques and strategies to support mental health for the performing artist. The author's focus on mental skills training, breathing, relaxation techniques, and visualization (mental rehearsal) reinforce the benefits of several therapies we highlight throughout this book. An additional section that discusses changing state is similar to the findings of Tawnya's dissertation study and complements the "Identifying and Working with Your Inner Voices" activity at the end of chapter 7.

Cameron, Julia. *The Artist's Way: A Spiritual Path to Higher Creativity*. New York: Putnam, 1992. Got twelve weeks? If so, consider Julia Cameron's book, which offers a step-by-step method for recovering your creative spirit. Each chapter is designed to reclaim specific aspects of the self, such as a sense of safety, identity, power, integrity, possibility, abundance, connection, strength, compassion, self-protection, autonomy, and faith. Written from an open place that will resonate with artists from all disciplines, this book provides helpful self-reflection exercises intended to focus the artist on the unique creative gifts that they alone might bring. Because the content focuses on spiritual aspects of creativity, this book may be helpful to those working to recover their self-esteem or those working to shift their purpose for performing from perfectionism to giving a musical gift. The book can serve as a guide for individual reflection but also contains activities for groups, which may be of particular interest to studio teachers, educators, and therapists.

Childre, Doc, and Howard Martin. *The HeartMath Solution*. New York: HarperCollins, 1999. Although not specifically geared toward musicians, this book provides potentially helpful research-based techniques for lowering stress and increasing emotional and mental clarity. It has a similar style to our book in that it combines research, personal vignettes, and activities

to offer new ways of thinking and being. The authors address issues of perfectionism and self-judgment, such as those we examine in chapter 2, unpacking differences between healthy, empathic "care" and anxiety-producing "overcare." In chapter 3, we include highlights from Childre and Martin's Freeze Frame technique for reducing stress and relearning habits of mind. For those interested in our discussion of "cognitive self-regulation" in chapter 8, we particularly recommend a deeper read of the Freeze Frame material from the book itself.

Conable, Barbara. *What Every Musician Needs to Know about the Body: The Practical Application of Body Mapping to Making Music.* Chicago: GIA, 2000. This is a resource for those interested in learning more about body mapping, a body awareness method for musicians that was informed by the Alexander technique. Complete with visuals and easy-to-grasp discussions of the body's frame, this book offers approaches for enhancing body awareness and developing healthier habits of body use and movement. This text would be most beneficial when used in conjunction with lessons from a certified Alexander technique instructor.

Cuddy, Amy. *Presence.* New York: Little, Brown, 2015. This best-selling book is an expansion on ideas presented in her TED talk listed in this chapter and is just as relatable and inspiring as the talk. Amy Cuddy artfully weaves research with practical anecdotes, maintaining a positive and uplifting tone throughout. The text describes poses of power versus powerlessness and details how different body stances align with how we feel and who we believe we are. *Presence* provides ideas for carrying your body with poise in any stressful situation and can easily be applied to music performance.

Cuddy, Amy. "Your Body Language Shapes Who You Are." Video. TEDxGlobal, June 2012. https://www.ted.com/talks/amy_cuddy_your_body_language_shapes_who_you_are?language=en. This TED talk focuses on the ways in which we carry our bodies in stressful situations and describes "power poses" that we can embody to stimulate stress-relieving hormones. Dr. Cuddy describes her research on the effectiveness of various "power poses" in a personal and relatable way. The video may be of particular significance to those who were interested in our discussions of rehearsed responses to tension (e.g., progressive muscular relaxation, meditation, biofeedback, Alexander technique, Feldenkrais, etc.). "Journeys: Turkeys, Power Poses, and the 'Flush' of Vulnerability" in chapter 6 offers a reflection about Karin's own practice with power poses in performance and beyond.

Dunkel, Stuart Edward. *The Audition Process: Anxiety Management and Coping Strategies.* York, UK: Pendragon, 1990. Stuart Dunkel draws from his personal experience as a professional oboist and teacher, as well as resources from rational-emotive and cognitive-behavioral therapies to provide strategies for mentally preparing for auditions and other stressful performance situations. Topics include relaxation, self-talk, visualization, humor, diet, drugs, and systematic desensitization, drawing heavily from Maltz's *Psycho-Cybernetics* (1960). This book may serve as a supplemental resource to our discussions of cognitive-behavioral therapies (chapter 3), cognitive self-regulation (chapter 8), and medicinal approaches (chapter 5).

Esposito, Janet. *Getting over Stage Fright: A New Approach to Resolving Your Fear of Public Speaking and Performing.* Self-published. Printed by Your Life Publishing, 2009. If you are looking for a book that approaches MPA as a journey of personal growth and transformation, then this author's focus on healing the mind, body, and spirit may resonate with you.

This book is written by an experienced licensed clinical social worker who has worked extensively with individuals with MPA and the fear of public speaking in both private practice and the workshop setting. Divided into sections on the mind, body, and spirit, this book explores psycho-spiritual healing and transpersonal growth. Because it is written by a therapist who has a deep understanding of how therapies work, it is a good complement to this book, as it further demonstrates aspects of relevant therapeutic approaches.

Gorrie, Jon. *Performing in the Zone*. Self-published. Printed by CreateSpace, Charleston, 2009. This book is for not only musicians but public speakers, dancers, actors, and entertainers as well. The zone, Gorrie explains, is the most ideal mentality for a given performing situation, ultimately resulting in optimal performance. *Performing in the Zone* both addresses the science behind states of arousal and offers tools and techniques to help control your personal performance arousal level. The zone is discussed by its other commonly used name, flow, in chapter 8 of this book.

Green, Barry, and W. Timothy Gallwey. *The Inner Game of Music*. New York: Doubleday, 1986. A classic in music performance circles, this book is a musical take on Gallwey's *The Inner Game of Tennis* and focuses on principles of "natural learning" to evoke musical ease and expression. The intervention and replacement of negative thought patterns with positive self-talk follows a similar model to rational emotive behavioral therapy, with its therapeutic premises rooted in proactively challenging destructive cognitive habits. Similar to Havas, Gallwey and Green emphasize the need for more attention to be given to the cognitive and emotional well-being of musicians in conservatories and educational environments. The book features a discussion of "Self 1" (critical voice) and "Self 2" (intuitive potential), along with numerous exercises designed to help you release and expand your intuitive musical self. *The Inner Game of Music* is a great complement to the "Identifying and Working with Your Inner Voices" activity we present in chapter 7; we recommend it for anyone who is interested in trying out additional music-specific exercises for inviting the "creator witness" while performing.

Greene, Don. *Performance Success: Performing Your Best under Pressure*. New York: Routledge, 2001. Greene relays his experience applying sports psychology to music. The beginning of *Performance Success* requires readers to score themselves according to Greene's "Artist Performance Survey" to assess strengths and weaknesses in particular aspects of performing. In the following chapters, Greene assists readers in making sense of their scores through the "Seven Essential Skills for Optimal Performance," including determination, poise, and mental outlook. He goes on to offer specific tactics in centering, achieving mental calm, and developing a positive outlook.

Havas, Kato. *Stage Fright: Its Causes and Cures with Special Reference to Violin Playing*. London: Bosworth, 1973. One of the earliest publications on this topic, *Stage Fright* focuses specifically on the inhibiting tension facing many violinists, as well as its underlying causes. Havas discusses both the physical aspects of stage fright as experienced by string players and the activating thoughts that trigger them, including the fear of the trembling bow arm, the fear of being out of tune, and the fear of high positions and shifts. For every listed fear, Havas offers personal insight on its origins and subsequent remedies, including physically therapeutic exercises the string player can adopt into regular practice. In a similar format, Havas

also touches on the mental aspects of MPA, including the common fear of memory lapses when reciting music in a pressured performance situation. She concludes with suggestions and practice implementations for auditions, competitions, and performances, impressing the importance of physical and emotional health.

Hendricks, Gay. *The Breathing Box.* Louisville, CO: Sounds True, 2005. In this packet of resources (CD, DVD, study guide, practice cards), Dr. Gay Hendricks shares exercises and approaches he has developed from more than thirty years of research on breathing. *The Breathing Box* helps individuals become more conscious of the way they breathe and practice healthier habits of breath in everyday life. These resources are an expansion on Hendricks's earlier book, *Conscious Breathing* (1995), and are intended to help reduce stress, promote mindfulness, increase energy, and assist in healing from emotional trauma.

Herrigel, Eugen. *Zen in the Art of Archery.* Translated by Richard Francis Carrington Hull. New York: Vintage Books, 1999. This book is not recommended as a resource to learn about Zen nor even to learn about archery. Instead, it can serve as a contemplative tool to help those bogged down in microaspects of technique in any field to regain focus on the larger picture—on the holistic aspects of art and craft. In storytelling style, Herrigel describes his experiences of learning (through archery lessons) how to let go of the need to control, get out of the way, and let experiences just happen. First published in 1953, this book paved the way for other classics, such as Gallwey's *The Inner Game of Tennis* (1997) and Pirsig's *Zen and the Art of Motorcycle Maintenance* (2006). If our discussion of perfectionism in chapter 2 resonates with you, then you may find this to be a refreshing read.

Jackson, Susanne. *YogaSing Trilogy.* DVD. New York: A.D.O. Entertainment, 2006. In chapter 6, we introduce yoga as a way of releasing stress and awakening body energy. When we interviewed Metropolitan Opera singer Cynthia Lawrence for this book, she recommended the *YogaSing* DVD series to our audience (you'll even see Cynthia's photo endorsement on the back of the first DVD). The *YogaSing* series is unique among yoga videos in that it was designed specifically with musicians in mind. The DVDs combine physical posturing with body and energy awareness to help calm, balance, and effectively energize musicians in preparation for artistic performances.

Jeffers, Susan. *Feel the Fear and Do It Anyway.* New York: Ballantine, 1987. This book is written for those of you who are afraid of fear itself. A self-help book that is approachable and easy to read, *Feel the Fear and Do It Anyway* provides strategies for looking at—and dealing with—old, persistent fears in new and powerful ways. Dr. Jeffers supplements conversational descriptions with hands-on activities that are further developed in *Feel the Fear and Beyond* (1998). We cite Jeffers's "Five Truths about Fear" in chapter 2 and share a quote about expanding your comfort zone in chapter 4. We recommend a thorough read of this book for further ideas of how to move, as Jeffers says, from "pain to power."[1]

Kaesler, Nancy. *The Little Girl in the Yellow Dress: A Musical Memoir Digging for the Roots of Performance Anxiety.* Self-published. Printed by CreateSpace, Charleston, 2014. Written by a respected pianist, piano teacher, judge, and teacher educator of more than forty-five years, this memoir offers a multifaceted story of MPA. The author reflects on the roots of her own MPA and discusses the musical and social experiences that contributed to it. While this

book is not focused on a specific therapy or treatment, it does emphasize the importance of going deep into the cause of MPA and makes clear what we can learn from doing so. This story is also one of hope and inspiration and may be helpful for those exploring or re-storying their own personal histories.

Klickstein, Gerald. *The Musician's Way.* New York: Oxford University Press, 2009. This text provides resources and suggestions for successful musical performance, focusing particularly on practice routines, performance preparation, and musical creativity. Klickstein devotes one chapter specifically to managing performance anxiety, discussing similar concepts to our chapter 2 discussion of what causes MPA. The book offers ideas that may help develop practice and performance habits that lead to more confident performances.

Lieberman, Julie Lyonn. *You Are Your Instrument.* New York: Huiksi Music, 1991. An excellent complement to Conable's *What Every Musician Needs to Know about the Body* (described earlier this chapter), this book includes various approaches for promoting ease and relaxation while playing. It contains a wealth of visual diagrams and lists various physical maladies, as well as offers recommendations for performance-specific situations. A valuable contribution of the book is a large section devoted to specific muscle balance exercises, which supplements our chapter 6 discussion of yoga, Alexander technique, and other body awareness approaches.

McAllister, Lesley Sisterhen. *The Balanced Musician: Integrating Mind and Body for Peak Performance.* Lanham, MD: Scarecrow Press, 2013. This comprehensive text covers many aspects of music performance, including performance challenges, cognitive strategies, relaxation techniques, mindfulness, imagery, practicing, and others. It is thorough and extensive and contains many research-based approaches for alleviating music performance anxiety. With supplemental questions, activities, and assignments at the end of each chapter, it has potential for use as a performance course textbook or as a guide for music teachers.

Ristad, Eloise. *A Soprano on Her Head: Right Side Up Reflections on Life and Other Performances.* Boulder, CO: Real People Press, 1982. An oldie but goodie, *A Soprano on Her Head* offers lighthearted yet compassionate reflections for performing artists, encouraging us to be flexible, take risks, and find our own musical voices. It is reflective of soprano Cynthia Lawrence's advice to find your place in the musical world through unique expression rather than by attempting to satisfy someone else's interpretation of perfection. It is full of fun insights that you may wish to include in your "Backstage Book" (see later in this chapter).

Skidmore, Jon. *Peak Performance Coaching.* 2016. www.jonskidmore.com. Although there are many MPA-related sources on the Internet, we particularly recommend this website because it is designed by a licensed psychologist and performance coach who has spent decades helping musicians manage stage fright and mentally prepare for performances. Dr. Skidmore's approach incorporates research-based principles that are framed into easy-to-grasp steps, which we have personally found to be effective (with consistent practice, of course). The site includes information about Skidmore's workshops, as well as downloadable resources for individuals with varying levels of performance anxiety. The site contains a number of free videos to offer support with various performance needs. Those interested in practicing meditation (as explained in chapter 6) may find his "relax the body, focus the

mind" MP3 useful, while those with more severe anxiety may wish to contact Dr. Skidmore via his website for a personal consultation.

Solovitch, Sara. *Playing Scared: A History and Memoir of Stage Fright.* New York: Bloomsbury, 2015. Written by a musician who quit performing in her twenties, this memoir tells the story of a woman who in her fifties decided to face her fear and return to performing midlife. A professional journalist, she intertwines interviews and stories of others' history with stage fright as she shares her experiences of lessons, workshops, retreats, yoga, and other approaches. She describes her personal experience with some of the therapies and treatments we cover in this book, demonstrating that healing is a journey and that there is hope.

Stohrer, Sharon. *The Performer's Companion.* Self-published. Printed by CreateSpace, Charleston, 2014. *The Performer's Companion* offers supplemental insights to those we have discussed in this book concerning creativity, performance preparation, self-exploration, visualization, positive affirmations, and encouragement to be honest and open about your fears. Written primarily from personal experience, the author shares ideas from years of performance and teaching to assist readers in their practice of music as well as self-care. This book is of particular interest to singers, as it includes a section on vocal health, while the chapter on backstage tips and audition-specific material is useful for a wider range of musicians. It concludes with a chapter contributed by Diana McCullough on Alexander technique.

Werner, Kenny. *Effortless Mastery: Liberating the Master Musician Within*, 20th anniversary ed. New Albany, IN: Jamey Aebersold, 2016. Written by a jazz pianist, this book emphasizes the importance of performing only what you can execute effortlessly while practicing to expand that zone to include more technical skill and material. *Effortless Mastery* includes stories from the author's own personal experiences, and the accompanying CD includes meditations to help cultivate a sense of relaxed focus. Werner's work expands on the idea of the neutral observer, or the returning to a nonjudgmental frame of mind that we introduce in the "Identifying and Working with Your Inner Voices" activity in chapter 7. We recommend it for those interested in learning further how to integrate this strategy into their practice and rehearsal routines.

ACTIVITY: THE BACKSTAGE BOOK

While working with Olympic and sports psychologist Dr. Dan Kirschenbaum in Chicago, Casey learned a great deal about the premises and practices behind rational emotive therapy (RET). The gist of it is simply this: Our confidence is more undermined by negative thought rehearsal than it is by our inability to technically execute the task at hand. A habit of degrading self-talk can defeat us before we even get started, punching our self-efficacy in the gut with a fistful of insults often so vile we would hesitate to repeat them out loud.

If you were ever made fun of for roller skating to school like Casey was, then it is possible the insults thrown at you were "memorized" by your brain and repeated as an

inner monologue later on. Similarly, with music, it's difficult to shake the discomfort and discouragement of a past performance gone awry. The tactless comments of colleagues or judges can sting just as much when remembering them as they did in the moment they were said. Maybe the dull ache of failure or cracking under pressure in a particularly crucial recital still resonates with you—enough that its memory inspires a string of self-commentary to the tune of "Why do you *always* miss that note?" or "You're not good enough to be here! You could never compete with these people!"

Ouch.

So, like RET suggests, you need an intervention with your subconscious mind. The "Backstage Book" is exactly that: a portable, positive, pick-me-up reminder right when you need it most. You can throw it in your case for quick reference as you wait for the audition proctor to call you onstage or pack it alongside your music for a referral right before you play a jury or give a lesson. It's a confidence-inspiring collage of messages, images, and other media of your choosing to help keep your mind—and your heart—in the best possible place.

Here's how it works:

1. Contact friends, family, and former or current teachers, and ask them to share something specific about your playing that they enjoy or to recount a favorite performance of yours that particularly resonated with them. This is totally a call for compliments, but don't be embarrassed—you're on a mission to construct a huge compilation of all the things you do well!
2. Print all the responses, and cut them onto individual strips of paper to be arranged in a scrapbook fashion on the pages of your book.
3. Alongside the pick-me-ups, find images to inspire you. They can be of your favorite performers or maybe images that complement the repertoire you're playing. Whatever helps get your head in the positive, include it.
4. Take it with you. Add to it. Make it an overwhelmingly positive reference of everything that makes you awesome and conditioned for success—however you define the word.

JOURNEYS: HOW THE MIGHTY GET BACK UP

By Casey

As a kid, I had an embarrassing habit of overachieving. I put Christmas lights on my science fair presentation board. I volunteered to sing the national anthem at the school assembly. My submission for the local young authors contest was more than one hundred pages long. And while my efforts were usually met with disdain from my peers, I was constantly showered with encouragement from my teachers. I would be great someday, they said, and I dutifully agreed.

Figure 9.1. *Photo courtesy of Alain Milotti*

Eventually, however, the verbal outpouring of validation dried up, and the "some-days" slowly transitioned to the "present days"—at some graduated level of music study, potential is almost completely trumped by what you can prove. People care less about what you dream of being and more about what you've made happen. My teachers were no longer peering over my shoulder, commenting on my natural abil-ity, and similarly, there was no encouraging word when I failed. At first reaction, I felt abandoned. After all, wasn't it my teacher's job to nurture my success? Perhaps, but it wasn't in their power to guarantee it. If I was going to conquer anything, it wasn't going to be due to some compliment I was thrown after a performance. It had to come from technical mastery and inner conviction—and that was up to me.

In *Stage Fright: Its Causes and Cures*, violinist Kato Havas talks about how the positive side of music making slowly becomes overshadowed with anxieties and fears as we grow more musically focused and that, eventually, the constant drill of self-evaluation poisons our artistic spirit. The relentless drive to stand out among an ocean of fiddle players or a swarm of trombonists pulls our attention to self-worth instead of the musical message; to play always with a blatant desire to please was like trying too hard on a first date. Only in letting go of my concern for others' assess-ment was I able present my most authentic self, which was only made more unique from the rough edges than my perfectionism ever would have imagined.

Unfortunately for many of us competing for a place in the music world, however, there is little room for error—at least in the classical spectrum. One slipup could cost us a huge opportunity, yet no one ever won a job trying to charm the panel. And while it's foolish to try to convince yourself that you don't really care about the outcome of an audition you've been anticipating for years, I think there is something to be said about shielding your heart from the soul-crushing reality of the process. Establish comforting rituals: I always wear my favorite Chuck Taylor Converse low-tops under my solo gowns, for instance, and I highly recommend making your own "Backstage Book," a project in which you fill a small notebook with reminders of your strengths for reference before high-pressure situations. I gathered the thoughts of friends, family, trusted colleagues, and past teachers to piece together into a per-fect preperformance reminder of everything I had to offer as an artist—but most im-portantly, I save a page for a letter to myself—maybe reserved for a count-by-count

Figure 9.2. Casey performs the Barber violin concerto. *Photo courtesy of Tom Bahar*

relay of all the moments I'd proven my inner strength in such a deep, personal way that it could never be accurately expressed to anyone else. I could abbreviate it with a simple date that only I would remember or a cryptic phrase that only I would understand. Because while the support of others is heartwarming, the support you give yourself is heart assuring. And in a business where the mighty fall often, certainty from the self helps you back up.

NOTE

1. Susan Jeffers, *Feel the Fear and Do It Anyway* (New York: Ballantine, 1987), 31.

Bibliography

"2008 Physical Activity Guidelines for Americans." *US Office of Disease Prevention and Health Promotion*. Accessed April 25, 2016. http://health.gov/paguidelines/guidelines/summary.aspx.

"About Expressive Arts." *International Expressive Arts Therapy Association*. Last modified 2014. Accessed April, 30, 2016. http://www.ieata.org/index.html.

"Acupuncture." *National Center for Complementary and Integrative Health*. Last modified April 7, 2016. Accessed April 22, 2016. https://nccih.nih.gov/health/acupuncture.

Addolorato, G., E. Capristo, G. Ghittoni, C. Valeri, R. Mascianà, C. Ancona, and G. Gasbarrini. "Anxiety but Not Depression Decreases in Coeliac Patients after One-Year Gluten-Free Diet: A Longitudinal Study." *Scandinavian Journal of Gastroenterology* 36, no. 5 (2001): 502–6.

Aderman, David. "Elation, Depression, and Helping Behavior." *Journal of Personality and Social Psychology* 24, no. 1 (1972): 91–101.

American Psychiatric Association. *Diagnostic and Statistical Manual of Mental Disorders DSM-5*. 5th ed. Arlington, VA: American Psychiatric Publishing, 2013.

Ansbacher, Heinz L., and Rowena R. Ansbacher, eds. *The Individual Psychology of Alfred Adler*. New York: Basic Books, 1956.

Antony, Martin M., Christine L. Purdon, Veronika Huta, and Richard P. Swinson. "Dimensions of Perfectionism across the Anxiety Disorders." *Behaviour Research and Therapy* 36, no. 12 (1998): 1143–54.

Antony, Martin M., and Richard P. Swinson. *When Perfect Isn't Good Enough: Strategies for Coping with Perfectionism*. 2nd ed. Oakland, CA: New Harbinger, 2009.

Appel, Sylvia. "Modifying Solo Performance Anxiety in Adult Pianists." EdD diss., Columbia University, 1974.

Armstrong, Calli. "Finding Catharsis in Fairy Tales: A Theoretical Paper Exploring the Roles Catharsis Plays When Fairy Tales Are Used in Drama Therapy for Children with Anxiety." Master's thesis, Concordia University, Montreal, Quebec, 2007.

"AT in Educational Institutions Nationwide." *American Society for the Alexander Technique*. Last modified 2016. Accessed April 30, 2016. http://www.amsatonline.org/educational-institutions-nationwide.

Austin, James R. "Competition: Is Music Education the Loser?" *Music Educators Journal* 76, no. 6 (1990): 21–25.

———. "The Effect of Music Contest Format on Self-Concept, Motivation, Achievement, and Attitude of Elementary Band Students." *Journal of Research in Music Education* 36 (1988): 95–107.

Bae, Min-Jeong. "Effect of Group Music Therapy on Student Music Therapist's Anxiety, Mood, Job Engagement and Self-Efficacy." PhD Diss., University of Kansas, 2011.

Balch, Phyllis A. *Prescription for Nutritional Healing*. 5th ed. New York: Penguin, 2010.

Bandura, Albert. *Self-Efficacy: The Exercise of Control*. New York: W. H. Freeman, 1997.

———. *Social Foundations of Thought and Action: A Social Cognitive Theory*. Englewood Cliffs, NJ: Prentice Hall, 1986.

Baritz, Robert W. *Herbal Therapy, Quality Issues*. Brockton, MA: Baritz Wellness Center, 2010.

Bassham, Lanny R. *With Winning in Mind*. London: Robert Hale, 2011.

Bearman, David, and Steven Shafarman. "The Feldenkrais Method in the Treatment of Chronic Pain: A Study of Efficacy and Cost Effectiveness." *American Journal of Pain Management* 9 (1999): 22–27.

Benson, Etienne. "The Many Faces of Perfectionism." *Monitor on Psychology* 34, no. 10 (2003). Accessed April 30, 2016. http://www.apa.org/monitor/nov03/manyfaces.aspx.

Besser, Avi, Gordon L. Flett, and Paul L. Hewitt. "Perfectionism, Cognition, and Affect in Response to Performance Failure vs. Success." *Journal of Rational-Emotive and Cognitive-Behavior Therapy* 22, no. 4 (2004): 297–324.

Bonnet, Fabrice, Kate Irving, Jean-Louis Terra, Patrice Nony, François Berthezène, and Philippe Moulin. "Anxiety and Depression Are Associated with Unhealthy Lifestyle in Patients at Risk of Cardiovascular Disease." *Atherosclerosis* 178, no. 2 (2005): 339–44.

Bonny, Helen Lindquist. *Music Consciousness: The Evolution of Guided Imagery and Music*. Gilsum, NH: Barcelona, 2002.

Bonpensiere, Luigi. *New Pathways to Piano Technique*. New York: Philosophical Library, 1953.

Brandfonbrener, Alice G. "History of Playing-Related Pain in 330 University Freshman Music Students." *Medical Problems of Performing Artists* 24, no. 1 (2009): 30–36.

Brantigan, C. O., T. A. Brantigan, and N. Joseph. "Effect of Beta Blockade and Beta Stimulation on Stage Fright." *American Journal of Medicine* 72, no. 1 (1982): 88–94.

Bratman, Gregory N., J. Paul Hamilton, Kevin S. Hahn, Gretchen C. Daily, and James J. Gross. "Nature Experience Reduces Rumination and Subgenual Prefrontal Cortex Activation." *Proceedings of the National Academy of Sciences* 112, no. 28 (2015): 8567–72.

Brauninger, Iris. "Dance Movement Therapy Group Intervention in Stress Treatment: A Randomized Controlled Trial (RTC)." *Arts in Psychotherapy* 39 (2012): 443–50.

Breen, Bill. "The 6 Myths of Creativity." *Fast Company*, December 2004. Accessed April 25, 2016. http://www.fastcompany.com/magazine/89/creativity.html.

Bricker, David C., and Jeffrey E. Young. *A Client's Guide to Schema Therapy*. New York: Schema Therapy Institute, 2010.

Broomhead, Paul, Jon B. Skidmore, Dennis L. Eggett, and Melissa M. Mills. "The Effect of Positive Mindset Trigger Words on the Performance Expression of Non-Expert Adult Singers." *Contributions to Music Education* (2010): 65–86.

———. "The Effects of a Positive Mindset Trigger Word Pre-Performance Routine on the Expressive Performance of Junior High Age Singers." *Journal of Research in Music Education* 60, no. 1 (2012): 62–80.

Brotons, Melissa. "Effects of Performing Conditions on Music Performance Anxiety and Performance Quality." *Journal of Music Therapy* 31, no. 1 (1994): 63–81.

Brown, Brené. "The Power of Vulnerability." TEDxHouston video. June 2010. https://www.ted.com/talks/brene_brown_on_vulnerability?language=en.

———. "Shame Resilience Theory: A Grounded Theory Study on Women and Shame." *Families in Society* 87, no. 1 (2006): 43–52.

Brown, Richard P., and Patricia L. Gerbarg. *The Healing Power of the Breath: Simple Techniques to Reduce Stress and Anxiety, Enhance Concentration, and Balance Your Emotions.* Boston: Shambhala, 2012.

Brugués, Adriana Ortiz. "Music Performance Anxiety: A Review of the Literature." PhD diss., University of Freiburg, 2009.

Buswell, David. *Performance Strategies for Musicians.* London: MX Publishing, 2006.

Byrne, A., and D. G. Byrne. "The Effect of Exercise on Depression, Anxiety and Other Mood States: A Review." *Journal of Psychosomatic Research* 37, no. 6 (1993): 565–74.

Cameron, Julia. *The Artist's Way: A Spiritual Path to Higher Creativity.* New York: Putnam, 1992.

Carney, Dana R., Amy J. C. Cuddy, and Andy J. Yap. "Power Posing: Brief Nonverbal Displays Affect Neuroendocrine Levels and Risk Tolerance." *Psychological Science* 21, no. 10 (2010): 1363–68.

Castaneda, Ricardo, Norman Sussman, Robert Levy, Mary O'Malley, and Laurence Westreich. "A Review of the Effects of Moderate Alcohol Intake on Psychiatric and Sleep Disorders." In *Recent Developments in Alcoholism*, edited by Mark Galanter, 197–226. New York: Kluwer Academic, 1998.

Chang, Joanne, Elizabeth Midlarsky, and Peter Lin. "Effects of Meditation on Music Performance Anxiety." Medical Problems of Performing Artists 18, no. 3 (2003): 126–30.

Channing, William Ellery. *The Complete Works of William Ellery Channing.* London: George Routledge and Sons, 1870.

Childre, Doc, and Howard Martin. *The HeartMath Solution.* New York: HarperCollins, 1999.

Chodorow, Joan. *Jung on Active Imagination.* Princeton, NJ: Princeton University Press, 1977.

Chödrön, Pema. *When Things Fall Apart.* Boston: Shambhala, 2002.

Conable, Barbara. *What Every Musician Needs to Know about the Body: The Practical Application of Body Mapping to Making Music.* Chicago: GIA, 2000.

Connors, Karol A., Mary P. Galea, and Catherine M. Said. "Feldenkrais Method Balance Classes Improve Balance in Older Adults: A Controlled Trial." *Evidence-Based Complementary and Alternative Medicine* 2011 (2011): 1–9. Accessed April 30, 2016. http://dx.doi.org/10.1093/ecam/nep055.

Conroy, David E., Miranda P. Kaye, and Angela M. Fifer. "Cognitive Links between Fear of Failure and Perfectionism." *Journal of Rational-Emotive and Cognitive-Behavior Therapy* 25, no. 4 (2007): 237–53.

Cooke, Gerald. "The Efficacy of Two Desensitization Procedures: An Analogue Study." *Behaviour Research and Therapy* 4, no. 1 (1966): 17–24.

Cox, Wendy J., and Justin Kenardy. "Performance Anxiety, Social Phobia, and Setting Effects in Instrumental Music Students." *Journal of Anxiety Disorders* 7, no. 1 (1993): 49–60.

Csikszentmihalyi, Mihaly. *Flow: The Psychology of Optimal Experience.* New York: Harper and Row, 1990.

Cuddy, Amy. *Presence.* New York: Little, Brown, 2015.

———. "Your Body Language Shapes Who You Are." TEDxGlobal video. June 2012. https://www.ted.com/talks/amy_cuddy_your_body_language_shapes_who_you_are?language=en.

Curry, Nancy A., and Tim Kasser. "Can Coloring Mandalas Reduce Anxiety?" *Art Therapy: Journal of the American Art Therapy Association* 22, no 2 (2005): 81–85.

Curtis, Russell C., Amy Kimball, and Erin L. Stroup. "Understanding and Treating Social Phobia." *Journal of Counseling and Development* 82, no. 1 (2004): 3–9.

Davis, William B., Kate E. Gfeller, and Michael H. Thaut, *An Introduction to Music Therapy: Theory and Practice.* Boston: McGraw Hill, 1999.

Deci, Edward L., Richard Koestner, and Richard M. Ryan. "A Meta-Analytic Review of Experiments Examining the Effects of Extrinsic Rewards on Intrinsic Motivation." *Psychological Bulletin* 125, no. 6 (1999): 627–68.

Deci, Edward L., and Richard M. Ryan. *Self-Determination.* Indianapolis: John Wiley and Sons, 2010.

Deen, Diana Rhea. "Awareness and Breathing: Keys to the Moderation of Musical Performance Anxiety." PhD diss., University of Kentucky, 2000.

DePalma, Emily. "Beta Blocker Usage among Musicians: Removing the Stigma and Encouraging Education." Research paper for DePaul University. Last modified November 12, 2014. Accessed May 1, 2016. https://depaul.digication.com/removing_the_stigma_from_beta-blocker_use/Research_Paper.

De Silva, P., and S. Rachman. "Is Exposure a Necessary Condition for Fear-Reduction?" *Behaviour Research and Therapy* 19, no. 3 (1981): 227–32.

Detmer, Michael R. "Effect of Orff-Based Music Interventions on State Anxiety of Music Therapy Students." Master's thesis, University of Kansas, 2010.

Dews, C. L. Barney, and Martha S. Williams. "Student Musicians' Personality Styles, Stresses, and Coping Patterns." *Psychology of Music* 17, no. 1 (1989): 37–47.

Diaz, Frank M. "Mindfulness, Attention, and Flow during Music Listening: An Empirical Investigation." *Psychology of Music* 41, no. 1 (2013): 42–58.

———. "Relationships between Mindfulness Disposition, Perfectionism, Performance Anxiety, and Self-Reported Meditation Practice among Collegiate Musicians." Paper presented at the NAfME Biennial Research Conference, Atlanta, GA, March 2016.

Dorothea, Gstrein. "Effectiveness of Psychodrama Group Therapy on Pupils with Mathematics Anxiety." *Zeitschrift für Psychodrama und Soziometrie* 15 (2016): 197–215.

"Drugs and Supplements: Propranolol (Oral Route)." *Mayo Clinic.* Last modified January 1, 2016. Accessed April 30, 2016. http://www.mayoclinic.org/drugs-supplements/propranolol-oral-route/side-effects/drg-20071164.

Duke, Stephen R. "Application of the Feldenkrais Method in Learning Music Performance." *Steve Duke: Saxophone.* Accessed April 22, 2016. www.steveduke.net/pdf/feldenkrais-music-performance.pdf.

Dunkel, Stuart Edward. *The Audition Process: Anxiety Management and Coping Strategies.* York, UK: Pendragon.

Dweck, Carol S. *Mindset: The New Psychology of Success.* New York: Random House, 2006.

Eckhardt, I., and L. Lüdemann. "Kennen Sie Lampenfieber." *Das Orchester* 1 (1974): 10–15.

Eden, Donna. *Energy Medicine: Balancing Your Body's Energies for Optimal Health, Joy, and Vitality.* New York: Penguin, 2008.

Edwards, Anne. *Streisand: A Biography.* New York: Little, Brown, 1997.

"EFT Is an Effective Tool for Anxiety." *Mercola.com.* Last modified January 15, 2015. Accessed April 22, 2016. http://articles.mercola.com/sites/articles/archive/2015/01/15/eft-tapping-anxiety.aspx.

Egner, Tobias, Emilie Strawson, and John H. Gruzelier. "EEG Signature and Phenomenology of Alpha/Theta Neurofeedback Training versus Mock Feedback." *Applied Psychophysiology and Biofeedback* 27, no. 4 (2002): 261–70.

Eguchi, Eri, Narumi Funakubo, Kiyohide Tomooka, Tetsuya Ohira, Keiki Ogino, and Takeshi Tanigawa. "The Effects of Aroma Foot Massage on Blood Pressure and Anxiety in Japanese Community-Dwelling Men and Women: A Crossover Randomized Controlled Trial." *PLOS One* 11, no. 3 (2016): e0151712. Accessed April 22, 2016. http://dx.doi .org/10.1371/journal.pone.0151712.

Ellis, Albert. "Extending the Goals of Behavior Therapy and of Cognitive Behavior Therapy." *Behavior Therapy* 28, no. 3 (1997): 333–39.

Ely, Mark C. "Stop Performance Anxiety!" *Music Educators Journal* 78, no. 2 (1991): 35–39.

Ericsson, K. Anders, Ralf T. Krampe, and Clemens Tesch-Römer, "The Role of Deliberate Practice in the Acquisition of Expert Performance." *Psychological Review* 100, no. 3 (1993): 363–406.

Esplen, Mary Jane, and Ellen Hodnett. "A Pilot Study Investigating Student Musicians' Experiences of Guided Imagery as a Technique to Manage Performance Anxiety." *Medical Problems of Performing Artists* 14, no. 3 (September 1999): 127–32.

Esposito, Janet. *Getting over Stage Fright: A New Approach to Resolving Your Fear of Public Speaking and Performing.* Self-published. Printed by Your Life Publishing, 2009.

Field, Tiffany M. "Massage Therapy Effects." *American Psychologist* 53, no. 12 (1998): 1270–81.

———. "Pregnancy and Labor Massage Therapy." *Expert Review of Obstetrics and Gynecology* 5 (2010): 177–81.

Field, Tiffany, Maria Hernandez-Reif, Sybil Hart, Olga Quintino, Levelle A. Drose, Tory Field, Cynthia Kuhn, and Saul Schanberg. "Effects of Sexual Abuse Are Lessened by Massage Therapy." *Journal of Bodywork and Movement Therapies* 1, no. 2 (1997): 65–69.

Field, Tiffany, Michael Peck, Maria Hernandez-Reif, Scott Krugman, Iris Burman, and Laura Ozment-Schenck. "Postburn Itching, Pain, and Psychological Symptoms Are Reduced with Massage Therapy." *Journal of Burn Care and Research* 21, no. 3 (2000): 189–93.

Fishbein, Martin, Susan E. Middlestadt, Victor Ottati, Susan Straus, and Alan Ellis. "Medical Problems among ICSOM Musicians: Overview of a National Survey." *Medical Problems of Performing Artists* 3, no. 1 (1988): 1–8.

Flett, Gordon L., Paul L. Hewitt, Kirk Blankstein, and Sean O'Brien. "Perfectionism and Learned Resourcefulness in Depression and Self-Esteem." *Personality and Individual Differences* 12, no. 1 (1991): 61–68.

Fogle, Dale O. "Toward Effective Treatment for Music Performance Anxiety." *Psychotherapy: Theory, Research and Practice* 19, no. 3 (1982): 368–75.

Freymuth, Malva Susanne. *Mental Practice and Imagery for Musicians.* Self-published. Printed by Integrated Musicians, 1999.

Fu, Chang-Chi Musetta. "Music Therapy and Women's Health: Effects of Music-Assisted Relaxation on Women Graduate Students' Stress and Anxiety Levels." Master's thesis, Michigan State University, 2008.

Gabbard, Glen O. "Stage Fright." *International Journal of Psychoanalysis* 60 (1979): 383–92.

Gach, Michael Reed, and Beth Ann Henning. *Acupressure for Emotional Healing.* New York: Bantam, 2004.

Gladwell, Malcom. *Outliers: The Story of Success.* New York: Little, Brown, 2008.

"GM Crops Now Banned in 38 Countries Worldwide." *Sustainable Pulse.* October 22, 2015. Accessed April 30, 2016. http://sustainablepulse.com/2015/10/22/gm-crops-now-banned-in-36-countries-worldwide-sustainable-pulse-research/#.VyVPNGNizVp.

Goleman, Daniel J., and Gary E. Schwartz, "Meditation as an Intervention in Stress Reactivity." *Journal of Consulting and Clinical Psychology* 44, no. 3 (1976): 456–66.

Gorelick, Kenneth. "Poetry Therapy." In *Expressive Therapies*, edited by Cathy A. Malchiodi, 117–40. New York: Guilford Press, 2007.

Gorrie, Jon. *Performing in the Zone*. Self-published. Printed by CreateSpace, Charleston, 2009.

Gould, Daniel, Robert Weinberg, and Allen Jackson. "Mental Preparation Strategies, Cognitions, and Strength Performance." *Journal of Sport Psychology* 2, no. 4 (1980): 329–39.

Green, Barry, and W. Timothy Gallwey. *The Inner Game of Music*. New York: Doubleday, 1986.

Green, Carolyn, C. W. Martin, K. Bassett, and A. Kazanjian. "A Systematic Review of Craniosacral Therapy: Biological Plausibility, Assessment Reliability and Clinical Effectiveness." *Complementary Therapies in Medicine* 7, no. 4 (1999): 201–7.

Greenberg, Ira A., ed. *Group Hypnotherapy and Hypnodrama*. Chicago: Burnham, 1977.

Greene, Don. *Fight Your Fear and Win*. New York: Random House, 2001.

———. *Performance Success: Performing Your Best under Pressure*. New York: Routledge, 2001.

Gutiérrez, Enrique Octavio Flores, and Víctor Andrés Terán Camarena. "Music Therapy in Generalized Anxiety Disorder." *Arts in Psychotherapy* 44 (2015): 19–24.

Gutman, Gloria M., Carol P. Herbert, and Stanley R. Brown. "Feldenkrais versus Conventional Exercises for the Elderly." *Journal of Gerontology* 32, no. 5 (1977): 562–72.

Gyllensten, Amanda Lundvik, Charlotte Ekdahl, and Lars Hansson. "Long-Term Effectiveness of Basic Body Awareness Therapy in Psychiatric Outpatient Care: A Randomized Controlled Study." *Advances in Physiotherapy* 11, no. 1 (2009): 2–12.

Hale, W. Daniel, and Bonnie R. Strickland. "Induction of Mood States and Their Effect on Cognitive and Social Behaviors." *Journal of Consulting and Clinical Psychology* 44, no. 1 (1976): 155.

Hammer, Susan E. "The Effects of Guided Imagery through Music on State and Trait Anxiety. *Journal of Music Therapy* 33, no. 1 (1996): 47–70.

Hanson, Jesse. "The Bonny Method of Guided Imagery and Music: Does It Reduce Anxiety in the General Toronto Population?" PhD diss., Chicago School of Professional Psychology, 2015.

Harris, David Alan. "Using [Beta]-Blockers to Control Stage Fright: A Dancer's Dilemma." *Medical Problems of Performing Artists* 16, no. 2 (2001): 72–77.

Hart, Sybil, Tiffany Field, Maria Hernandez-Reif, Graciela Nearing, Seana Shaw, Saul Schanberg, and Cynthia Kuhn. "Anorexia Nervosa Symptoms Are Reduced by Massage Therapy." *Eating Disorders* 9, no. 4 (2001): 289–99.

Häuser, Winfried, Karl-Heinz Janke, Bodo Klump, Michael Gregor, and Andreas Hinz. "Anxiety and Depression in Adult Patients with Celiac Disease on a Gluten-Free Diet." *World Journal of Gastroenterology* 16, no. 22 (2010): 2780–87.

Havas, Kato. *A New Approach to Violin Playing*. London: Bosworth, 1961.

———. *Stage Fright: Its Causes and Cures with Special Reference to Violin Playing*. London: Bosworth, 1973.

Hayes, Steven C., Kirk D. Strosahl, and Kelly G. Wilson. *Acceptance and Commitment Therapy: The Process and Practice of Mindful Change*. New York: Guilford Press, 2011.

Hayes, Steven C., Kelly G. Wilson, Elizabeth V. Gifford, Victoria M. Follette, and Kirk Strosahl. "Experiential Avoidance and Behavioral Disorders: A Functional Dimensional Approach to Diagnosis and Treatment." *Journal of Consulting and Clinical Psychology* 64, no. 6 (1996): 1152–68.

Heinrich, Darlene L., and Charles D. Spielberger. "Anxiety and Complex Learning." In *Series in Clinical and Community Psychology: Achievement, Stress, and Anxiety*, edited by Heinz W. Krohne and Lothar Laux, 145–65, Washington, DC: Hemisphere, 1982.

Helgeson, Jayson Joe. "The Effects of Hypnotherapy on Musical Performance Anxiety." Master's thesis, University of Southern California, 1999.

Hendricks, Gay. *The Big Leap*. New York: HarperCollins, 2009.

———. *The Breathing Box*. Louisville, CO: Sounds True, 2005.

———. *Conscious Breathing*. New York: Bantam, 1995.

Hendricks, Karin S. "Changes in Self-Efficacy Beliefs over Time: Contextual Influences of Gender, Rank-Based Placement, and Social Support in a Competitive Orchestra Environment." *Psychology of Music* 42 (2014): 347–65.

———. "Relationships between the Sources of Self-Efficacy and Changes in Competence Perceptions of Music Students during an All-State Orchestra Event." PhD diss., University of Illinois at Urbana–Champaign, 2009.

———. "The Sources of Self-Efficacy: Educational Research and Implications for Music." *Update: Applications of Research in Music Education* 35 (2016): 32–38.

Hendricks, Karin S., Tawnya D. Smith, and Allen R. Legutki. "Competitive Comparison in Music: Influences upon Self-Efficacy Belief by Gender." *Gender and Education* (2015). Accessed November 23, 2015. doi:10.1080/09540253.2015.1107032.

Hendricks, Karin S., Tawnya D. Smith, and Jennifer Stanuch. "Creating Safe Spaces for Music Learning." *Music Educators Journal* 101, no. 1 (2014): 35–40.

Hennessey, Rachel. "Living in Color: The Potential Danger of Artificial Dyes." *Forbes*, August 27, 2012. Accessed April 22, 2016. http://www.forbes.com/sites/rachelhennessey/2012/08/27/living-in-color-the-potential-dangers-of-artificial-dyes/#faca8b332132.

Hernandez-Reif, Maria, Tiffany Field, Josh Krasnegor, Z. Hossain, Hillary Theakston, and I. Burman. "High Blood Pressure and Associated Symptoms Were Reduced by Massage Therapy." *Journal of Bodywork and Movement Therapies* 4, no. 1 (2000): 31–38.

Herrigel, Eugen. *Zen in the Art of Archery*. Translated by Richard Francis Carrington Hull. New York: Vintage Books, 1999.

Hewitt, Paul L., and Gordon L. Flett. "Dimensions of Perfectionism, Daily Stress, and Depression: A Test of the Specific Vulnerability Hypothesis." *Journal of Abnormal Psychology* 102, no. 1 (1993): 58–65.

———. "Perfectionism in the Self and Social Contexts: Conceptualization, Assessment, and Association with Psychopathology." *Journal of Personality and Social Psychology* 60, no. 3 (1991): 456–70.

Hewitt, Paul L., Gordon L. Flett, and Evelyn Ediger. "Perfectionism Traits and Perfectionistic Self-Presentation in Eating Disorder Attitudes, Characteristics, and Symptoms." *International Journal of Eating Disorders* 18, no. 4 (1995): 317–26.

Hingley, Virginia Dee. "Performance Anxiety in Music: A Review of the Literature." DMA diss., University of Washington, 1985.

"Holistic Medicine." *American Cancer Society*. 2013. Accessed April 22, 2016. https://web.archive.org/web/20150217103045/http://www.cancer.org/treatment/treatmentsandsideeffects/complementaryandalternativemedicine/mindbodyandspirit/holistic-medicine.

"Is Popping Pills the Sure Way to Beat Performance Nerves?" *Strad Magazine*. Last modified November 1, 2013. Accessed April 30, 2016. http://www.thestrad.com/cpt-latests/is-popping-pills-the-sure-way-to-beat-performance-nerves.

Jacka, Felice N., Julie A. Pasco, Arnstein Mykletun, Lana J. Williams, Allison M. Hodge, Sharleen Linette O'Reilly, Geoffrey C. Nicholson, Mark A. Kotowicz, and Michael Berk. "Association of Western and Traditional Diets with Depression and Anxiety in Women." *American Journal of Psychiatry* 167, no. 3 (2010): 305–11.

Jackson, Susanne. *YogaSing*. DVD. New York: A.D.O. Entertainment, 2006.

Jacobson, Edmund. *Progressive Relaxation*. Chicago: University of Chicago Press, 1938.
———. *You Must Relax*. New York: Whittlesey House, 1934.
James, I. M., D. N. W. Griffith, R. M. Pearson, and Patricia Newbury. "Effect of Oxprenolol on Stage-Fright in Musicians." *Lancet* 310, no. 8045 (1977): 952–54.
James Ian, and Imogen Savage. "Beneficial Effects of Nadolol on Anxiety-Induced Disturbances of Performance in Musicians: A Comparison with Diazepam and Placebo." *American Heart Journal* 108, no. 4 (1984): 1150–55.
Jeffers, Susan. *Feel the Fear and Do It Anyway*. New York: Ballantine, 1987.
Jensen, Eric. *Teaching with the Brain in Mind*. 2nd ed. Alexandria, VA: Association for Supervision and Curriculum Development, 1998.
Jorm, Anthony F., Helen Christensen, Kathleen M. Griffiths, Ruth A. Parslow, Bryan Rodgers, and Kelly A. Blewitt. "Effectiveness of Complementary and Self-Help Treatments for Anxiety Disorders," *Medical Journal of Australia* 181, no. 7 (2004): S29–S46.
Jung, Carl G. *The Red Book: Liber Novus*. Edited by Sonu Shamdasani. Translated by Mark Kyburz, John Peck, and Sonu Shamdasani. New York: W. W. Norton, 2009.
Kaesler, Nancy. *The Little Girl in the Yellow Dress: A Musical Memoir Digging for the Roots of Performance Anxiety*. Self-published. Printed by CreateSpace, Charleston, 2014.
Kanfer, Frederick H. "Self-Management: Strategies and Tactics." In *Maximizing Treatment Gains: Transfer Enhancement in Psychotherapy*, edited by Arnold P. Goldstein and Frederick H. Kanfer, 185–224. New York: Academic Press, 1979.
Kaplan, Donald M. "On Stage Fright." *Drama Review* 14, no. 1 (1969): 60–83.
Kendrick, Margaret J., Kenneth D. Craig, David M. Lawson, and Park O. Davidson. "Cognitive and Behavioral Therapy for Musical-Performance Anxiety." *Journal of Consulting and Clinical Psychology* 50, no. 3 (1982): 353–62.
Kenny, Dianna T. *The Psychology of Music Performance Anxiety*. New York: Oxford University Press: 2011.
———. "A Systematic Review of Treatments for Music Performance Anxiety." *Anxiety, Stress, and Coping* 18, no. 3 (2005): 183–208.
Kenny, Dianna T., and Margaret S. Osborne. "Music Performance Anxiety: New Insights from Young Musicians." *Advances in Cognitive Psychology* 2, nos. 2–3 (2006): 103–12.
Kent, Michael, ed. *The Oxford Dictionary of Sports Science and Medicine*. Vol. 10. New York: Oxford University Press, 2006.
Kern, Michael. "Introduction to Byodynamic Craniosacral Therapy." *Byodynamic Craniosacral Therapy Association of North America*. Last modified 2013. Accessed April 22, 2106. https://www.craniosacraltherapy.org/Whatis.htm.
Khalsa, Sat Bir S., and Stephen Cope. "Effects of a Yoga Lifestyle Intervention on Performance-Related Characteristics of Musicians: A Preliminary Study." *Medical Science Monitor* 12, no. 8 (2006): CR325-CR331.
Khalsa, Sat Bir S., Stephanie M. Shorter, Stephen Cope, Grace Wyshak, and Elyse Sklar. "Yoga Ameliorates Performance Anxiety and Mood Disturbance in Young Professional Musicians." *Applied Psychophysiology and Biofeedback* 34, no. 4 (2009): 279–89.
Kim, Soo Young. "The Effect of Guided Imagery and Preferred Music Listening versus Guided Imagery and Silence on Musical Performance Anxiety." Master's thesis, Texas Woman's University, 2002.
King, Hilary. "Glossary: Use." *Hilary King, MSTAT: Alexander Technique Teacher in North London*. Last modified 2016. Accessed April 30, 2016. http://www.hilaryking.net/glossary/use.html.

Kipper, David A., and Daniel Giladi. "Effectiveness of Structured Psychodrama and Systematic Desensitization in Reduction of Test Anxiety." *Journal of Counseling Psychology* 25, no. 6 (1978): 499–505.

Kirchner, Joann Marie, Arvid J. Bloom, and Paula Skutnick-Henley. "The Relationship between Performance Anxiety and Flow." *Medical Problems of Performing Artists* 23, no. 2 (2008): 59–65.

Kjelland, James Martin. "The Effects of Electromyographic Biofeedback Training on Violoncello Performance: Tone Quality and Muscle Tension." PhD diss., University of Texas at Austin, 1985.

Klein, Sabine D., Claudine Bayard, and Ursula Wolf. "The Alexander Technique and Musicians: A Systematic Review of Controlled Trials." *BioMed Central Complementary and Alternative Medicine* 14, no. 1 (2014). Accessed May 1, 2016. http://bmccomplementalternmed.biomedcentral.com/articles/10.1186/1472-6882-14-414.

Klickstein, Gerald. *The Musician's Way.* New York: Oxford University Press: 2009.

Knill, Paolo J., Helen Nienhaus Barba, and Margo N. Fuchs. *Minstrels of Soul: Intermodal Expressive Therapy.* Toronto: EGS Press, 2004.

Kobori, Osamu, and Yoshihiko Tanno. "Self-Oriented Perfectionism and Its Relationship to Positive and Negative Affect: The Mediation of Positive and Negative Perfectionism Cognitions." *Cognitive Therapy and Research* 29, no. 5 (2005): 555–67.

Kohn, Alfie. *Punished by Rewards: The Trouble with Gold Stars, Incentive Plans, A's, Praise, and Other Bribes.* Boston: Houghton Mifflin, 1999.

Kolt, Gregory S., and Janet C. McConville. "The Effects of a Feldenkrais® Awareness through Movement Program on State Anxiety." *Journal of Bodywork and Movement Therapies* 4, no. 3 (2000): 216–20.

LeBlanc, Albert, Young Chang Jin, Mary Obert, and Carolyn Siivola. "Effect of Audience on Music Performance Anxiety." *Journal of Research in Music Education* 45, no. 3 (1997): 480–96.

LeDoux, Joseph. *The Emotional Brain: The Mysterious Underpinnings of Emotional Life.* New York: Touchstone Books, 1996.

———. "The Emotional Brain, Fear, and the Amygdala." *Cellular and Molecular Neurobiology* 23, nos. 4–5 (2003): 727–38.

Lehrer, Paul M. "A Review of the Approaches to the Management of Tension and Stage Fright in Music Performance." *Journal of Research in Music Education* 35, no. 3 (1987): 143–53.

Lehrer, Paul M., Nina S. Goldman, and Erik F. Strommen. "A Principal Components Assessment of Performance Anxiety among Musicians." *Medical Problems of Performing Artists* 5, no. 1 (1990): 12–18.

Leichsenring, Falk, Manfred Beutel, and Eric Leibing. "Psychodynamic Psychotherapy for Social Phobia: A Treatment Manual Based on Supportive-Expressive Therapy." *Bulletin of the Menninger Clinic* 71, no. 1 (2007): 56–84.

Leivadi, Stella, Maria Hernandez-Reif, Tiffany Field, Maureen O'Rourke, Susan D'Arienzo, Daniel Lewis, Natasha del Pino, Saul Schanberg, and Cynthia Kuhn. "Massage Therapy and Relaxation Effects on University Dance Students." *Journal of Dance Medicine and Science* 3, no. 3 (1999): 108–12.

Levine, Stephen K. *Trauma, Tragedy, Therapy: The Arts and Human Suffering.* Philadelphia: Jessica Kingsley, 2009.

Lidén, Sture, and Carl-Gerhard Gottfries. "Beta-Blocking Agents in the Treatment of Catecholamine-Induced Symptoms in Musicians." *Lancet* 304, no. 7879 (1974): 529.

Lieberman, Julie Lyon. *You Are Your Instrument*. New York: Huiksi Music, 1991.

Lin, Peter, Joanne Chang, Vance Zemon, and Elizabeth Midlarsky. "Silent Illumination: A Study on Chan (Zen) Meditation, Anxiety, and Musical Performance Quality." *Psychology of Music* 36, no. 2 (2008): 139–55.

Lyda, Alex. "Hypnosis Gaining Ground in Medicine." *Columbia (Columbia University) News*, July 1, 2005.

Malchiodi, Cathy A. "Expressive Therapies: History, Theory, and Practice." In *Expressive Therapies*, edited by Cathy A. Malchiodi, 1–15. New York: Guilford Press, 2007.

Mandler, George, and Seymour B. Sarason. "A Study of Anxiety and Learning." *Journal of Abnormal and Social Psychology* 47, no. 2 (1952): 166–73.

Marks, I. M. "Exposure Treatments: Clinical Applications." In *Behavior Modification: Principles and Clinical Applications*, edited by Stewart Agras, 204–42. Boston: Little, Brown, 1978.

Marlett, Nancy J., and David Watson. "Test Anxiety and Immediate or Delayed Feedback in a Test-Like Avoidance Task." *Journal of Personality and Social Psychology* 8 (1968): 200–3.

Mathews, Andrew M., Michael G. Gelder, and Derek W. Johnston. *Agoraphobia: Nature and Treatment*. London: Tavistock, 1981.

McAllister, Lesley Sisterhen. *The Balanced Musician: Integrating Mind and Body for Peak Performance*. Lanham, MD: Scarecrow Press, 2013.

McGinnis, Anne M., and Leonard S. Milling. "Psychological Treatment of Musical Performance Anxiety: Current Status and Future Directions." *Psychotherapy: Theory, Research, Practice, Training* 42, no. 3 (2005): 357–73.

McNiff, Shaun. *Art as Medicine: Creating a Therapy of the Imagination*. Boston: Shambhala, 1992.

Meichenbaum, Donald. *Cognitive Behavior Modification: An Integrative Approach*. New York: Plenum Press, 1977.

Mercer, Amanda, Elizabeth Warson, and Jenny Zhao. "Visual Journaling: An Intervention to Influence Stress, Anxiety and Affect Levels in Medical Students." *Arts in Psychotherapy* 37 (2010): 143–48.

Miller, Tess A. "Why Did It Sound Better in the Practice Room? A Guide to Music Performance Anxiety and How to Cope with It through Journal Writing." DMA diss., Michigan State University, 2004.

Montello, Louise, Edgar E. Coons, and Jay Kantor. "The Use of Music Therapy as a Treatment for Musical Performance Stress." *Medical Problems of Performing Artists* 5, no. 1 (1990): 49–57.

Mor, Shulamit, Hy I. Day, Gordon L. Flett, and Paul L. Hewitt. "Perfectionism, Control, and Components of Performance Anxiety in Professional Artists." *Cognitive Therapy and Research* 19, no. 2 (1995): 207–25.

Morris, Frances J. "Should Art Be Integrated into Cognitive Behavioral Therapy for Anxiety Disorders?" *The Arts in Psychotherapy* 41, no. 4 (2014): 343–52.

Muller, Bryan J. "Guided Imagery and Music: A Survey of Current Practices." PhD diss., Temple University, 2010.

"Music Therapy Definition." *Music Therapy Association of Ontario*. Last modified 2016. Accessed April, 30, 2016. http://www.musictherapyontario.com/page-1090464.

Nagel, Julie J. "How to Destroy Creativity in Music Students: The Need for Emotional and Psychological Support Services in Music Schools." *Medical Problems of Performing Artists* 24, no. 1 (2009): 15–17.

———. "Performance Anxiety and the Performing Musician: A Fear of Failure or a Fear of Success?" *Medical Problems of Performing Artists* 5, no. 1 (1990): 37–40.

———. "Treatment of Music Performance Anxiety via Psychological Approaches: A Review of Selected CBT and Psychodynamic Literature." *Medical Problems of Performing Artists* 25, no. 4 (2010): 141–48.

Nagel, Julie Jaffee, David P. Himle, and James D. Papsdorf. "Cognitive-Behavioural Treatment of Musical Performance Anxiety." *Psychology of Music* 17, no. 1 (April 1989): 12–21.

Neftel, Klaus A., Rolf H. Adler, Louis Kappeli, Mario Rossi, Martin Dolder, Hans E. Kaser, Heinz H. Bruggesser, and Helmut Vorkauf. "Stage Fright in Musicians: A Model Illustrating the Effect of Beta Blockers." *Psychosomatic Medicine* 44, no. 5 (1982): 461–69.

Netz, Yael, and Ronnie Lidor. "Mood Alterations in Mindful versus Aerobic Exercise Modes." *Journal of Psychology* 137, no. 5 (2003): 405–19.

Neumeister, Kristie L. Speirs. "Understanding the Relationship between Perfectionism and Achievement Motivation in Gifted College Students." *Gifted Child Quarterly* 48, no. 3 (2004): 219–31.

Nideffer, Robert M., and Nancy D. Hessler. "Controlling Performance Anxiety." *College Music Symposium* 18, no. 1 (1978): 146–53.

Norton, G. Ron, Lynne MacLean, and Elaine Wachna. "The Use of Cognitive Desensitization and Self-Directed Mastery Training for Treating Stage Fright." *Cognitive Therapy and Research* 2, no. 1 (1978): 61–64.

Nube, Jacqueline. "Beta Blockers: Effects on Performing Musicians." *Medical Problems of Performing Artists* 6, no. 2 (1991): 61–68.

O'Neil, Michael, ed. *The ADA Practical Guide to Substance Use Disorders and Safe Prescribing.* Malden, MA: John Wiley and Sons, 2015.

O'Neill, Susan A. "Flow Theory and the Development of Musical Performance Skills." *Bulletin of the Council for Research in Music Education* 141 (1999): 129–34.

Osborne, Margaret S., and John Franklin. "Cognitive Processes in Music Performance Anxiety." *Australian Journal of Psychology* 54 (2002): 86–93.

Oxendine, Joseph B. "Emotional Arousal and Motor Performance." *Quest* 13, no. 1 (1970): 23–32.

Paparo, Stephen A. "Embodying Singing in the Choral Classroom: A Somatic Approach to Teaching and Learning." *International Journal of Music Education* (2015): 1–11. doi:10.1177/0255761415569366.

Park, Jung-Eun. "The Relationship between Musical Performance Anxiety, Healthy Lifestyle Factors, and Substance Use among Young Adult Classical Musicians: Implications for Training and Education." EdD diss., Teachers College, Columbia University, 2010.

Petruzzello, Steven J., Daniel M. Landers, Brad D. Hatfield, Karla A. Kubitz, and Walter Salazar. "A Meta-Analysis on the Anxiety-Reducing Effects of Acute and Chronic Exercise." *Sports Medicine* 11, no. 3 (1991): 143–82.

Pilkington, Karen. "Anxiety, Depression and Acupuncture: A Review of the Clinical Research." *Autonomic Neuroscience* 157, no. 1 (2010): 91–95.

Pilkington, Karen, Graham Kirkwood, Hagen Rampes, Mike Cummings, and Janet Richardson. "Acupuncture for Anxiety and Anxiety Disorders: A Systematic Literature Review." *Acupuncture in Medicine* 25, nos. 1–2 (2007): 1–10.

Plaut, Eric A. "Psychotherapy of Performance Anxiety." *Medical Problems of Performing Artists* 3, no. 3 (1988): 113–18.

Plott, Thomas M. "An Investigation of the Hypnotic Treatment of Music Performance Anxiety." PhD diss., University of Tennessee, 1986.

Plummer, Charles D. "Performance Enhancement for Brass Musicians Using Eye Movement Desensitization and Reprocessing." PhD diss., University of Cincinnati, 2007.

Popple, Ian. "How Beta-Blockers Came to Be." *McGill Reporter* 37, no. 3 (October 14, 2004).. Accessed April 30, 2016. https://www.mcgill.ca/reporter/37/03/black.

Powell, Graham E. "Negative and Positive Mental Practice in Motor Skill Acquisition." *Perceptual and Motor Skills* 37, no. 1 (1973): 312.

Price, Jennifer S. "Creative Healing: An Expressive Art Therapy Curriculum Designed to Decrease the Symptoms of Depression and Anxiety." Master's thesis, Prescott College, 2009.

Raeburn, Susan D., John Hipple, William Delaney, and Kris Chesky. "Surveying Popular Musicians' Health Status Using Convenience Samples." *Medical Problems of Performing Artists* 18, no. 3 (2003): 113–19.

Rardin, M. Anne. "The Effects of an Injury Prevention Intervention on Playing-Related Pain, Tension, and Attitudes in the High School Orchestra Classroom." PhD diss., University of Southern California, Los Angeles, 2007.

Rickels, Karl, W. George Case, Robert W. Downing, and Andrew Winokur. "Long-Term Diazepam Therapy and Clinical Outcome." *Journal of the American Medical Association* 250, no. 6 (1983): 767–71.

Rife, Nora A., Leah Blumberg Lapidus, and Zachary M. Shnek. "Musical Performance Anxiety, Cognitive Flexibility, and Field Independence in Professional Musicians." *Medical Problems of Performing Artists* 15, no. 4 (2000): 161–67.

Ristad, Eloise. *A Soprano on Her Head: Right Side Up Reflections on Life and Other Performances.* Boulder, CO: Real People Press, 1982.

Roesler, Rebecca A. "Musically Meaningful: The Interpersonal Goals of Performance." *Music Educators Journal* 100, no. 3 (2014): 39–43.

Rogers, Carl R. *On Becoming a Person: A Therapist's View of Psychotherapy.* New York: Houghton Mifflin, 1961.

———. *A Way of Being.* New York: Houghton Mifflin, 1981.

Rogers, Natalie. *The Creative Connection: Expressive Arts as Healing.* Palo Alto, CA: Science and Behavior Books, 1993.

Rosaio, Emily E. "How Do Individuals with Fears of Social Situations Experience Making Art of Their Feared Situation?" Master's thesis, Drexel University, 2013.

Rosenthal, P. "Inderal for Performance Anxiety: Better Living through Chemistry or Bargaining with Satan?" *Horn Call: Journal of the International Horn Society* 30, no 3 (2000): 67–73.

Ross, Stewart L. "The Effectiveness of Mental Practice in Improving the Performance of College Trombonists." *Journal of Research in Music Education* 33, no. 4 (1985): 221–30.

Rotella, Bob. *Golf Is Not a Game of Perfect.* New York: Simon and Schuster, 2012.

Ryan, Charlene. "Exploring Musical Performance Anxiety in Children." *Medical Problems of Performing Artists* 13 (1998): 83–88.

Ryan, Richard M., and Edward L. Deci. "Self-Determination Theory and the Facilitation of Intrinsic Motivation, Social Development, and Well-Being." *American Psychologist* 55, no. 1 (2000): 68–78.

Salmon, Paul. "A Psychological Perspective on Musical Performance Anxiety: A Review of the Literature." *Medical Problems of Performing Artists* 5 (1990): 2–11.

Sanders, Brian. "Hypnosis as an Alternative to Beta Blockers for Stage Fright." *Sanders Hypnosis Official Blog.* Accessed April 30, 2016. http://sandershypnosis.blogspot.com.

Sanderson, William C., Peter A. DiNardo, Ronald M. Rapee, and David H. Barlow. "Syndrome Comorbidity in Patients Diagnosed with a DSM-III—R Anxiety Disorder." *Journal of Abnormal Psychology* 99, no. 3 (1990): 308–12.

Sarris, Jerome, Steven Moylan, David A. Camfield, M. P. Pase, David Mischoulon, Michael Berk, F. N. Jacka, and Isaac Schweitzer. "Complementary Medicine, Exercise, Meditation, Diet, and Lifestyle Modification for Anxiety Disorders: A Review of Current Evidence." *Evidence-Based Complementary and Alternative Medicine* 2012 (2012): 1–20. doi:10.1155/2012/809653.

Schmidt, Charles P. "Relations among Motivation, Performance Achievement, and Music Experience Variables in Secondary Instrumental Music Students." *Journal of Research in Music Education* 53, no. 2 (2005): 134–47.

Schou, Mogens. "Artistic Productivity and Lithium Prophylaxis in Manic-Depressive Illness." *British Journal of Psychiatry* 135, no. 2 (1979): 97–103.

Scotton, Bruce W., Allan B. Chinen, and John R. Battista. *Transpersonal Psychiatry and Psychology.* New York: Basic Books, 1996.

Setzer, William N. "Essential Oils and Anxiolytic Aromatherapy." *Natural Product Communications* 4, no. 9 (2009): 1305–16.

Severson, Paul, and Mark McDunn. *Brass Wind Artistry: Master Your Mind, Master Your Instrument.* North Greece, NY: Accura Music, 1983.

Shapiro, Francine. "Getting Past Your Past." RodaleBooks video. December 2011; accessed April 25, 2016, https://www.youtube.com/watch?v=nylajeG6uFY.

———. *Getting Past Your Past: Take Control of Your Life with Self-Help Techniques from EMDR Therapy.* New York: Rodale, 2012.

Simon, Julie Ann, and Rainer Martens. "Children's Anxiety in Sport and Nonsport Evaluative Activities." PhD diss., University of Illinois at Urbana–Champaign, 1977.

Sisterhen, Lesley Ann. "The Use of Imagery, Mental Practice, and Relaxation Techniques for Musical Performance Enhancement." PhD diss., University of Oklahoma, 2005.

Skidmore, Jon. *Peak Performance Coaching.* Accessed April 13, 2016. www.jonskidmore.com.

———. *Relax the Body and Focus the Mind.* CD. Orem, UT: Jon Skidmore, 2003.

Slomka, Jacquelyn. "Playing with Propranolol." *Hastings Center Report* 22, no. 4 (1992): 13–17.

Smith, Tawnya D. "Using the Expressive Arts to Facilitate Group Music Improvisation and Individual Reflection: Expanding Consciousness in Music Learning for Self-Development." PhD diss., University of Illinois at Urbana–Champaign, 2014.

Solovitch, Sara. *Playing Scared: A History and Memoir of Stage Fright.* New York: Bloomsbury, 2015.

Sondheim, Stephen. *Into the Woods.* New York: Rilting Music, 1989.

Stanton, Harry E. "Using Hypnotherapy to Overcome Examination Anxiety." *American Journal of Clinical Hypnosis* 35, no. 3 (1993): 198–204.

Steptoe, Andrew. "Performance Anxiety: Recent Developments in Its Analysis and Management." *Musical Times* 123, no. 1674 (1982): 537–41.

———. "Stress, Coping and Stage Fright in Professional Musicians." *Psychology of Music* 17, no. 1 (1989): 3–11.

Steptoe, Andrew, and Helen Fidler. "Stage Fright in Orchestral Musicians: A Study of Cognitive and Behavioural Strategies in Performance Anxiety." *British Journal of Psychology* 78, no. 2 (1987): 241–49.

Stern, Judith R. S., Sat Bir S. Khalsa, and Stefan G. Hofmann. "A Yoga Intervention for Music Performance Anxiety in Conservatory Students." *Medical Problems of Performing Artists* 27, no. 3 (2012): 123–28.

Stewart, James H. "Hypnosis in Contemporary Medicine." *Mayo Clinic Proceedings* 80, no. 4 (2005): 511–24.

Stoeber, Joachim, and Ulrike Eismann. "Perfectionism in Young Musicians: Relations with Motivation, Effort, Achievement, and Distress." *Personality and Individual Differences* 43, no. 8 (2007): 2182–92.

Stohrer, Sharon. *The Performer's Companion.* Self-published. Printed by CreateSpace, Charleston, 2014.

Suinn, Richard M. "Behavioral Methods at the Winter Olympic Games." *Behavior Therapy* 8, no. 2 (1977): 283–84.

———. "Behavior Rehearsal Training for Ski Racers." *Behavior Therapy* 3, no. 3 (1972): 519–20.

———. "Visual Motor Behavior Rehearsal: The Basic Technique." *Cognitive Behaviour Therapy* 13, no. 3 (1984): 131–42.

"Suzuki Principles in Action." *Suzuki Association of the Americas.* Accessed February 16, 2015. https://suzukiassociation.org/teachers/training/spa.

Swart, Inette. "Overcoming Adversity: Trauma in the Lives of Music Performers and Composers." *Psychology of Music* 42, no. 3 (2013): 386–402.

Thrane, Susan, and Susan M. Cohen. "Effect of Reiki Therapy on Pain and Anxiety in Adults: An In-Depth Literature Review of Randomized Trials with Effect Size Calculations." *Pain Management Nursing* 15, no. 4 (2014): 897–908.

Thurber, Myron Ross. "Effects of Heart-Rate Variability Biofeedback Training and Emotional Regulation on Music Performance Anxiety in University Students." PhD diss., University of North Texas, 2006.

Tindall, Blair. "Better Playing through Chemistry." *New York Times*, October, 17, 2004. Accessed May 1, 2016. http://www.nytimes.com/2004/10/17/arts/music/better-playing-through-chemistry.html?_r=0.

Tobacyk, Jerome J., and Alan Downs. "Personal Construct Threat and Irrational Beliefs as Cognitive Predictors of Increases in Musical Performance Anxiety." *Journal of Personality and Social Psychology* 51, no. 4 (1986): 779.

Trusheim, William. "Mental Imagery and Musical Performance: An Inquiry into Imagery Use by Eminent Orchestral Brass Players in the United States." EdD diss., Rutgers University, 1987.

Tyrer, P. J., and M. H. Lader, "Response to Propranolol and Diazepam in Somatic and Psychic Anxiety." *British Medical Journal* 2, no. 5909 (1974): 14–16.

Usry, Jennifer. "Effect of Music Therapy Relaxation Techniques on the Stress and Anxiety Levels of Music and Music Therapy Students and Music and Music Therapy Professionals." Master's thesis, Florida State University, 2006.

Valentine, Elizabeth. "Alexander Technique." In *Musical Excellence: Strategies and Techniques to Enhance Performance*, edited by Aaron Williamon, 179–95. New York: Oxford University Press, 2004.

Valentine, Elizabeth R., David F. P. Fitzgerald, Tessa L. Gorton, Jennifer A. Hudson, and Elizabeth R. C. Symonds. "The Effect of Lessons in the Alexander Technique on Music Performance in High and Low Stress Situations." *Psychology of Music* 23, no. 2 (1995): 129–41.

van Kemenade, Johannes, F. L. M. Maarten, J. M. van Son, and Nicolette C. A. van Heesch. "Performance Anxiety among Professional Musicians in Symphonic Orchestras: A Self-Report Study." *Psychological Reports* 77, no. 2 (1995): 555–62.

Van Vreeswijk, Michiel, Jenny Broersen, and Marjon Nadort. *The Wiley-Blackwell Handbook of Schema Therapy: Theory, Research and Practice.* Malden, MA: John Wiley and Sons, 2015.

Walsh, Roger, and Frances Vaughan. "Meditation: Royal Road to the Transpersonal." In *Paths beyond Ego: The Transpersonal Vision*, edited by Roger Walsh and Frances Vaughan, 47–55. New York: Penguin Putnam, 1993.

Watson, P., and Elizabeth Valentine. "The Practice of Complementary Medicine and Anxiety Levels in a Population of Musicians." *Journal of the International Society for the Study of Tension in Performance* 4, no. 2 (1987): 26–30.

Werner, Kenny. *Effortless Mastery: Liberating the Master Musician Within.* 20th anniversary ed. New Albany, IN: Jamey Aebersold, 2016.

Wesner, Robert B., Russell Noyes, and Thomas L. Davis. "The Occurrence of Performance Anxiety among Musicians." *Journal of Affective Disorders* 18, no. 3 (1990): 177–85.

"What Is Art Therapy?" *American Art Therapy Association.* Last modified 2013. Accessed April, 30, 2016. http://www.arttherapy.org/upload/whatisarttherapy.pdf.

"What Is Dance/Movement Therapy?" *American Dance Therapy Association.* Last modified 2016. Accessed April, 30, 2016. https://adta.org/faqs.

"What Is Drama Therapy?" *North American Drama Therapy Association.* Last modified 2016. Accessed April, 30, 2016. http://www.nadta.org/what-is-drama-therapy.html.

"What Is EMDR?" *Eye Movement Desensitization and Reprocessing Institute.* Last modified 2016. Accessed March 15, 2016. http://www.emdr.com/what-is-emdr.

"What Is Hypnotherapy?" *Institute of Clinical Hypnosis and Related Sciences.* Accessed April 30, 2016. http://www.instituteofclinicalhypnosis.com/hypnotherapy.

"What Is Music Therapy?" *American Music Therapy Association.* Last modified 2016. Accessed April, 30, 2016. http://www.musictherapy.org/about/musictherapy.

"What Is Poetry Therapy?" *Institute for Poetic Medicine.* Last modified 2008. Accessed April, 30, 2016. http://poeticmedicine.org/about.poetrytherapy.html.

"What Is Reiki?" *Reiki.org.* Last modified 2016. Accessed April 22, 2016. http://www.reiki.org/faq/whatisreiki.html.

"What Is the Feldenkrais Method?" *Feldenkrais Educational Foundation of North America and Feldenkrais Guild of North America.* Last modified 2016. Accessed April 22, 2016. http://www.feldenkrais.com/whatis.

Whitaker, Charlotte Sibley. "The Modification of Psychophysiological Responses to Stress in Piano Performance." PhD diss., Texas Tech University, 1984.

Wolfe, Mary L. "Correlates of Adaptive and Maladaptive Musical Performance Anxiety." *Medical Problems of Performing Artists* 4, no. 1 (1989): 49–56.

Wood, Albert Lee. "The Relationship of Selected Factors to Achievement Motivation and Self-Esteem among Senior High School Band Members." PhD diss., Louisiana State University and Agricultural and Mechanical College, 1973.

Woolfolk, Robert L., Mark W. Parrish, and Shane M. Murphy. "The Effects of Positive and Negative Imagery on Motor Skill Performance." *Cognitive Therapy and Research* 9, no. 3 (1985): 335–41.

Zarate, Rebecca. "Clinical Improvisation and Its Effect on Anxiety: A Multiple Single Subject Design." *Arts in Psychotherapy* 48 (2016): 46–53.

———. "The Sounds of Anxiety: A Quantitative Study of Music Therapy and Anxiety." PhD diss., Lesley University, 2012.

Zimmerman, Barry J., "A Social Cognitive View of Self-Regulated Academic Learning." *Journal of Educational Psychology* 81, no. 3 (1989): 329–39.

Index

About the Authors

Casey McGrath, violinist, holds a doctorate of musical arts in performance and literature from the University of Illinois at Urbana–Champaign as a student of Stefan Milenkovich, received her master of music degree in violin performance from the Cincinnati Conservatory of Music, and her bachelor of music in performance at Butler University as a student of Larry Shapiro. She currently studies with Drew Lecher.

Casey serves as concertmaster for the Fox Valley Orchestra where she has appeared as concerto soloist in addition to solo performances with the Illinois Valley Symphony, the Joliet Symphony, the Fox Valley Philharmonic, the Metropolitan Youth Symphony Orchestra, the Antiqua Baroque Consort, and Tango Espejo, an ensemble dedicated to the authentic performance of works by Astor Piazzolla. As an orchestral violinist, she has appeared in section and principal positions with various regional orchestras, including the New Philharmonic, Northwest Indiana Symphony, Elgin Symphony, Rockford Symphony, the Salt Creek Ballet, Lafayette Symphony, Marion Philharmonic, the Kokomo Symphony, the Pro Arte Chamber Orchestra, among others. Casey currently serves on the music faculty of Joliet Junior College and maintains a private studio in the Chicago suburbs. Aside from teaching and an active performance career, Casey enjoys jumping from airplanes as a B-licensed skydiver.

Karin S. Hendricks is an assistant professor of music education at Boston University, with previous appointments at Ball State University and the University of Illinois. She has a degree in cello performance from the Oberlin Conservatory of Music as a student of Peter Rejto, a degree in German studies from Oberlin College, and a PhD in music education from the University of Illinois. Dr. Hendricks is an award-winning music teacher and taught orchestra in the public schools for thirteen years. She has presented research and practitioner workshops nationally and

internationally and has published papers in professional and peer-reviewed journals such as the *American Suzuki Journal, American String Teacher, Bulletin of the Council for Research in Music Education, Early Childhood Research and Practice, Gender and Education, International Journal of Music Education: Research, Music Educators Journal, Research Studies in Music Education, Philosophy of Music Education Review,* and *Psychology of Music.* She has contributed book chapters for texts published by the Canadian Music Educators' Association, GIA, Meredith Music, Peter Lang, and Rowman and Littlefield.

Tawnya D. Smith is lecturer in music education at the Boston University College of Fine Arts. She completed a PhD in curriculum and instruction at the University of Illinois and a certificate of advanced graduate study in expressive arts therapy at Lesley University. Her research focuses on integrating expressive arts approaches in music learning, and she has published articles and chapters in a variety of professional and peer-reviewed journals and books. She is an experienced music educator who has taught in the public schools and in the community. She recently completed a term of service as publications co-chair on the board of the International Expressive Arts Therapy Association.

Made in the USA
Coppell, TX
12 February 2023

12709835R00111